HOW TO DRAW AND PAINT
PORTRAITS

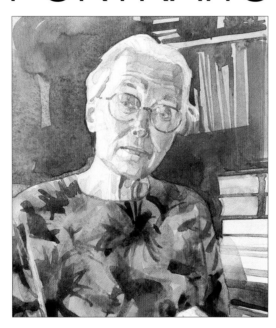

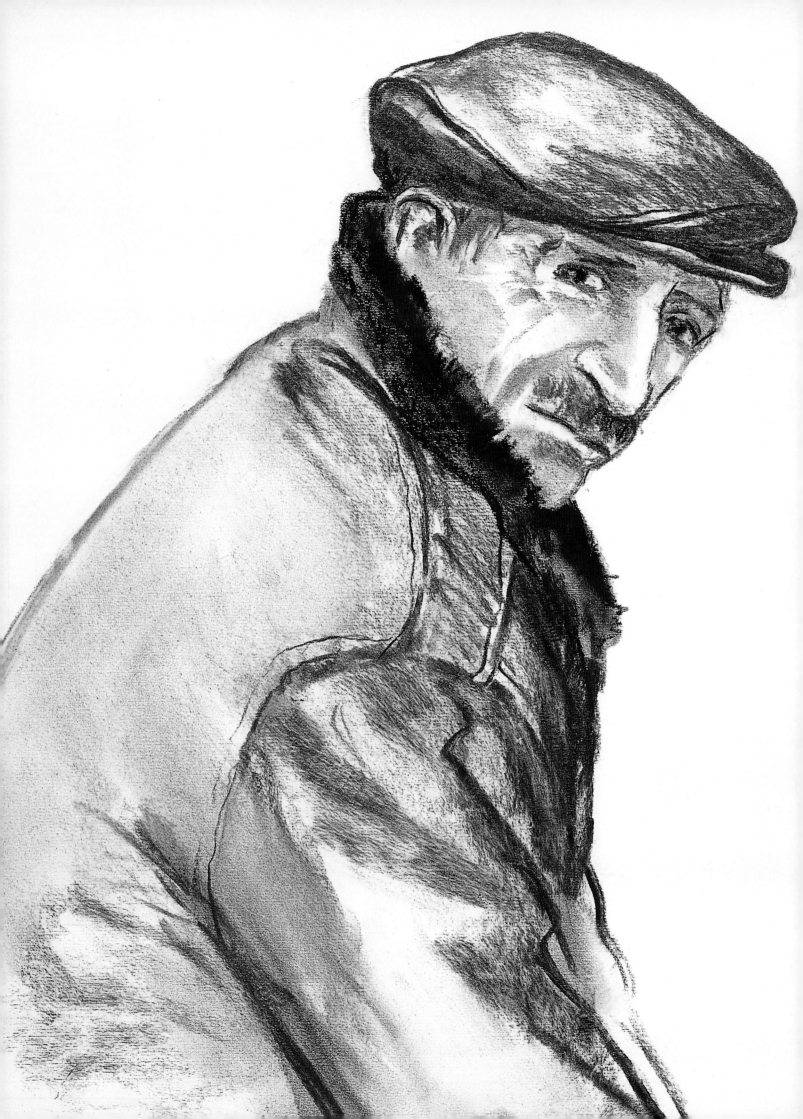

HOW TO DRAW AND PAINT
PORTRAITS

Learn how to draw people through taught example, with more than 400 superb photographs and practical exercises, each designed to help you develop your skills

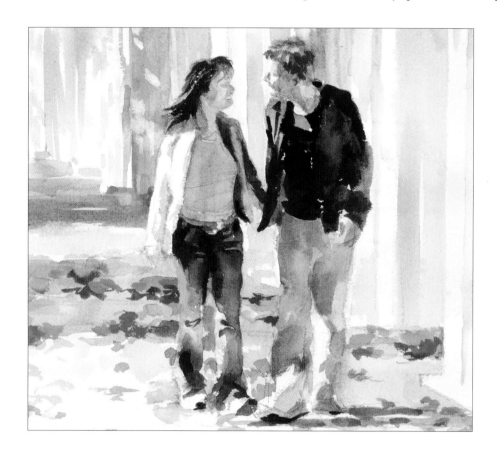

All the basics shown step by step, from drawing facial features and hair texture to capturing expressions, character and posture

Sarah Hoggett and Vincent Milne

southwater

This edition is published by Southwater, an imprint of Anness Publishing Ltd,
Blaby Road, Wigston, Leicestershire LE18 4SE

Email: info@anness.com

Web: www.southwaterbooks.com; www.annesspublishing.com

If you like the images in this book and would like to investigate using
them for publishing, promotions or advertising, please visit our website
www.practicalpictures.com for more information.

Publisher: Joanna Lorenz
Editorial Director: Helen Sudell
Project Editors: Rosie Gordon and Elizabeth Young
Photographer: Martin Norris
Design: Nigel Partridge
Cover Design: Lisa Tai
Production Controller: Bessie Bai

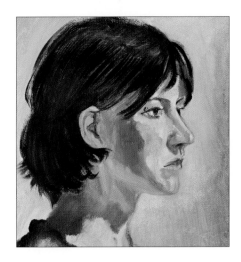

Acknowledgements
The publishers are grateful to the following for permission to reproduce illustrations:
Gerry Baptist: p55b; Paul Bartlett: pp 47b, 56tr; Gerald Cains: p54t; Trevor Chamberlain:
p58t; Patrick Clossick: p59tr; David Curtis: p60tl; Timothy Easton: p56b; Ted Gould: p58b,
59b; Hazel Harrison: p56; Geoff Marsters: p60tr; Vincent Milne: pp 26-8, 30–5, 37,38–9,
40, 41b, 42–5, 62–71; Ken Paine: page 57t, 61tl, b; Karen Raney: p59tl; Ian Sidaway:
pp 54b, 55t; Sally Strand: p57b.

The publishers are grateful to the following artists for contributing step-by-step
demonstrations: Diana Constance: pp102–107; Abigail Edgar: pp90–5, 96–101, 114–19,
120–3, 124–7; Vincent Milne: pp84–9; John Raynes: pp108–13; Ian Sidaway: pp78–83;
Albany Wiseman: pp72–7.

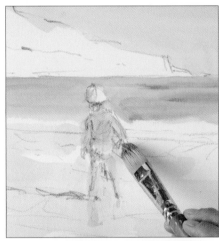

Ethical Trading Policy
At Anness Publishing we believe that business should be conducted in an ethical and
ecologically sustainable way, with respect for the environment and a proper regard to the
replacement of the natural resources we employ.

As a publisher, we use a lot of wood pulp to make high-quality paper for printing, and that
wood commonly comes from spruce trees. We are therefore currently growing more than
750,000 trees in three Scottish forest plantations: Berrymoss (130 hectares/320 acres), West
Touxhill (125 hectares/305 acres) and Deveron Forest (75 hectares/185 acres). The forests we
manage contain more than 3.5 times the number of trees employed each year in making
paper for the books we manufacture.

Because of this ongoing ecological investment programme, you, as our customer, can have
the pleasure and reassurance of knowing that a tree is being cultivated on your behalf to
naturally replace the materials used to make the book you are holding.

Our forestry programme is run in accordance with the UK Woodland Assurance Scheme
(UKWAS) and will be certified by the internationally recognized Forest Stewardship Council
(FSC). The FSC is a non-government organization dedicated to promoting responsible
management of the world's forests. Certification ensures forests are managed in an
environmentally sustainable and socially responsible way. For further information about this
scheme, go to www.annesspublishing.com/trees

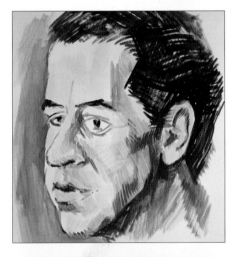

A CIP catalogue record for this book is available from the British Library.

Previously published as part of a larger volume, *A Masterclass in Drawing and Painting
the Human Figure*

Publisher's Note
Although the advice and information in this book are believed to be accurate and true at the
time of going to press, neither the authors nor the publisher can accept any legal responsibility
or liability for any errors or omissions that may be made nor for any inaccuracies nor for any
loss, harm or injury that comes about from following instructions or advice in this book.

Contents

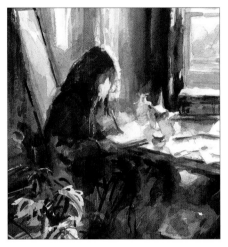

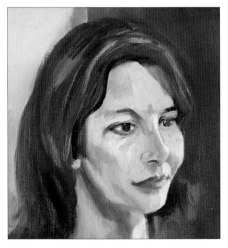

Introduction

Portraiture has gone through many styles and changes over the centuries, from formal portraits intended as much to flatter the subject and show off a patron's wealth as to capture a realistic likeness, to 'warts and all' portraits that seek to convey, or lay bare, the character and personality of the sitter.

For many amateur artists, being able to produce good portraits and life drawings is the ultimate goal. Wouldn't it be lovely to be able to paint one's family and friends? At the same time, however, the subject is viewed with a certain amount of trepidation. There's a feeling that drawing and painting people is somehow harder than painting things like landscapes and flowers and, for beginners in particular, there's something quite intimidating about being faced with a live model.

In truth, one of the reasons that painting people is perceived as being so difficult is that our expectations, both as viewers and as artists, are somewhat different. No one will worry if you alter

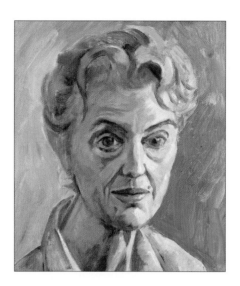

▲ A grey-green colour is a traditional choice for underpainting portraits, as it helps to establish a contrast between shadow areas and warmer highlights.

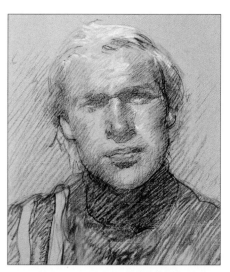

▲ Working in just three colours is an excellent way to model form. Here, areas of the lightly coloured paper are left uncovered, while the light and dark tones are achieved by shading with white and black.

the position of a tree in a landscape, or if you don't put in every single petal of a flower. On the contrary, your changes will probably be put down to artistic licence – if they're noticed at all.

Paintings of people, on the other hand, are expected to be true, almost photographically accurate, likenesses. "It doesn't even look like him" is probably the most common criticism of a painting – and a critique like that could well put you off life drawing for good. In the face of that, perhaps it's understandable that many amateurs decide to play it safe and stick to less contentious subjects such as still lifes and scenes of holiday destinations.

If you'd like to have a go at drawing and painting people, the material within this book is designed to provide a thorough introduction to everything you need to know. After a look at the tools and materials available, the book moves on to a tutorials section, which sets out some of the technicalities of portraiture such as measuring and proportions and the facial features, then touches on artistic concerns such as composition and lighting. If you're a complete beginner, work through this section page by page, as it will help you build up the confidence to tackle portraits on your own. Alternatively, if there are

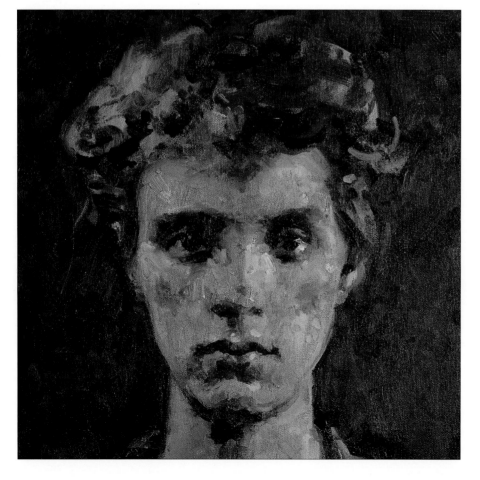

◄ The central placing of the head on the canvas and the solemn outward gaze impart a sense of strength and dignity to the image.

specific aspects of drawing and painting people that you feel you need a little help with, dip into the section for a refresher course whenever you need to.

The rest of the book is a collection of step-by-step projects. This section begins with a gallery of works by professional artists that you can use as a source of ideas and inspiration, and ends with a series of projects covering a whole range of poses and media.

Naturally, your own models may look very different to those who have sat for the projects in this book, and you will have your own ideas on compositions, room settings and so on – but don't be put off by that. You can learn a lot from the artists who have contributed to this book, and gain from their experience.

Although they work in a range of media, the one thing the artists all have in common is their ability to assess the essentials of the pose and translate it to the two-dimensional surface of the paper or canvas. Studying their step-by-step projects will give you all kinds of insights that you can use in your own work, from working out an effective composition to looking at the effect of light and shade on your subject and creating a lively and convincingly three-dimensional portrayal.

What comes after that? Well, it's up to you! The old adage 'practice makes perfect' really holds true in drawing and painting. Practise when you can – and don't wait until you have the time to

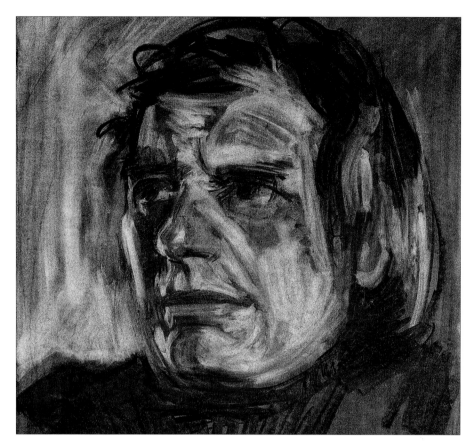

▲ Charcoal encourages bold drawing and can give a dramatic effect.

create a full-scale life study, or you will never get started. Artists' sketchbooks are crammed full of studies made whenever they have got a few minutes to spare, and, whether they are preparatory sketches for a larger work or practice exercises to sharpen observational skills, the time this work takes is always valuably spent.

Drawing and painting people is an unending voyage of discovery. Every person is different and every pose is different; even shapes and relationships within the same pose may alter slightly as the work progresses, keeping you on the alert and making you continually reassess things. And this is what makes life drawing and painting so fascinating.

▶ Drawing the figure in motion is a good exercise in studying people. Choose a medium that allows you to work quickly.

◀ Keeping the background plain results in a strong, simple portrait.

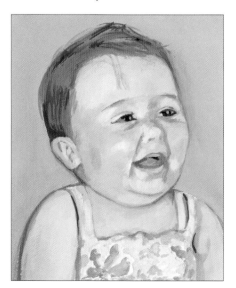

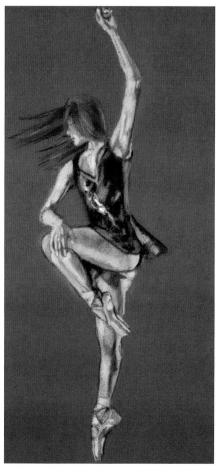

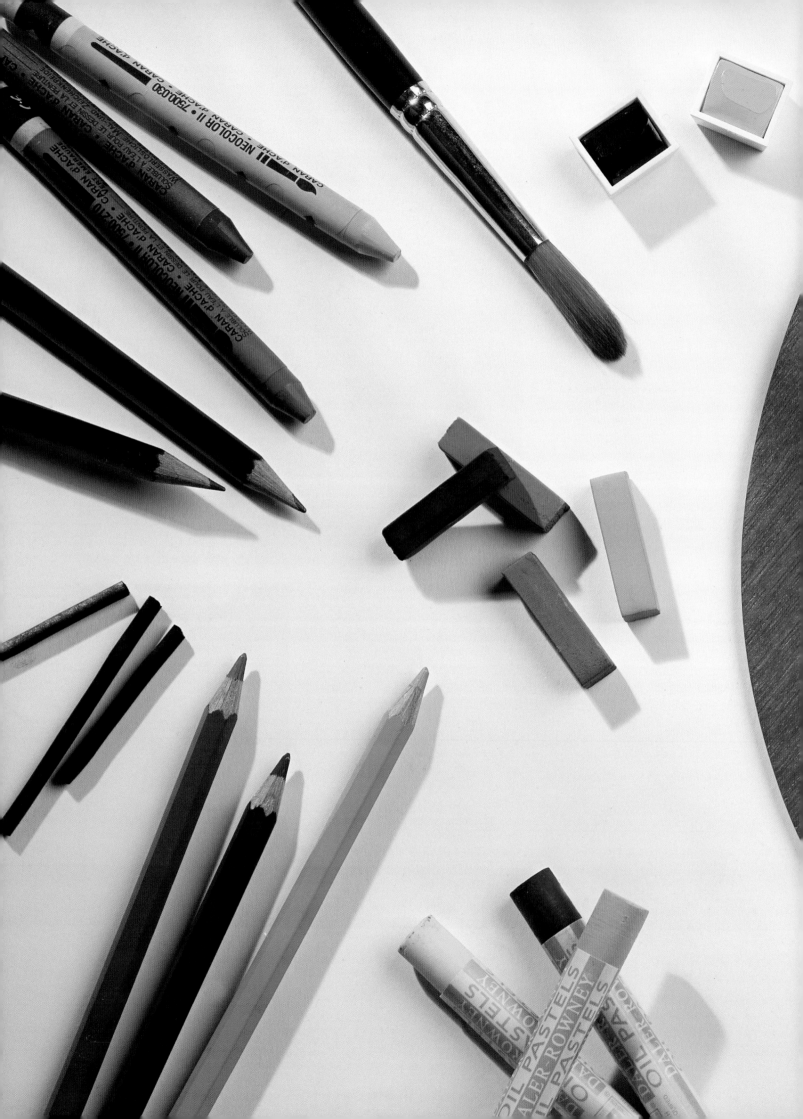

Materials

You can draw and paint portraits using a variety of media. Why not experiment with different media to practise the effects you can achieve? In a good art supply store, you can find huge boxes of soft pastels and pans of watercolour paint in every shade of every colour in the rainbow; rows of tubes of paint; pads of paper ranging in colour from pale biscuit to forest green.

This chapter sets out the pros and cons of the most popular media, and provides practical information on essentials so that you can begin to feel confident navigating your way around the array of materials in your local art store.

You can also use this as an introduction to a medium that you might not previously have considered. If you've always worked in watercolour, for example, why not try oils or acrylics for a change? If you love the powdery texture of charcoal, why not give soft pastels a go? Or be bolder still and experiment with mixed media, perhaps combining pen and ink with soft watercolour washes. You'll be amazed at what you can achieve!

Monochrome media

For sketching and underdrawing, as well as for striking studies in contrast and line, there are many different monochrome media, all of which offer different qualities to your artwork.

A good selection is the foundation of your personal art store, and it is worth exploring many media, including different brands, to find the ones you like working with.

Pencils

Pencils are graded according to hardness. 9H is the hardest down to HB and F (for fine) and then up to 9B, which is the softest. The higher the proportion of clay to graphite, the harder the pencil. A selection of five grades – say, a 2H, HB, 2B, 4B and 6B – is adequate for most purposes.

Soft pencils give a very dense, black mark, while hard pencils give a grey mark. The differences can be seen below – these marks were made by appying the same pressure to different grades of pencil. If you require a darker mark, do not try to apply more pressure, but switch to a softer pencil.

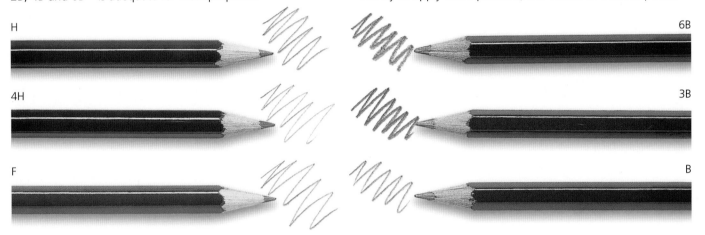

Water-soluble graphite pencils

There are also water-soluble graphite pencils, which are made with a binder that dissolves in water. Available in a range of grades, they can be used dry, dipped in water or worked into

with a brush and water to create a range of watercolour-like effects. Water-soluble graphite pencils are an ideal tool for sketching on location, as they offer you the versatility of combining linear marks with tonal washes. Use the tip to create fine details and the side of the pencil to cover large areas quickly.

Graphite sticks

Solid sticks of graphite come in various sizes and grades. Some resemble conventional pencils, while others are shorter and thicker. You can also buy irregular-shaped chunks and fine graphite powder, and thinner strips of graphite in varying degrees of hardness that fit a barrel with a clutch mechanism.

Graphite sticks are capable of making a wider range of marks than conventional graphite pencils. For example, you can use the point or edge of a profile stick to make a thin mark, or stroke the whole side of the stick over the paper to make a broader mark.

Charcoal

The other monochromatic drawing material popular with artists is charcoal. It comes in different lengths and in thin, medium, thick and extra-thick sticks. You can also buy chunks that are ideal for expressive drawings. Stick charcoal is very brittle and powdery, and is great for broad areas of tone.

Compressed charcoal is made from charcoal dust mixed with a binder and fine clay and pressed into shape. Sticks and pencils are available. Unlike stick charcoal, charcoal pencils are ideal for detailed, linear work.

As with other powdery media, drawings made in charcoal should be sprayed with fixative to hold the pigment in place and prevent smudging.

Thick charcoal stick

Thin charcoal stick

Pen and ink

With so many types of pens and colours of ink available, not to mention the possibility of combining linear work with broad washes of colour, this is an extremely versatile medium and one that is well worth exploring. Begin by making a light pencil underdrawing of your subject, then draw over with pen – but beware of simply inking over your pencil lines, as this can look rather flat and dead. When you have gained enough confidence, your aim should be to put in the minimum of lines in pencil, simply to ensure you've got the proportions and angles right, and then do the majority of the work in pen.

Inks

The two types of inks used by artists are waterproof and water-soluble. The former can be diluted with water, but are permanent once dry, so line work can be worked over with washes without any fear of it being removed.

They often contain shellac, and thick applications dry with a sheen. The best-known is Indian ink, actually from China. It makes great line drawings. It is deep black but can be diluted to give a beautiful range of warm greys.

Water-soluble inks can be reworked once dry, and work can be lightened and corrections made. Don't overlook watercolours and liquid acrylics – both can be used like ink but come in a wider range of colours.

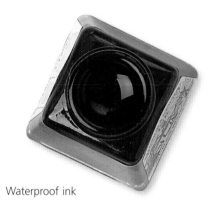
Waterproof ink

Water-soluble ink

Liquid acrylic

Dip pens and nibs

A dip pen does not have a reservoir of ink; as the name suggests, it is simply dipped into the ink to make marks. Drawings made with a dip pen have a

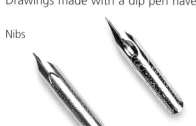
Nibs

Dip pen

unique quality, as the nib can make a line of varying width depending on how much pressure you apply. You can also turn the pen over and use the back of the nib to make broader marks. As you have to keep reloading with ink, it is difficult to make a long, continuous line – but for many subjects the rather scratchy, broken lines are very attractive.

When you first use a new nib it can be reluctant to accept ink. To solve this, rub it with a little saliva.

Sketching pens, fountain pens and technical pens

Sketching pens and fountain pens make ideal sketching tools and enable you to use ink on location without having to carry bottles of ink.

Technical pens deliver ink through a tube rather than a shaped nib, so the line is of a uniform width. If you want to make a drawing that has a range of line widths, you will need several pens with different-sized tubular nibs.

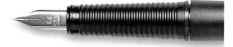
Sketching pen

Bamboo, reed and quill pens

The nib of a bamboo pen delivers a 'dry', rather coarse line. Reed and quill pens are flexible and give a subtle line that varies in thickness. The nibs break easily, but can be recut with a knife.

Rollerball, fibre-tip and marker pens

Rollerball and fibre-tip pens are ideal for sketching out ideas, although finished drawings made using these pens can have a rather mechanical feel to them, as the line does not vary in width. This can work well as an effect.

By working quickly with a rollerball you can make a very light line by delivering less ink to the nib. Fibre-tip and marker pens come in an range of tip widths, from super-fine to calligraphic style tips and also in a wide range of colours.

Coloured drawing media

Coloured pencils contain a coloured pigment and clay, held together with a binder. They are impregnated with wax so that the colour holds to the support with no need for a fixative. They are especially useful for making coloured drawings on location, as they are a very stable medium and are not prone to smudging. Mixing takes place optically on the surface of the support rather than by physical blending, and all brands are inter-mixable, although certain brands can be more easily erased than others; so always try out one or two individual pencils from a range before you buy a large set. Choose hard pencils for linear work and soft ones for large, loosely-applied areas of colour.

Huge colour range ▲
Artists who work in coloured pencil tend to accumulate a vast range in different shades – the variance between one tone and its neighbour often being very slight. This is chiefly because you cannot physically mix coloured pencil marks to create a new shade (unlike watercolour or acrylic paints). So, if you want lots of different greens in a landscape, you will need a different pencil for each one.

Water-soluble pencils

Most coloured-pencil manufacturers also produce a range of water-soluble pencils, which can be used to make conventional pencil drawings and blended with water to create watercolour-like effects. In recent years, solid pigment sticks that resemble pastels have been introduced that are also water-soluble and can be used in conjunction with conventional coloured pencils or on their own.

Wet and dry ▼
Water-soluble pencils can be used dry, the same way as conventional pencils.

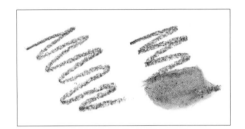

Conté crayons and pencils

The best way to use Conté crayons is to snap off a section and use the side of the crayon to block in large areas, and a tip or edge for linear marks.

The pigment in Conté crayons is relatively powdery, so, like soft pastels and charcoal, it can be blended by rubbing with a finger, rag or torchon. Conté crayon drawings benefit from

being given a coat of fixative to prevent smudging. However, Conté crayons are harder and more oily than soft pastels, so you can lay one colour over another, letting the under-colour show through.

Conté is also available in pencils, which contain wax and need no fixing (setting); the other benefit is that the tip can be sharpened to a point.

Conté crayons ▼
These small, square-profile sticks are available in boxed sets of traditional colours. Drawings made using these traditional colours are reminiscent of the wonderful chalk drawings of old masters such as Michelangelo or Leonardo da Vinci.

Conté pencils ▼
As they can be sharpened to a point, Conté pencils are ideal for drawings that require precision and detail.

Pastels

Pastel work is often described as painting rather than drawing as the techniques used are often similar to techniques used in painting. Pastels are made by mixing pigment with a weak binder, and the more binder used the harder the pastel will be. Pastels are fun to work with and ideal for making colour sketches as well as producing vivid, dynamic artwork.

Soft pastels

As soft pastels contain relatively little binder, they are prone to crumbling, so they have a paper wrapper to help keep them in one piece. Even so, dust still comes off, and can easily contaminate other colours nearby. The best option is to arrange your pastels by colour type and store them in boxes.

Pastels are mixed on the support either by physically blending them or by allowing colours to mix optically. The less you blend, the fresher the image looks. For this reason, pastels are made in a range of hundreds of tints and shades.

As pastels are powdery, use textured paper to hold the pigment in place. Spray soft pastel drawings with fixative to prevent smudging. You can fix (set) work in progress, too – but colours may darken, so don't overdo it.

Box of pastels ▼
When you buy a set of pastels, they come packaged in a compartmentalized box so that they do not rub against each other and become dirtied.

Hard pastels

One advantage of hard pastels is that, in use, they do not shed as much pigment as soft pastels, therefore they will not clog the texture of the paper as quickly. For this reason, they are often used in the initial stages of a work that is completed using soft pastels. Hard pastels can be blended together by rubbing, but not as easily or as seamlessly as soft pastels.

Oil pastels

Made by combining fats and waxes with pigment, oil pastels are totally different to pigmented soft and hard pastels and should not be mixed with them. Oil pastels can be used on unprimed drawing paper and they never completely dry.

Oil-pastel sticks are quite fat and therefore not really suitable for detailed work or fine, subtle blending. For bold, confident strokes, however, they are perfect.

Oil-pastel marks have something of the thick, buttery quality of oil paints. The pastels are highly pigmented and available in a good range of colours. If they are used on oil-painting paper, they can be worked in using a solvent such as white spirit (paint thinner), applied with a brush or rag. You can also smooth out oil-pastel marks with wet fingers. Oil and water are not compatible, and a damp finger will not pick up colour.

Oil pastels can be blended optically on the support by scribbling one colour on top of another. You can also create textural effects by scratching into the pastel marks with a sharp implement – a technique known as sgraffito.

Oil pastels ▼
Less crumbly than soft pastels, and harder in texture, oil pastels are round sticks and come in various sizes.

Pastel pencils

The colours of pastel pencils are strong, yet the pencil shape makes them ideal for drawing lines. The pastel strip can be sharpened to a point, making pastel pencils ideal for describing detail in drawings that have been made using conventional hard or soft pastels.

Pastel pencils ▼
Available in a comprehensive range of colours, pastel pencils are clean to use and are ideal for linear work.

Watercolour paint

Watercolour paints are available in two main forms: pans, which are the familiar compressed blocks of colour that need to be brushed with water to release the colour; or tubes of moist paint. The same finely powdered pigments bound with gum arabic solution are used to make both types. The pigments provide the colour, while the gum arabic allows the paint to adhere to the paper, even when diluted.

It is a matter of personal preference whether you use pans or tubes. The advantage of pans is that they can be slotted into a paintbox, making them easily portable, and this is something to consider if you often paint on location. Tubes, on the other hand, are often better if you are working in your studio and need to make a large amount of colour for a wash. With tubes, you need to remember to replace the caps immediately, otherwise the paint will harden and become unusable. Pans of dry paint can be rehydrated.

Tubes of paint ▼
Tubes of watercolour paint are available in different sizes. It is worth buying the larger sizes for colours that you think you will use frequently. Keep the caps tightly sealed and rinse spilt paint off the tubes before storing them.

Grades of paint

There are two grades of watercolour paint: artists' and students' quality. Artists' quality paints are the more expensive, because they contain a high proportion of good-quality pigments. Students' quality paints contain less pure pigment and more fillers, and are usually available in a smaller range of colours than artists' quality paints.

If you come across the word 'hue' in a paint name, it indicates that the paint contains cheaper alternatives instead of the real pigment. Generally speaking, you get what you pay for: artists' quality paints tend to produce more subtle mixtures of colours.

The other thing that you need to think about when buying paints is their permanence. The label or the manufacturer's catalogue should give you the permanency rating. In the United Kingdom, the permanency ratings are class AA (extremely permanent), class A (durable), class B (moderate) and class C (fugitive). The ASTM (American Society for Testing and Materials) codes for light-fastness are ASTM I (excellent), ASTM II (very good) and ASTM III (not sufficiently light-fast). Some pigments, such as alizarin crimson and viridian, stain more than others: they penetrate the fibres of the paper and cannot be removed.

Finally, although we always think of watercolour as being transparent, you should be aware that some pigments are actually slightly opaque and will impart a degree of opacity to any colours with which they are mixed. These so-called opaque pigments include all the cadmium colours and cerulean blue.

Judging colours

It is not always possible to judge the colour of paints by looking at the pans in your palette, as they often look dark. In fact, it is very easy to dip your brush into the wrong pan, so always check before you put brush to paper.

Even when you have mixed a wash in your palette, appearances can be deceptive, as watercolour paint always looks lighter when it is dry. The only way to be sure what colour or tone you have mixed is to apply it to paper and let it dry. It is always best to build up tones gradually until you get the effect you want. The more you practise, the better you will get at anticipating results.

Appearances can be deceptive ▼
These two pans look very dark, almost black. In fact, one is Payne's grey and the other a bright ultramarine blue.

Test your colours ▼
Keep a piece of scrap paper next to you as you work so that you can test your colour mixes before you apply them.

Gouache paint

Made using the same pigments and binders found in transparent water-colour, gouache is a water-soluble paint. The addition of *blanc fixe* – a chalk – gives the paint its opacity. Because gouache is opaque you can paint light colours over darker ones – unlike traditional watercolour, where the paint's inherent transparency means that light colours will not cover any darker shades that lie underneath.

The best-quality gouache contains a high proportion of coloured pigment. Artists' gouache tends to be made using permanent pigments that are light-fast. The 'designers' range uses less permanent pigments, as designers' work is intended to last for a short time.

Characteristics of gouache

All of the equipment and techniques used with watercolour can be used with gouache. Like watercolour, gouache can be painted on white paper or board; due to its opacity and covering power, it can also be used on a coloured or toned ground and over gesso-primed board or canvas. Gouache is typically used on smoother surfaces than might be advised for traditional watercolour, as the texture of the support is less of a creative or aesthetic consideration.

If they are not used, certain gouache colours are prone to drying up over time. Gouache does remain soluble when dry, but dried-up tubes can be a problem to use.

Certain dye-based colours are very strong and, if used beneath other layers of paint, can have a tendency to bleed.

Work confidently ▲
Gouache remains soluble when it is dry, so if you are applying one colour over another, your brushwork needs to be confident and direct: a clean, single stroke, as here, will not pick up paint from the first layer.

Muddied colours ▲
If you scrub paint over an underlying colour, you will pick up paint from the first layer and muddy the colour of the second layer, as here.

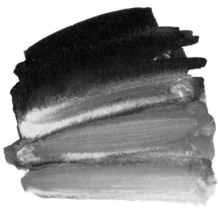

Wet into wet ▲
Like transparent watercolour paint, gouache paint can be worked wet into wet (as here) or wet on dry.

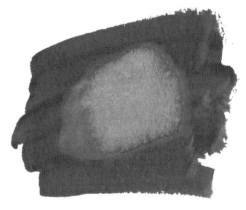

Removing dry paint ▲
Dry paint can be re-wetted and removed by blotting with an absorbent paper towel.

Change in colour when dry ▼
Gouache paint looks slightly darker when dry than it does when wet, so it is good practice to test your mixes on a piece of scrap paper – although, with practice, you will quickly learn to make allowances for this.

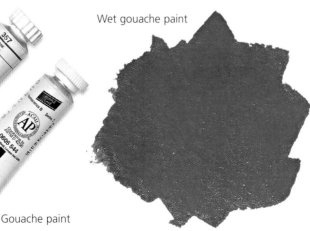

Gouache paint

Wet gouache paint

Dry gouache paint

Oil paint

There are two types of traditional oil paint – professional, or artists', grade and the less expensive students' quality. The difference is that artists' paint uses finely ground, high-quality pigments, which are bound in the best oils and contain very little filler, while students' paints use less expensive pigments and contain greater quantities of filler to bulk out the paint. The filler is usually *blanc fixe* or aluminium hydrate, both with a very low tinting strength.

Students' quality paint is often very good and is, in fact, used by students, amateur painters and professionals.

The range of colours is more limited but still comprehensive, and each tube of paint in the range, irrespective of its colour, costs the same. Artists' quality paint is sold according to the quality and cost of the pigment used to make it. Each colour in the range is given a series number or letter; the higher the number or letter, the more expensive the paint. Various oils are used to bind and make the paint workable; linseed, poppy and safflower oil are the most common. The choice of oil depends on the characteristics and drying properties of the pigment being mixed.

Working "fat over lean" ▲
The golden rule when using oil paint is to work 'fat' (or oily, flexible paint) over 'lean', inflexible paint that contains little or no oil.

Tubes or tubs? ▼
Oil paint is sold in tubes containing anything from 15 to 275ml (1 tbsp to 9fl oz). If you tend to use a large quantity of a particular colour – for toning grounds, for example – you can buy paint in cans containing up to 5 litres (8¾ pints).

Drawing with oils ▶
Oil bars consist of paint with added wax and drying agents. The wax stiffens the paint, enabling it to be rolled into what resembles a giant pastel.

Glazing with oils ▲
Oils are perfect for glazes (transparent applications of paint over another colour). The process is slow, but quick-drying glazing mediums can speed things up.

Mixing colours with oils

Colour mixing with oils is relatively straightforward, as there is no colour shift as the paint dries: the colour that you apply wet to the canvas will look the same when it has dried, so (unlike acrylics, gouache or watercolour) you do not need to make allowances for changes as you paint. However, colour that looks bright when applied can begin to look dull as it dries. This is due to the oil in the paint sinking into a previously applied absorbent layer of paint below. You can revive the colour in sunken patches by 'oiling out' – that is, by brushing an oil-and-spirit mixture or applying a little retouching varnish over the affected area.

Water-mixable oil paint

Water-mixable oil paint is made using linseed and safflower oils that have been modified to be soluble in water. Once the paint has dried and the oils have oxidized, it is as permanent and stable as conventional oil paint. Some water-mixable paint can also be used with conventional oil paint, although its mixability is gradually compromised with the more traditional paint that is added.

Alkyd oil paints

Alkyd oil paints contain synthetic resin but are used in the same way as traditional oil paints and can be mixed with the usual mediums and thinners.

Alkyd-based paint dries much faster than oil-based paint, so it is useful for underpainting prior to using traditional oils and for work with glazes or layers. However, you should not use alkyd paint over traditional oil paint, as its fast drying time can cause problems.

Acrylic paint

Acrylic paint can be mixed with a wide range of acrylic mediums and additives and is thinned with water. Unlike oil paint, it dries quickly and the paint film remains extremely flexible and will not crack. The paint can be used with a wide range of techniques, from thick impasto, as with oil paint, to the semi-transparent washes of watercolour. Indeed, most of the techniques used in both oil and watercolour painting can be used with acrylic paint. Acrylic paints come in three different consistencies. Tube paint tends to be of a buttery consistency and holds its shape when squeezed from the tube. Tub paint is thinner and more creamy in consistency, which makes it easier to brush out and cover large areas. There are also liquid acrylic colours with the consistency of ink, sold as acrylic inks.

You may experience no problems in mixing different brands or consistencies, but it is always good practice to follow the manufacturer's instructions.

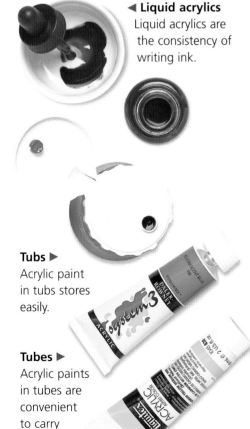

◄ Liquid acrylics
Liquid acrylics are the consistency of writing ink.

Tubs ►
Acrylic paint in tubs stores easily.

Tubes ►
Acrylic paints in tubes are convenient to carry and use with a palette.

Characteristics of acrylic paint

Being water soluble, acrylic paint is very easy to use, requiring only the addition of clean water. Water also cleans up wet paint after a work session. Once it has dried, however, acrylic paint creates a hard but flexible film that will not fade or crack and is impervious to more applications of acrylic or oil paint or their associated mediums or solvents.

Acrylic paint dries relatively quickly: a thin film will be touch dry in a few minutes and even thick applications dry in a matter of hours. Unlike oil paints, all acrylic colours, depending on the thickness of paint, dry at the same rate.

Mediums and additives ▲
A wide range of mediums and additives can be mixed into acrylic paint to alter and enhance its handling characteristics.

Extending drying time ▲
The drying time of acrylic paint can be extended by using a retarding medium, which gives you longer to work into the paint and blend colours.

Covering power
Acrylic paint that is applied straight from the tube has good covering power, even when you apply a light colour over a dark one, so adding highlights to dark areas is easy.

Texture gels ▲
Various gels can be mixed into acrylic paint to give a range of textural effects. These can be worked in while the paint is still wet.

Adhesive qualities ▲
Many acrylic mediums have very good adhesive qualities, making them ideal for collage work– sticking paper or other materials on to the support.

Glazing with acrylics ▲
Acrylic colours can be glazed by thinning the paint with water, although a better result is achieved by adding an acrylic medium.

Shape-holding ability
Like oil paint, acrylic paint that is applied thickly, straight from the tube, holds its shape and the mark of the brush as it dries, which can allow you to use interesting textures.

Palettes

The surface on which an artist arranges colours prior to mixing and applying them to the support is known as the palette. (Somewhat confusingly, the same word is also used to describe the range of colours used by a particular artist, or the range of colours found in a painting.) The type of palette that you use depends on the medium in which you are working, but you will undoubtedly find that you need more space for mixing colours than you might imagine. A small palette gets filled with colour mixes very quickly and it is a false economy to clean the mixing area too often: you may be cleaning away usable paint or mixed colours that you might want to use again. Always buy the largest palette practical.

Wooden palettes

Flat wooden palettes in the traditional kidney or rectangular shapes with a thumb hole are intended for use with oil paints. They are made from hardwood, or from the more economical plywood.

Before you use a wooden palette with oil paint for the first time, rub linseed oil into the surface of both sides. Allow it to permeate the surface. This will prevent oil from the paint from being absorbed into the surface of the palette and will make it easier to clean. Re-apply linseed oil periodically and a good wooden palette will last for ever.

Wooden palettes are not recommended for acrylic paint, however, as hardened acrylic paint can be difficult to remove from the surface.

Holding and using the palette ▼
Place your thumb through the thumb hole and balance the palette on your arm. Arrange pure colour around the edge. Position the dipper(s) at a convenient point, leaving the centre of the palette free for mixing colours.

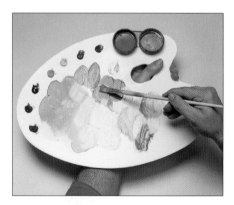

White palettes

Plastic palettes are uniformly white. They are made in both the traditional flat kidney and rectangular shapes. The surface is impervious, which makes them ideal for use with either oil or acrylic paint. They are easy to clean, but the surface can become stained after using very strong colours such as viridian or phthalocyanine blue.

There are also plastic palettes with wells and recesses, intended for use with watercolour and gouache. The choice of shape is entirely subjective, but it should be of a reasonable size.

White porcelain palettes offer limited space for mixing. Intended for use with watercolour and gouache, they are aesthetically pleasing but can easily be chipped and broken.

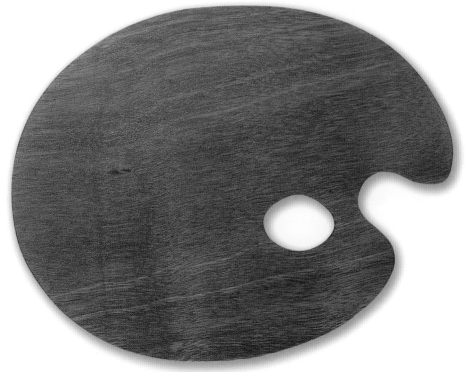

Wooden palette ▲
Artists working with oil paints generally prefer a wooden palette. Always buy one that is large enough to hold all the paint and mixes that you intend to use.

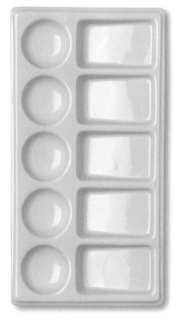

Slanted-well palette ▲
This type of porcelain palette is used for mixing gouache or watercolour. The individual colours are placed in the round wells and the paint is mixed in the rectangular sections.

Disposable palettes

A relatively recent innovation is the disposable paper palette, which can be used with both oils and acrylics. These come in a block and are made from an impervious parchment-like paper. A thumb hole punched through the block enables it to be held in the same way as a traditional palette; alternatively, it can be placed flat on a surface. Once the work is finished, the used sheet is torn off and thrown away.

Paper palette ▲
Disposable palettes are convenient and make cleaning up after a painting session an easy task.

Stay-wet palette

Intended for use with acrylic paints, the stay-wet palette will stop paints from drying out and becoming unworkable if left exposed to the air for any length of time. The palette consists of a shallow, recessed tray into which a water-impregnated membrane is placed. The paint is placed and mixed on this membrane, which prevents the paint from drying out. If you want to leave a painting halfway through and come back to it later, you can place a plastic cover over the tray, sealing the moist paint in the palette. This prevents the water from evaporating and the paint from becoming hard and unusable. The entire palette can be stored in a cool place or even in the refrigerator. If the membrane does dry out, simply re-wet it.

Stay-wet palette ▶
This type of palette, in which the paint is mixed on a water-impregnated membrane, prevents acrylic paint from drying out. If you like, you can simply spray acrylic paint with water to keep it moist while you work.

Containers for water, solvents and oil

Although a regular supply of containers, such as empty jam jars, can be recycled from household waste and are just as good as a container bought for the purpose, several types of specially designed containers are available from art supply stores.

Among the most useful are dippers – small, open containers for oil and solvent that clip on to the edge of the traditional palette. Some have screw or clip-on lids to prevent the solvent from evaporating when it is not in use. You can buy both single and double dippers, like the one shown on the right. Dippers are useful when you want to work at speed.

Dipper ▼
Used in oil painting, dippers are clipped on to the side of the palette and contain small amounts of oil or medium and thinner.

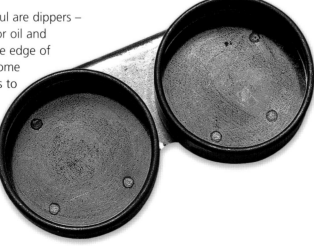

Improvised palettes

For work in the studio, any number of impermeable surfaces and containers can be used as palettes. Perhaps the most adaptable is a sheet of thick counter glass, which you can buy from a glazier; the glass should be at least ¼in (5mm) thick and the edges should be polished smooth. Glass is easy to clean and any type of paint can be mixed on it. To see if your colours will work on the support you have chosen to use, slip a sheet of paper the same colour as the support beneath the glass.

Aluminium-foil food containers, tin cans, glass jars, paper and polystyrene cups also make useful and inexpensive containers for mixing large quantities of paint and for holding water or solvents. Take care not to put oil solvents in plastic or polystyrene containers, though, as the containers may dissolve.

Additives

Artists working with oils and acrylics will need to explore paint additives, which help attain various textures and effects in their work. Although oil paint can be used straight from the tube, it is usual to alter the paint's consistency by adding a mixture of oil or thinner (solvent). Simply transfer the additive to the palette a little at a time and mix it with the paint. Manufacturers of acrylic paints have also introduced a range of mediums and additives that allow artists to use the paint to its full effect.Oils and mediums are used to alter the consistency of the paint, allowing it to be brushed out smoothly or to make it dry more quickly. Once exposed to air, the oils dry and leave behind a tough, leathery film that contains the pigment. Different oils have different properties – for example, linseed dries relatively quickly but yellows with age so is only used for darker colours.

A painting medium is a ready-mixed painting solution that may contain various oils, waxes and drying agents. The oils available are simply used as a self-mixed medium. Your choice of oil or medium will depend on several factors, including cost, the type of finish required, the thickness of the paint being used and the range of colours.

There are several alkyd-based mediums on the market. They all accelerate the drying time of the paint, which can help to considerably lessen the waiting time between each application of paint. Some alkyd mediums are thixotropic; these are initially stiff and gel-like but, once worked, become clear and loose. Other alkyd mediums contain inert silica and add body to the paint; useful for impasto techniques where a thick mix of paint is required. Discussing your work with an art stockist will help you decide which additives you need.

Oils

There are a great many oils and thinners available. The more common ones are listed below.

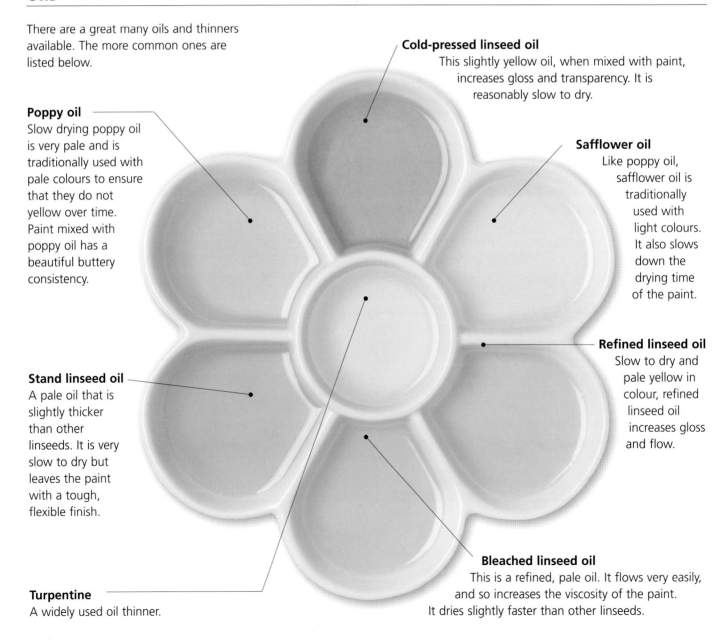

Cold-pressed linseed oil
This slightly yellow oil, when mixed with paint, increases gloss and transparency. It is reasonably slow to dry.

Poppy oil
Slow drying poppy oil is very pale and is traditionally used with pale colours to ensure that they do not yellow over time. Paint mixed with poppy oil has a beautiful buttery consistency.

Safflower oil
Like poppy oil, safflower oil is traditionally used with light colours. It also slows down the drying time of the paint.

Stand linseed oil
A pale oil that is slightly thicker than other linseeds. It is very slow to dry but leaves the paint with a tough, flexible finish.

Refined linseed oil
Slow to dry and pale yellow in colour, refined linseed oil increases gloss and flow.

Turpentine
A widely used oil thinner.

Bleached linseed oil
This is a refined, pale oil. It flows very easily, and so increases the viscosity of the paint. It dries slightly faster than other linseeds.

Thinners

The amount of thinner that you use depends on how loose or fluid you want the paint to be. If you use too much, however, the paint film may become weak and prone to cracking.

Turpentine
Turpentine is the strongest and best of all the thinners used in oil painting. It has a very strong smell. Old turpentine can discolour and become gummy if exposed to air and light. To help prevent this, store it in cans or dark glass jars.

White spirit
Paint thinner or white spirit is clear and has a milder smell than turpentine. It does not deteriorate and dries faster than turpentine. However, it can leave the paint surface matt.

Oil of spike lavender
Unlike other solvents, which speed up the drying time of oil paint, oil of spike lavender slows the drying time. It is very expensive. Like turpentine and white spirit, it is colourless.

Low-odour thinners
Various low-odour thinners have come on to the market in recent years. The drawback of low-odour thinners is that they are relatively expensive and dry slowly.

Citrus solvents
You may be able to find citrus thinners. They are thicker than turpentine or white spirit but smell wonderful. They are more expensive than traditional thinners and slow to evaporate.

Liquin
Liquin is just one of a number of alkyd painting mediums that speed up drying time considerably – often to just a few hours. It also improves flow and increases the flexibility of the paint film. It is excellent for use in glazes.

Acrylic additives

Acrylic paints dry to leave a matt or slightly glossy surface. Gloss or matt mediums can be added, singly or mixed, to leave the surface with the desired finish. A gloss surface tends to make colours look brighter.

Gloss and matt mediums ▶
Both gloss (top) and matt (bottom) mediums are relatively thin white liquids that dry clear if applied to a support without being mixed with paint. Matt medium increases transparency and can be used to make matt glazes, but as a varnish can deaden colour. Gloss will enhance the depth of colour.

Flow-improving mediums

Adding flow-improving mediums reduces the water tension, increasing the flow of the paint and its absorption into the surface of the support.

One of the most useful applications for flow-improving medium is to add a few drops to very thin paint, which can tend to puddle rather than brush out evenly across the surface of the support. This is ideal when you want to tone the ground with a thin layer of acrylic before you begin your painting.

When a flow-improving medium is used with slightly thicker paint, a level surface will result, with little or no evidence of brushstrokes.

The medium can also be mixed with paint that is to be sprayed, as it assists the flow of paint and helps to prevent blockages within the spraying mechanism.

Retarding mediums

Acrylic paints dry quickly. Although this is generally considered to be an advantage, there are occasions when you might want to take your time over a particular technique or a specific area of a painting – when you are blending colours together or working wet paint into wet, for example. Adding a little retarding medium slows down the drying time of the paint considerably, keeping it workable for longer.

Gel mediums

With the same consistency as tube colour, gel mediums are available as matt or gloss finishes. They are added to the paint in the same way as fluid mediums. They increase the brilliance and transparency of the paint, while maintaining its thicker consistency. Gel medium is an excellent adhesive and extends drying time. It can be mixed with various substances such as sand or sawdust to create textural effects.

The effect of modelling paste ▼
Modelling pastes dry to give a hard finish, which can be sanded or carved into using a sharp knife.

The effect of heavy gel medium ▼
Mixed with acrylic paint, heavy gel medium forms a thick paint that is useful for impasto work.

Paintbrushes

Oil-painting brushes are traditionally made from hog bristles, which hold their shape well and can also hold a substantial amount of paint. Natural hair brushes are usually used for watercolour and gouache, and can be used for acrylics and fine detail work in oils, if cleaned thoroughly afterwards.

Synthetic brushes are good quality and hard-wearing, and less expensive than either bristle or natural-hair brushes. However, they can quickly lose their shape if they are not looked after and cleaned well.

Cleaning brushes

1 Cleaning your brushes thoroughly will make them last longer. Wipe off any excess wet paint on a rag or a piece of newspaper. Take a palette knife and place it as close to the metal ferrule as possible. Working away from the ferrule towards the bristles, scrape off as much paint as you can.

2 Pour a small amount of household white spirit (paint thinner) – or water, if you are using a water-based paint such as acrylic or gouache – into a jar; you will need enough to cover the bristles of the brush. Agitate the brush in the jar, pressing it against the sides to dislodge any dried-on paint.

3 Rub household detergent into the bristles with your fingers. Rinse in clean water until the water runs clear. Reshape the bristles and store the brush in a jar with the bristles pointing upward, so that they hold their shape.

Brush shapes

Brushes for fine detail ▶
A rigger brush is very long and thin. It was originally invented for painting the straight lines of the ropes and rigging on ships in marine painting – hence the rather odd-sounding name. A liner is a flat brush which has the end cut away at an angle. Both of these brushes may be made from natural or synthetic fibres.

Wash brushes ▶
The wash brush has a wide body, which holds a large quantity of paint. It is used for covering large areas with a uniform or flat wash of paint. There are two types of wash brush: rounded or 'mop' brushes, which are commonly used with watercolour and gouache, and flat wash brushes, which are more suited for use with oils and acrylics.

Flat brushes ▼
These brushes have square ends. They hold a lot of paint, which can be applied as short impasto strokes or brushed out flat. Large flat brushes are useful for blocking in and covering large areas quickly. Short flats, known as 'brights', hold less paint and are stiffer. They make precise, short strokes, ideal for impasto work and detail.

Rigger brush

Liner brush

Rounded or "mop" brush

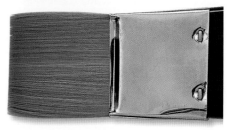

Flat wash brush

Round brushes ▼
These are round-headed brushes that are used for detail and for single-stroke marks. Larger round brushes hold a lot of paint and are useful for the initial blocking-in. The point on round brushes can quickly disappear, as it becomes worn down by the abrasive action of the rough support. The brushes shown here are made of natural hair.

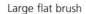

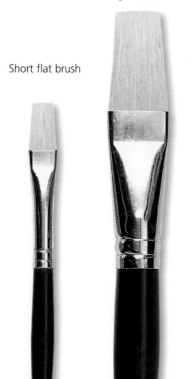

Large flat brush

Short flat brush

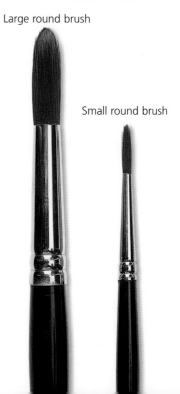

Large round brush

Small round brush

Other paint applicators

Brushes are only part of the artist's toolbox. You can achieve great textual effects by using many other types of applicator, from knives to rags.

Artists' palette and painting knives

Palette knives are intended for mixing paint with additives on the palette, scraping up unwanted paint from the palette or support, and general cleaning. Good knives can also be found in DIY or decorating stores.

You can create a wide range of marks using painting knives. In general, the body of the blade is used to spread paint, the point for detail and the edge for making crisp linear marks.

Regardless of the type of knife you use, it is very important to clean it thoroughly after use. Paint that has dried on the blade will prevent fresh paint from flowing evenly off the blade. Do not use caustic paint strippers on plastic blades, as they will dissolve; instead, peel the paint away.

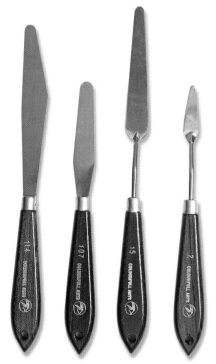

Steel knives ▲
A wide range of steel painting and palette knives is available. In order to work successfully with this method of paint application, you will need several.

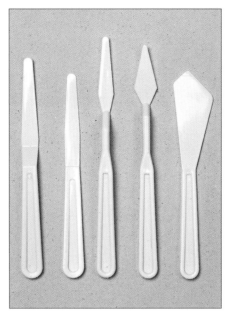

Plastic knives ▲
Less expensive and less durable than steel knives, plastic knives manipulate watercolour and gouache paints better than their steel counterparts.

Paint shapers

A relatively new addition to the artist's range of tools are paint shapers. They closely resemble brushes, but are used to move paint around in a way similar to that used when painting with a knife. Instead of bristle, fibre or hair, the shaper is made of a non-absorbent silicone rubber.

Foam and sponge applicators

Nylon foam is used to make both foam brushes and foam rollers. Both of these are available in a range of sizes and, while they are not intended as substitutes for the brush, they are used to bring a different quality to the marks they make.

Sponge applicators and paint shapers ▶
Shapers can be used to apply paint and create textures, and to remove wet paint. Foam rollers can cover large areas quickly. Sponge applicators are useful for initial blocking in.

Natural and man-made sponges
With their pleasing irregular texture, natural sponges are used to apply washes and textures, and are invaluable for spreading thin paint over large areas and for making textural marks. They are also useful for mopping up spilt paint and for wiping paint from the support in order to make corrections. They are especially useful to landscape artists. Man-made sponges can be cut to the desired shape and size and used in a similar fashion.

Alternative applicators

Paint can be applied and manipulated using almost anything. The only limitations are set by practicality and imagination. The tool box and cutlery drawer are perhaps a good starting point, but you will no doubt discover plenty of other items around the home that you can use. Cardboard, pieces of rag, wood, wire wool and many other seemingly unlikely objects can all be – quite literally – pressed into service.

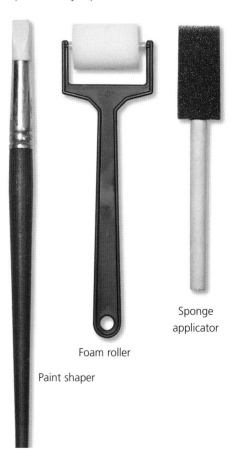

Sponge applicator

Foam roller

Paint shaper

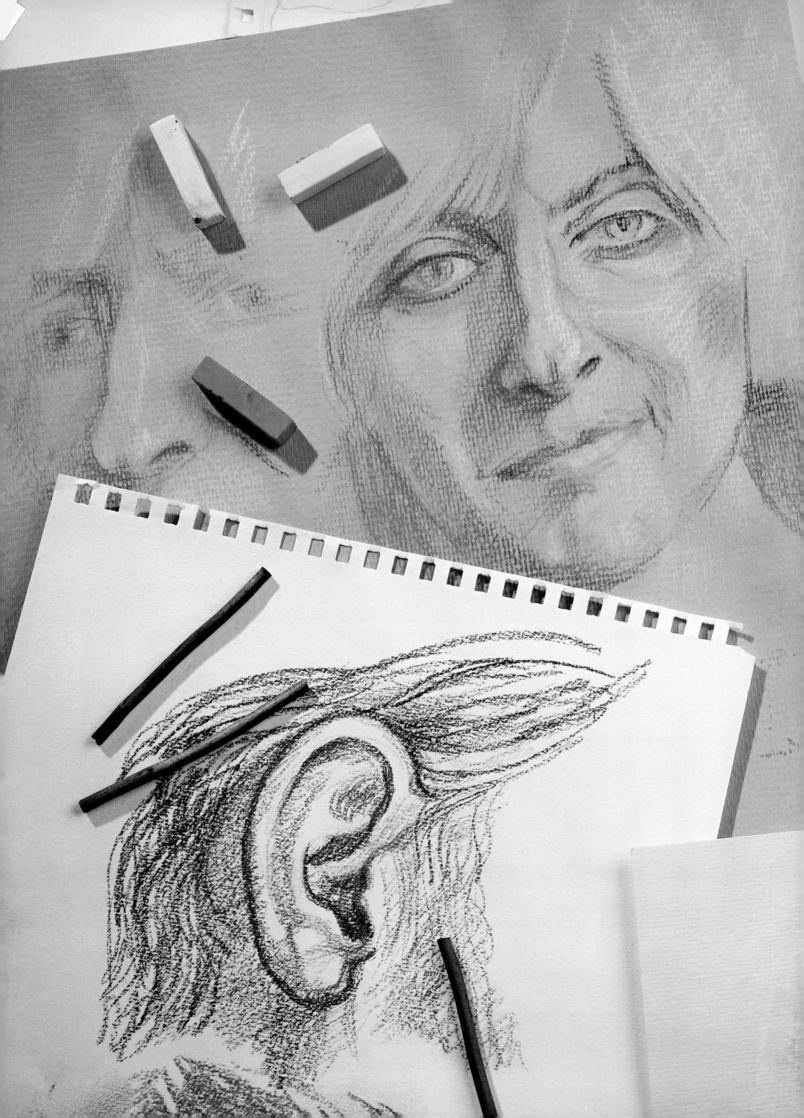

Tutorials

This chapter consists of a series of lessons on the technical aspects of drawing and painting people. Careful observation is the basis of all good representational drawing and painting. We begin by looking at the basic shape of the human head and how to place the features: the eyes, the nose and nostrils, the mouth and the ears. This is followed by useful information on taking measurements, which is essential if you want to keep the proportions true to life. We then move on to drawing and painting hair, the hands and feet, and choosing colours for different skin tones.

Of course, good portraits are about much more than simply getting a good likeness. The composition and lighting that you choose, and your model's character and mood are all integral and essential to the whole, and in capturing the personality of your subject. The last part of this chapter examines all these topics and is packed with ideas and useful tips that you can incorporate into your own work.

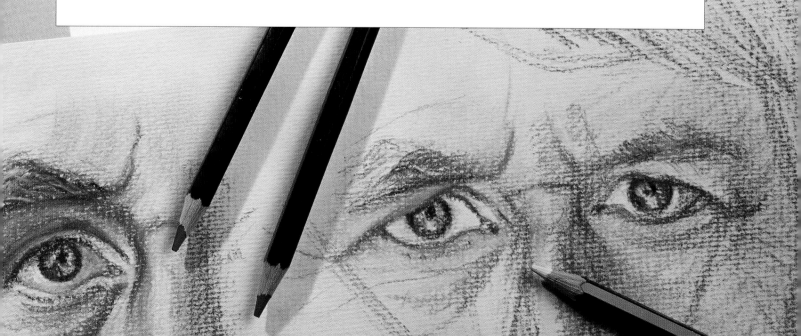

The head

One of the most common mistakes that beginners make when they are drawing a portrait is to try to put in too much detail in the very early stages. The most important thing to remember is that, as with any subject, you need to start by getting the basic shape right.

Although every head is different, and you have to learn to carefully observe your subject and measure the individual parts and the distances between them, it is nevertheless possible to set out some general guidelines that you can use as a starting point.

Start by practising viewing the head from straight on, to get used to looking at the general shape. From this angle the head is not a perfect circle, as often seen in children's drawings, but an egg shape, so begin with that.

Drawing the basic shape of the head

Draw this basic shape, keeping your initial marks quite light so that you can alter them if necessary. Build up the shape from the inside, making a series of curved marks that go around the shape and across it, so that you start to build up a three-dimensional sense of the form rather than a contour. In this way your hand is also working rhythmically, building up the shape without getting engrossed in the detail.

1 Start by drawing a series of curves.

2 Then add more spherical movements.

3 Add spheres and ovals for the features.

Positioning the facial features

Once you're used to the basic shape of the head, you can then begin to look at where the individual features of the face are positioned. Draw a line dividing the face from top to bottom, passing between the eyes, down the bridge of the nose, through the centre of the mouth and chin and through the neck. All the facial features are positioned symmetrically on either side of the face, so you can use this central line to check that you are placing them correctly.

Now lightly draw a series of lines across the face to mark the position of the facial features – the corners of the eyes, the top and bottom of the nose and the corners of the mouth. (Even the most experienced of artists often draw lines like this, which are known as 'construction lines', in the early stages of a portrait.) However, the exact positions will vary from one person to another, so careful measuring is essential.

General guidelines ▶
Although everyone's face is different, you can use these basic guides for assistance. Remember that these rules apply only when the head is viewed from straight on.

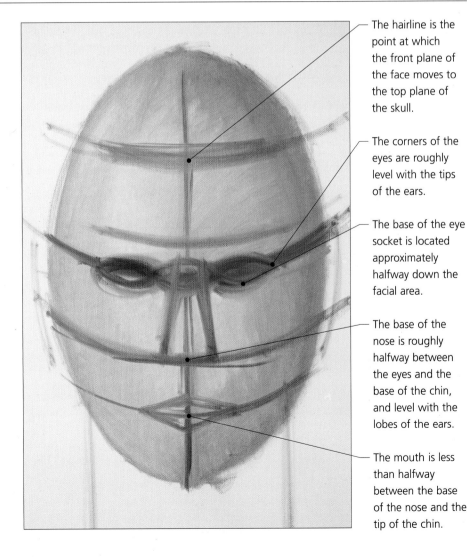

The hairline is the point at which the front plane of the face moves to the top plane of the skull.

The corners of the eyes are roughly level with the tips of the ears.

The base of the eye socket is located approximately halfway down the facial area.

The base of the nose is roughly halfway between the eyes and the base of the chin, and level with the lobes of the ears.

The mouth is less than halfway between the base of the nose and the tip of the chin.

The features in an inverted triangle

Another useful way of checking the position of the facial features is to draw an inverted triangle. There are two ways of doing this. You can either draw a horizontal line across to the outer corner of each eye and a line down from the corner of each eye to the chin (shown right, in blue) or alternatively, draw lines down from the outer corners of the eyes to the middle of the lips (shown right, in red). If the mouth extends beyond the side edges of the triangle, or the chin is below the apex, then you have probably positioned them incorrectly and need to re-measure – although, of course, people vary considerably, so you must judge with your eye as well.

Inverted triangles as construction lines ▶

In most people, all the facial features should be contained within these inverted triangles, so you can use them to check that you haven't made the mouth too wide or placed the chin too low down.

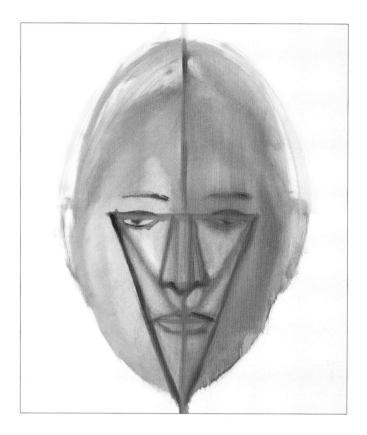

The head from different viewpoints

If you look at your sitter from above or below, then the relative positions of the features will alter. Measuring becomes even more important and you must train yourself to do this rather than rely on any prior knowledge of where the features are in relation to each other. Put in the central axis through the face, as before, then take careful measurements to establish where the features should be placed exactly – and keep measuring as you draw to ensure you are still on track.

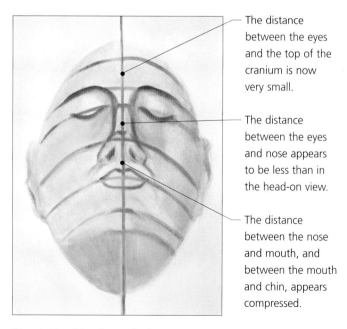

The tips of the ears are now above the level of the eyes.

The distance between the eyes and nose appears to be greater than in the head-on view.

The distance between the nose and mouth, and the mouth and chin, is very small.

The distance between the eyes and the top of the cranium is now very small.

The distance between the eyes and nose appears to be less than in the head-on view.

The distance between the nose and mouth, and between the mouth and chin, appears compressed.

Head tilted forwards ▲

When the head is tilted forwards – as it might be, for example, if your model is reading a book – you can see more of the cranium and less of the facial features.

Head tilted backwards ▲

When the model is looking up and his or her head is tilted backwards, you can see very little of the cranium. The lower part of the face, from nose to chin, takes up a larger proportion of the facial area.

▶

Making the head look three-dimensional

In addition to placing the facial features correctly, you also need to make the head look three-dimensional. To do this you need to create a sense of the major planes – the front, the sides, the top and the underside. No matter what subject you're drawing, a good principle is to try to think of it as a basic geometric shape – a sphere, a box, a cylinder or a cone. You will find that even the most complicated of subjects can often be looked at in this way. So think of the skull as a box. Draw (lightly) a box around the basic egg shape, noting where the different planes occur.

The number of planes that you see will vary depending on your viewpoint. From straight on, you see only one plane – the front. But if you look at the head from the side on and from the same eye level, you will see two planes – the side and the front. And if you look at the head from above or below, you will see three planes – the top (or underside), side and front.

Drawing the major planes of the head

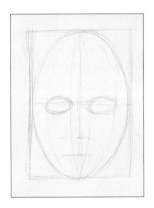
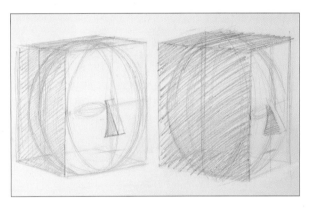

1 Draw the egg shape of the face inside a box and draw a central perpendicular and horizontal axis.

2 Now draw the box at different angles (but don't worry too much about the perspective at this stage). Depending on your viewpoint and the tilt of the head, you will see different planes and perhaps even different numbers of planes.

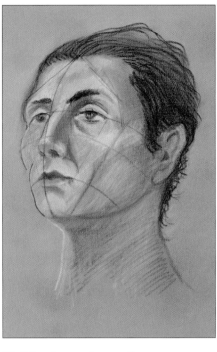

Visible planes depending on viewpoint ▲
In making this sketch, the artist was positioned slightly to one side of the model. As a result, we can see two major planes (the side and the front) and, as the model's head is tilted upwards, a suggestion of a third plane underneath. Marking the position of the different planes, however lightly, is a good idea for beginners.

Drawing the minor planes of the head

Up to now we've only looked at the very simple planes of the sides of the enclosing box. Within the head, however, there are many more planes that you need to capture. The nose is perhaps the most obvious, as it juts forward from the front of the box: it has four major planes – two sides, the top and the underside. But there are other less extreme planes, too – for example, within the forehead, across the cheekbones and under the chin. Try exploring your own face with your fingertips to see where these changes in plane, which define the underlying bone structure, occur. They are gradual but essential if you are to create a convincingly three-dimensional rendition of your subject.

Minor planes ▶
This sketch demonstrates breaking up the surface of the face into a number of different planes, depending on the underlying bone structure. Here we can clearly see the top plane of the head; the other major planes have been subdivided into smaller planes.

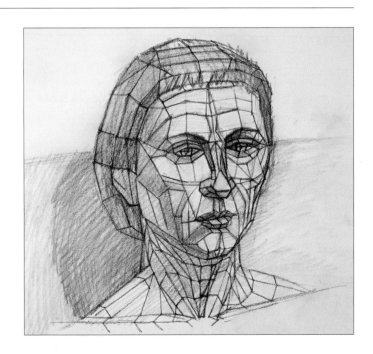

Using tone to create a three-dimensional impression

Up to this point, we've looked primarily at drawing the head using only line. Thinking of the head as a box, rather than a flat two-dimensional object, is the first step. Now you should begin to use tone – cross-hatching in pencil, shading with the side of a stick of charcoal or pastel, or applying a light wash in watercolour or acrylics – to create a sense of light and shade.

Changes in tone occur when the planes of the face and head change direction – for example, if your model is lit from the side, the side of the face nearest the light source will be light, while the side furthest away from it will be dark – and there will be a whole host of mid-tones in between.

The images here show a plaster-cast head of the French writer and philosopher Voltaire, lit from different directions. Where light falls directly on the subject, very little detail is discernible. But on the sides that are turned away from the light, strong shadows are formed – and these show up the muscle formation and bone structure, making the cast look three-dimensional.

Lit from the left, almost full profile ▼
Here, the light was positioned to the left of the plaster cast and slightly above it. As a result, the forehead is brightly illuminated: the artist left the paper untouched in this part of the drawing. On the left side of the head, (the right side as we look at the drawing), a mid-tone is used to draw deep shadows that reveal the sunken cheeks and indentations in the skull. The slab of the neck is drawn using a tone that is even darker, as virtually no direct light hits this part of the cast.

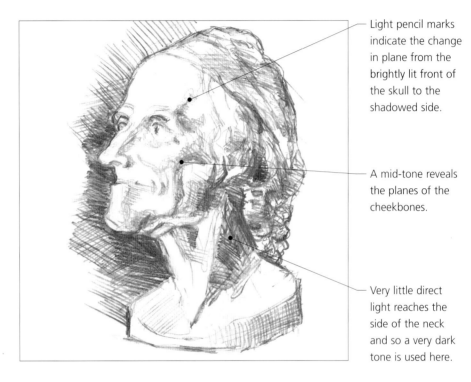

Light pencil marks indicate the change in plane from the brightly lit front of the skull to the shadowed side.

A mid-tone reveals the planes of the cheekbones.

Very little direct light reaches the side of the neck and so a very dark tone is used here.

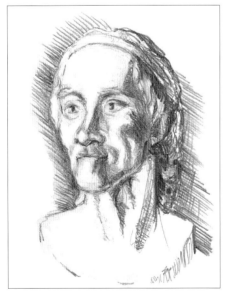

Lit from left, almost full face ▲
Here, the cast was turned to show more of the face. The light is shining from the left, so everything on the other side of the rather prominent nose is in shadow.

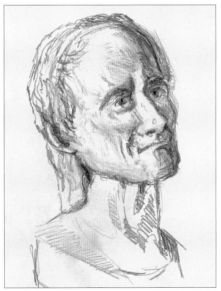

Lit from left, three-quarters view ▲
Here the light was again positioned to the left – but slightly lower, almost level with the cast – and the cast was turned further to the right, emphasizing different features.

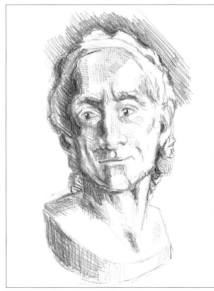

Lit from front, full face ▲
With the light in front and slightly to the right, the right side of the face is shaded. Note how the lighting flattens out the features: the cheekbones, in particular, look less angular.

The skull bones and muscles

You do not need to know the names of all the bones and muscles in the skull, but by knowing something of the skull's proportions, shapes and rhythms, you will have a much better understanding of how the flesh can reveal a true sense of the underlying form. If you have access to a model of a skull, draw it. If you do not, practise by referring to anatomy books.

The bones of the skull

The skull has both convex and concave surfaces. Convex forms protrude and are visible beneath the surface of the flesh at the brow, the cheeks and chin and jaw. The concave cavities are not visible on the surface: the eye sockets, for example, appear huge, but they are filled with the eyes and surrounding flesh of the eyelids.

Unlike most of the other bones in the body, the skull is not covered by large amounts of muscles and tissue – so the form of the head and face closely follow the form of the skull beneath. Once you know the general shape of the skull, you will then have some idea of the shapes to look for when drawing or painting the head – although the relative sizes, shapes and distances between different areas of the skull vary considerably from one person to another.

The structure of the skull ▼
The skull consists of only two separate parts – the mandible (or jawbone) and the cranium (which encloses the brain). Shown here are the bones that are most relevant to the artist. It is important to remember, however, that every individual's skull is slightly different. It is these differences that play an important part in making us recognizable as individuals.

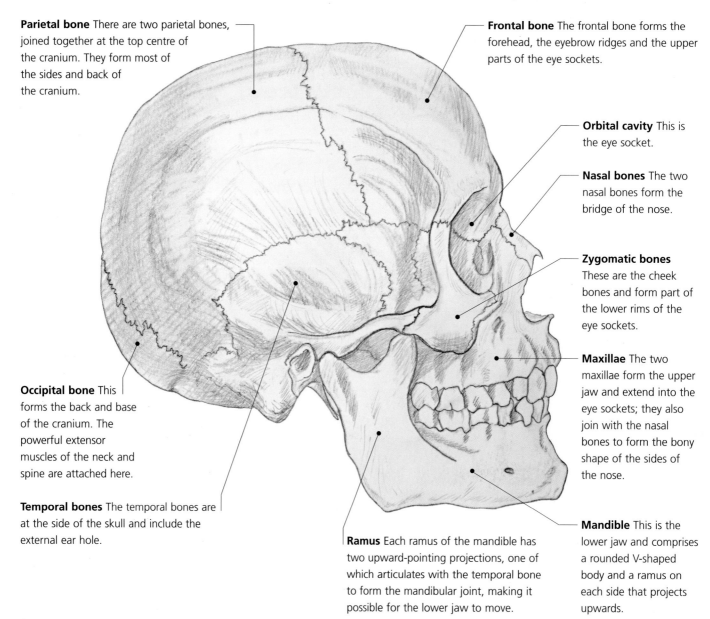

Parietal bone There are two parietal bones, joined together at the top centre of the cranium. They form most of the sides and back of the cranium.

Frontal bone The frontal bone forms the forehead, the eyebrow ridges and the upper parts of the eye sockets.

Orbital cavity This is the eye socket.

Nasal bones The two nasal bones form the bridge of the nose.

Zygomatic bones These are the cheek bones and form part of the lower rims of the eye sockets.

Occipital bone This forms the back and base of the cranium. The powerful extensor muscles of the neck and spine are attached here.

Maxillae The two maxillae form the upper jaw and extend into the eye sockets; they also join with the nasal bones to form the bony shape of the sides of the nose.

Temporal bones The temporal bones are at the side of the skull and include the external ear hole.

Ramus Each ramus of the mandible has two upward-pointing projections, one of which articulates with the temporal bone to form the mandibular joint, making it possible for the lower jaw to move.

Mandible This is the lower jaw and comprises a rounded V-shaped body and a ramus on each side that projects upwards.

The muscles of the head

In some areas of the head it is the muscles, rather than the bones of the skull, that determine the surface form. These muscles that move the facial features and give the face a range of expressions are known as the mimetic muscles. In most of the mimetic muscles, very little force is required. The muscles of mastication, which act on the mandible, are capable of exerting considerable force; the masseter is the most prominent of these.

The mimetic muscles ▼

Knowing a little bit about where the mimetic muscles occur and the effect that they have on the surface of the skin can help you to read and capture your model's mood and expression. For example, you will know which muscles are working to make a smile. Remember, when you create a portrait you are not just drawing or painting a face – you are trying to express a personality.

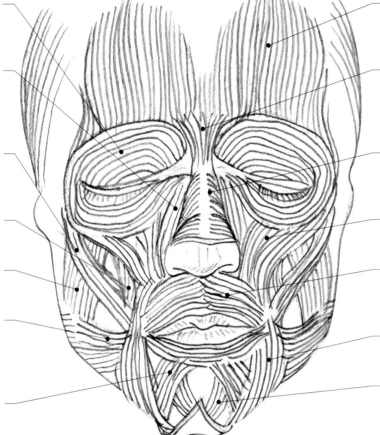

Orbicularis oculi Is concerned with blinking and closing the eyelid.

Levator labii superioris alaeque nasi Raises the nostrils and upper lip and slightly lifts the tip of the nose.

Zygomaticus major Lifts the corner of the mouth up and sideways.

Levator anguli oris Lifts the mouth upwards.

Masseter Lifts the mandible and closes the jaws.

Rissorius Works with the zygomaticus major to create the folds around the mouth when you laugh or smile.

Depressor labii inferioris Pulls the lower lip downwards.

Occipitofrontalis Moves the skin of the forehead and eyebrows.

Procerus Creates the fold in the top of the nose and wrinkles the bridge of the nose.

Nasalis Pulls the sides of the nose downwards and backwards.

Levator labii superioris Lifts and furrows the upper lip.

Orbicularis oris Closes and purses the mouth.

Depressor anguli oris Pulls the mouth downwards.

Mentalis Produces the horizontal furrow between the chin and lower lip.

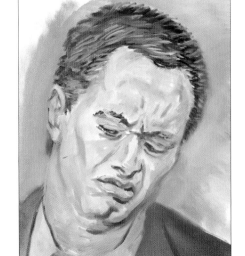

Frowning man ◄

When you frown, the skin on your forehead wrinkles; the occipitofrontalis muscle, which is located just below the surface of the skin, enables this movement. The procerus creates the fold at the bridge of the nose. Also, the chin may lower; the mouth may pucker.

Laughing girl ▶

When you laugh or smile, your mouth stretches out to the sides; at the same time, deep folds are created on either side of the base of the nose; this is achieved through the movement of the rissorius and zygomaticus major muscles. The eyes and brow also move.

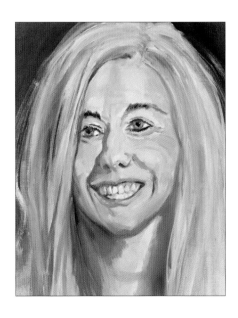

The facial features

Once you've mastered the position of the facial features, have a go at drawing each one by itself. In addition to giving you much-needed practice in observing and drawing what you see, this will also give you an insight into just how different people's appearances can be. The differences between one eye and its neighbour, the crookedness or straightness of the bridge of the nose or the fullness or thinness of someone's lips – all these are part of the individual's unique appearance. If you can't persuade anyone to pose for you, do a self-portrait or draw from photographs.

The eyes

The eyeball is a spherical form and it is important to make it look rounded. The way to do this, as with any rounded form, is to use light and dark tones to imply the curvature of the surface, which requires very careful observation on your part. The darks are strongest where the form comes forward, usually around the pupil. The upper eyelid generally casts a band of shadow across the upper part of the eye.

The highlights are strongest near the top of the iris, close to the pupil, as this is the zenith of the curvature of the eye. In oils, you can either let the darks dry first and then put in the highlight; alternatively, you can work wet into wet and put in the highlight in thicker paint with a rapid, light brushstroke. In watercolour, you need to leave a point of light, or use masking fluid to keep a spot of the paper white.

Another option with both oil and watercolour paint is to lift out the highlights.

The white of the eye is not pure white; it is often shadowed and may reflect a bright highlight. The eyelashes are larger and more visible on the upper lid than on the lower lid. Do not try to paint or draw every single eyelash; instead, put in a dark line to give an impression of eyelashes.

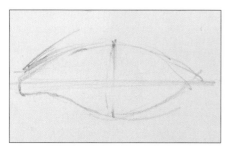

Central axis ▲
To start with, establish a central axis running through both eyes, so that you do not position one higher than the other. Establish the corners of each eye, measuring the space between the eyes.

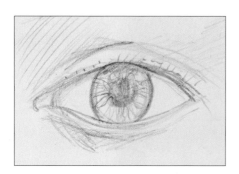

The shape of the eye ▲
Then look at the shape of the individual eyes – how far open or closed are they? Draw the visible part of the iris; remembering that we rarely see the complete circle of the iris, as the upper lid usually obscures the top – especially in older people.

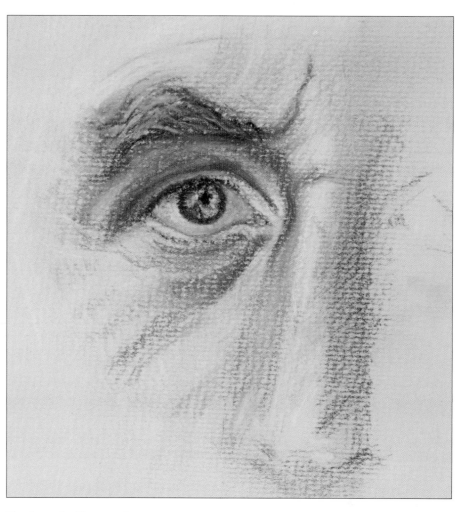

Shadows in the eye ▲
Pay attention to the lights and darks: the upper lids and eyelashes usually cast a shadow on to the eye. Here, a shadow is cast in the socket and underneath the brow. There is a faint bluish shadow in the eye, which accentuates the white.

The nose and nostrils

At first glance, the nose looks a rather complicated shape to draw, so simplify things by thinking of it initially as a matchbox turned on its side; this makes it easier to see the individual planes. The nose has four distinct planes – the bridge, two side planes moving from the bridge to the cheeks, and the plane underneath the tip of the nose where we see the dark of the nostrils.

On the lower nose there are so many changes in direction, from convex to concave, that it may be difficult to see the separate planes. The way that these convex and concave forms face into or away from the light source means that the nostrils always appear dark – but these contrasts in tone are relative to the other areas of shadow under the nose and on the upper lip. Take care

not to make them too dark and flat – look carefully at the colours and tones within the shadow.

Highlights usually appear at the edge where two planes meet, as at the junction between the bridge and side planes of the nose and on the tip of the nose. There will also be reflected mid-tones in the plane underneath, around the dark of the nostrils.

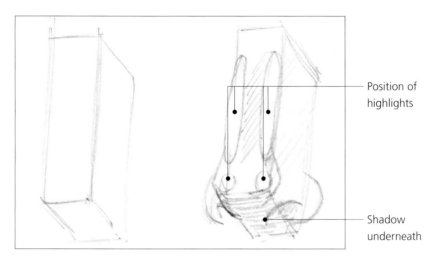

Position of highlights

Shadow underneath

The shape of the nose ▲
Although the nose may have many curves and bumps within it, try to think of it as a box shape, like an upended matchbox, in which the individual planes – the two sides, the bridge and the underside – can be clearly defined.

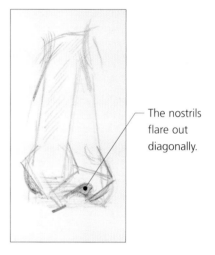

The nostrils flare out diagonally.

The shape of the nostrils ▲
The nostrils have planes that catch the light and cast shadows. The dark part of the nostril should be considered as part of the underside of the nose.

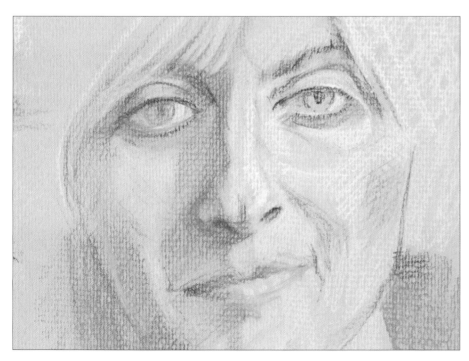

Highlights ▲
Areas of light appear on the bridge, in the nostrils and at the end of the nose.

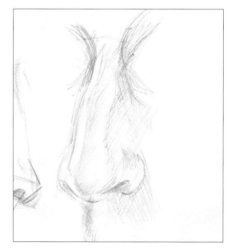

The planes of the nose ▲
Most people's noses change near this point on the bridge of the nose – the transition from bone to cartilage. Light reflects into the shadow under the nose and on the upper lip. Look very carefully: this is not solid shadow.

The mouth

Regardless of whether a person's lips are thin or full, they are pushed outwards by the teeth and follow the curve of the teeth – even though, from the front, the lips appear to be almost on a straight axis. The top lip often appears darker than the bottom lip because the plane of the top lip angles away from light above. (You can see this more clearly if you look at someone's mouth from the side.)

The philtrum is the groove of flesh in the upper lip, which gives the top lip its shape in the middle. This 'valley' of light and dark can be very useful with the right lighting: it signals direction and brings a sense of sculptural relief to an area that often has shadows cast by the nose.

Although you might think of the lips as a flat splash of colour across the lower half of the face, it's important to observe their shape – and, of course, that shape is affected by what lies beneath them.

The upper lip follows the groove of the philtrum, which descends from the nose. When we smile, the upper lip turns outwards and flattens against the teeth, and the philtrum changes shape.

If you make the line between the lips too dark, it can come forwards in the picture rather than recede, so look carefully at the tone of the two lips to see if the top lip overlaps the bottom one, in the centre below the philtrum.

Without lipstick, the lips are not necessarily different in colour to other colours in the face. Use the same colour for both lips, adjusting the tone as necessary. Usually the upper lip is darker than the bottom lip. There are also highlights in the lower lip; sometimes these can be created by using white, sometimes a totally different colour is required. A crimson mixed with yellow ochre or white in differing proportions usually gives a distinct lip colour. A darker colour in the lips may be an earth tone or a deeper purple.

Shape of the mouth ▼

There is a huge difference between the shapes of different people's mouths. To establish the shape, find the corners and use the philtrum in the upper lip to find the centre of the mouth.

Axis

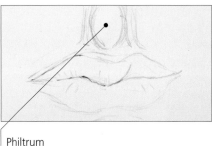

Philtrum

Lip shape and tone ▼

Lips are not a flat shape. Note how the upper lip overhangs the lower one. The top lip is darker than the lower one, as it slopes inwards, facing away from the light source.

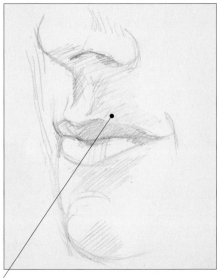

Light catches the edge of the upper lip

Folds around the mouth ▼

There is a faint line (in young people) or a deep fold (in older people) running from the nose around the mouth, dividing the mouth and cheek. The philtrum is also clearly visible: use contrasts of tone to make the recesses obvious. There may also be slight undulations below the lower lip. The folds around the mouth are more apparent in older people.

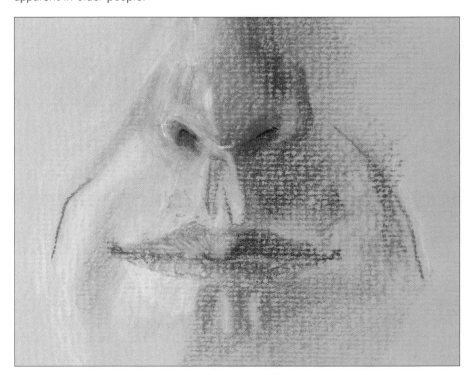

The ear

When you make studies of ears, make sure you work in strong light so that you can see the sculptural, shell-like, three-dimensional rhythms. Shadows give you the sense of the form of ears, especially in the interior. Try to model the form of the ear using light and dark tones.

To place the ear correctly, look to see where the ears align with other features such as the eyes or mouth, and look at the distance between the features. Start by taking a light diagonal line from the base of the lobe to the top of the ear to establish the length. The upper part of the ear is wider than the lower. Carefully observe the length of the lobe; it is longer in older people. Look at the shadow behind and below the ear and note how hair moves around the top and behind.

The interior of the ear always appears darker than the surrounding flesh – but if you make the interior of the ear too dark, you destroy the sense of where these recesses are and they jump forwards in the picture. Always look at the tonal contrasts – the amount of half tones and light that are around these darker areas.

Shape and structure of the ear ▼
Think of the ear as being like a seashell in the way that the outer ear spirals in to the centre. Look for the lights and darks in the different surfaces of the ear. The top of the ear and the ear lobe are the fleshiest parts and invariably appear lighter. The recesses of the inner part of the ear are in shadow.

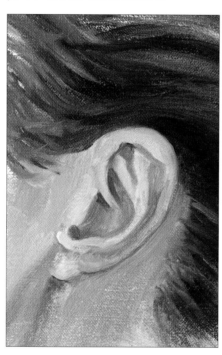

Examine your own reflection ▼
Look at your reflection in a mirror and see what shapes you can see in the ear. The shapes and angles will vary depending on your viewpoint. Note, for example, how the bony cartilage of the inner ear appears to jut out in this individual when he is viewed from this particular angle.

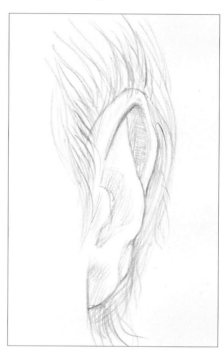

Shadows ▼
Look at the shadow underneath the lobe as this shaded area shows the relief of the ear.

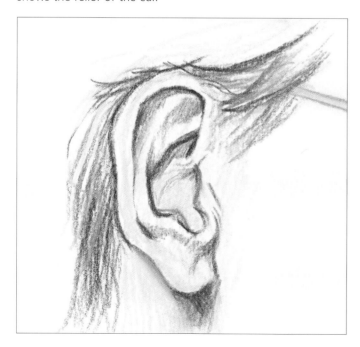

Hair around the ear ▼
Look at the way the hair falls around the ear: it may obscure the ear, but always remember the structure underneath.

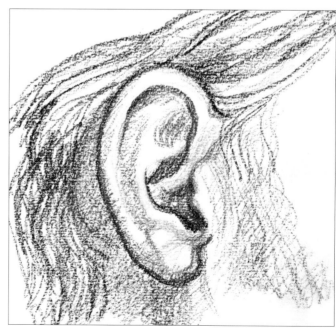

Measuring and proportions

No matter what subject you're drawing or painting, you need take careful measurements so that the relative sizes of different elements are correct. You also need to check continually as you work to make sure that you keep the proportions true to life. After a while, you'll find that this becomes second nature – but if you're a beginner, it's important to make a conscious effort to measure and check everything before you put it down on paper. Remember, too, to make your initial marks quite light so that you can make adjustments if need be. Even experienced artists find that they need to make revisions – and this is particularly true in portraiture and life drawing, where the position of the model will inevitably shift slightly during the course of the pose.

Taking measurements
Choose a unit within your subject against which you can measure everything else. That unit can be anything you like – the width of the eyes, the length of the nose, the distance between the bridge of the nose and the chin, for example.

With this method, it's absolutely vital that you keep your arm straight, so that the pencil remains a constant distance from the subject. Close one eye to make it easier to focus, and concentrate on looking at the pencil rather than at your subject.

The subject ▶
Here, the subject is a small statue, but the principle remains the same whatever you are drawing.

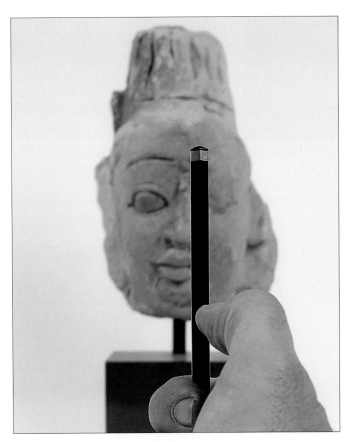

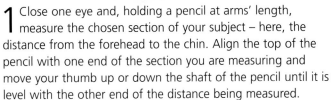

1 Close one eye and, holding a pencil at arms' length, measure the chosen section of your subject – here, the distance from the forehead to the chin. Align the top of the pencil with one end of the section you are measuring and move your thumb up or down the shaft of the pencil until it is level with the other end of the distance being measured.

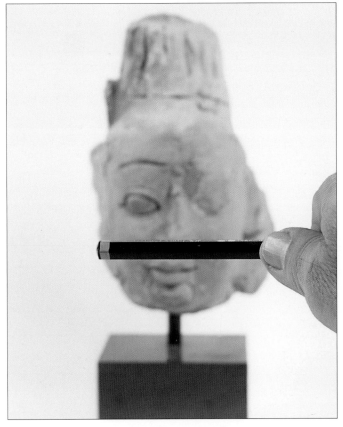

2 Then transfer this unit of measurement to the paper. The unit of measurement is relative to the scale of your drawing. You will need to double or treble the ratio. Next, use the same unit of measurement to compare the size of other parts of the subject. Here, the distance across the widest part of the statue is the same as the measurement taken in Step 1.

The proportions of the human body

Artists have tried for centuries to define the proportions of the human body, but in reality proportions vary from one individual to another just as features vary. However, the head is a standard 'unit of measurement' that is often used in assessing proportions. Generally speaking, the average adult is roughly seven and a half heads tall. The height of his or her head fits seven and a half times into the total height of the body. It is important to stress that these proportions are average. Nonetheless, if you know the 'norm', you will find it easier to assess how far your model conforms to or departs from it.

Children, however, are another matter. In babies, the head takes up a larger proportion of the whole and a young baby's total height may be only about four times the height of the head, with about three-quarters of the height being the head and abdomen. The limbs then grow dramatically in the early years; by the age of three, the legs make up about half the total height.

Although the head is a standard and accepted unit of measurement, you can use anything you choose. For example, in a sitting pose the head may be seen in perspective, which will make it difficult to use it as a unit against which to judge other parts of the body. In a portrait where the model's hand supports the chin, for example, you could compare the length of the head to the hand. Or you could look at the length of the forearm in relation to the thigh. The important thing is that you check and measure sizes as you work.

If we look at further sub-divisions, more general guidelines emerge. In a standing figure, the pubic area is just below the mid-point of the body; the legs make up nearly half the total height. If the hands are hanging loosely by the sides, they will reach the mid-point of the thighs, while the elbows will be roughly level with the waist. When you're drawing or painting the figure, look for alignments such as this to check that you're placing limbs and features correctly. You can also put in 'landmarks' such as the nipples as guides, although there is no substitute for repeated and careful measuring.

There are also some differences in body shape between the sexes. Men's shoulders are generally wider than women's and their legs longer. A female pelvis is wider at the top.

General proportions ▼
See how proportions change with age. In this sketch, the adult male figure is seven-and-a-half heads tall and the woman is just over seven heads. The boy is just over six heads tall; the young child is just over four heads, while the baby is just under four – so his head takes up a much larger proportion of his total height than it does in adults.

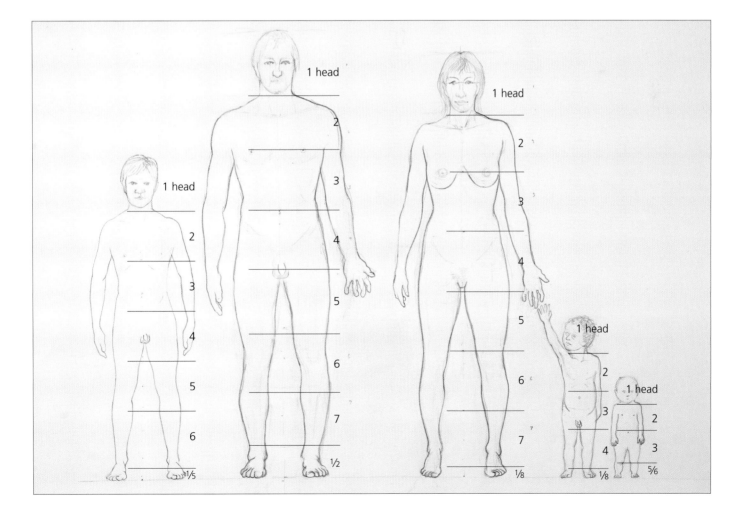

The hair

When drawing or painting hair, you must consider it as part of the head as a whole, rather than as a separate entity. Start by thinking about the overall shape and mass of the hair before you concern yourself with colour and texture. If someone has long, thin hair, it may hang down over the head, face and shoulders, showing the form underneath rather like a tight-fitting garment on the body. Big, curly hair, on the other hand, can almost double the volume of the head as a whole, and it can be hard to imply the shape of the cranium beneath.

Use the hair to help you search out the different planes within the head. Since the hair follows the contours of the scalp and therefore the different planes of the skull, even straight, very thin hair contains highlight and shadow areas as one plane changes direction into the next. Coarse, wavy hair may contain many transitions from light to dark as it undulates over the surface of the skull. Try to see hair as a series of blocks, rather than individual strands. These blocks reflect light in different ways, depending on the colour and type of hair. In straight, dark hair that clings closely to the scalp, the highlight may look like a bar of light; in wavy hair, each curl will have its own pattern of highlights and dark areas, so the highlights over the head as a whole will be much more fragmented.

The way that you convey these areas of light and shade depends, of course, on your choice of medium. A pencil drawing may include cross hatching to create different tones, erasing to lift out the highlights and lines illustrating the movement of strands or clumps of hair. If you are using soft pastels, use the side of the pastel for broad areas beneath any light strands and put in the lights on top as a final series of touches. You could also lightly brush or wipe a paper tissue over the broad areas to create softer effects.

If you are using oils or acrylics, you might choose to put in the darks first and use a rag (or a damp brush) to wipe them out, applying a lighter colour on

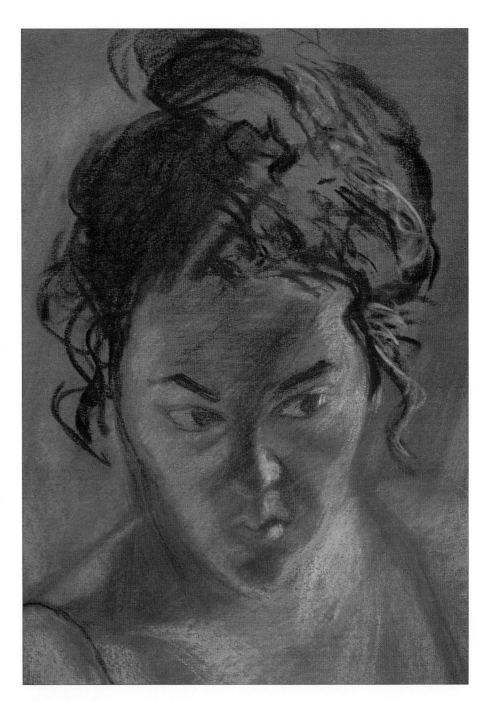

Wavy hair ▲

Here, the model's hair was pulled back over her scalp and tied up on the top of her head – but it still escapes in unruly waves! The bulk of the dark hair on the shaded side of her head was put in using the side of a charcoal stick, with bold, curling strands conveying the direction of hair growth. On the lighter side of her head, the artist left the original dark ochre colour of the paper showing through, just as he did in the mid-toned areas of the model's skin. You can also see some fleck of pinks and purples in the hair. You might think this is an unusual colour choice, but the artist selected them for their tonal values, rather than for their actual colour: they relate to the light and dark areas in the skin. Another reason for choosing them was that the model was from Hawaii and he wanted to create a sense of hot, tropical colours, just as Gauguin did so famously in his wonderfully vibrant paintings of Tahitian women.

top, making the subsequent layers thicker so that they do not merge with the underpainting. In watercolour, you normally work from light to dark so you need to establish the lightest tones first and then add the darks on top, allowing each layer to dry before the next.

Whatever medium you use, exploit the contrasts between warm and cool colours in order to convey the areas of light and dark within the hair. Hair picks up some reflected colour from its surroundings: you may see green/blue tones in blonde hair, hints of blue in black hair, and red or blonde in brown hair, depending on the light.

Sleek, shiny hair ▼

Here, the hair closely follows the contours of the scalp, but the artist has taken care to use different tones to convey the changes in plane. Note the blue highlights on the top of the head, for example, while the side nearest us is in shadow and is therefore darker in tone. A crimsony purple oil paint serves as a mid-toned ground colour for the hair. The artist then applied a darker violet on top; with the addition of white, this same violet becomes a cool half light in the highlights in the back of the hair, behind the ear. The yellow background is reflected into the hair, so adding yellow ochre to the violet both lightens it and gives a complementary colour contrast which emphasizes the glossy quality of the hair.

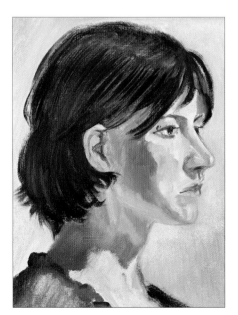

Long flowing hair ▼

The key to drawing hair like this is to think of it not as a solid mass nor as a wild array of individual strands, but to aim for something in between: try to capture the general direction of hair growth without putting in every strand – and remember to look at how the hair follows the contours of the scalp. With charcoal and other monochrome media, you're limited to a small range of tones. Here, the mid tones are created by smudging the charcoal with the tip of a finger and the light tones by lifting off pigment with a torchon or kneaded eraser.

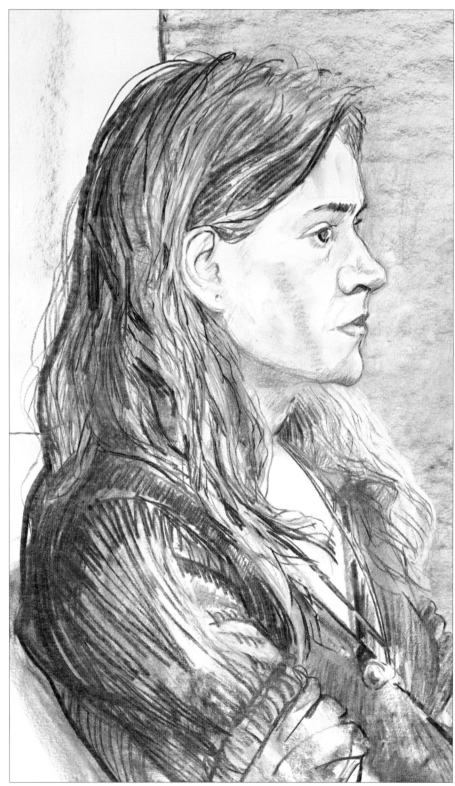

The hands and feet

Hands and feet are notoriously difficult to draw. One of the reasons for this is that people do not look at the hand or foot as a single unit; instead of being able to schematize the form into simple planes, they get too caught up in drawing details such as individual fingers and toes with too much prominence and tend to make them too big. Study them carefully until you are confident in your observational skills.

To find out about the basic anatomy, start by drawing your own hand or foot. Place your hand on paper, trace around the outline, and then 'fill in' the missing information – the veins, wrinkles of the knuckles and so on – using line. This gives a flat image. If you shine a light on your hand from the side, you will throw these details into relief; you can then describe the hand's surface using tone, which is much more interesting.

Schematize the shapes into simpler forms and define the planes. A clenched fist, for example, is a rough cube shape: there are four changes in plane on the back of the hand and fingers, plus two on the sides of the hand. Try to analyze the foot in the same way.

Then look at the surface anatomy – the veins, wrinkles, lines and folds. Flex your fingers or rotate your ankle and see how the tendons fan out. The tendons that you can see are the long tapering ends of the flexor muscles in the forearm (or, in the foot, the long tendons of the muscles running down the front of the lower leg). Look at how light catches the veins and wrinkles, but do not give them too much definition; if you make them too strong, they become too dominant and the sense of the form underneath gets lost.

The colour of hands and feet may also be different from other areas of the body. Hands are exposed to light, while feet are generally not exposed to the same degree. The skin's colour may also change because of its texture.

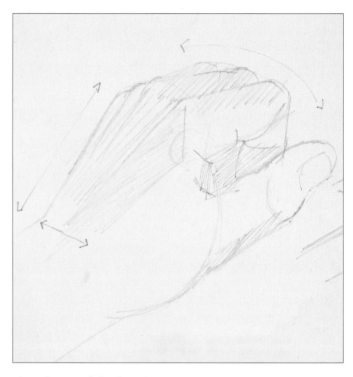

The planes of the hand ▲

Here we can see three main planes – the back of the hand, the side of the hand, and the section between the base of the fingers and the first knuckle. Tucked out of sight but implied, there are two further planes on the fingers – between the first and second knuckles, and the second knuckle and fingernail. Use tone to suggest the changes of plane: here, the brightest section is the side plane, with the back of the hand, and then the first segment of the fingers becoming progressively darker in tone as the planes turn away from the light source.

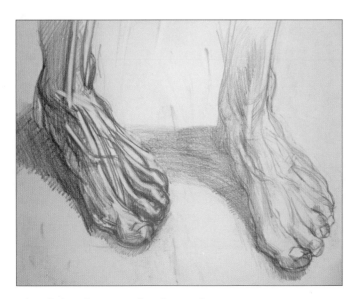

Visualizing forms under the surface ▲

Here you can see the muscles and tendons beneath the skin. The artist has used his knowledge of anatomy and studied the foot, shading in the raised and shadowed areas.

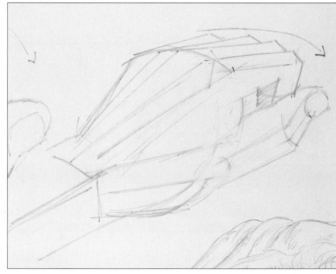

Underlying structure ▲

You may see the wrinkles and creases on your hand as a pattern of flowing lines, but don't forget that this is only the surface detail: what's more important is what lies underneath.

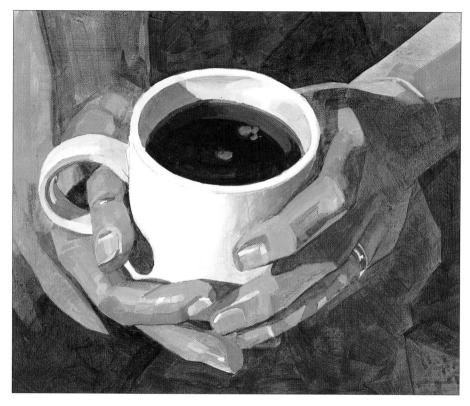

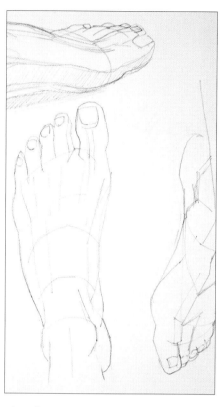

Cupped hands ▲

The different planes of the hands and fingers can be clearly seen, with subtle differences in tone (delineated with a flat brush) conveying the shape of the hands and the way the fingers curl around the coffee mug. The shadows cast on the mug by the fingers, as well as the highlights on the fingernails, reveal both the direction and the intensity of the light, while the dark, plain background allows the hands to stand out clearly. Note, too, how the amount of fingernail that is visible varies according to whether the fingers are angled towards or away from our view.

The planes of the feet ▲

These sketches show how the foot is broken down into a series of simplified planes. It is important to do this and to analyze the tones of the sections when you're depicting the foot, as it makes it easier for you to think of the whole unit and make it appear three-dimensional.

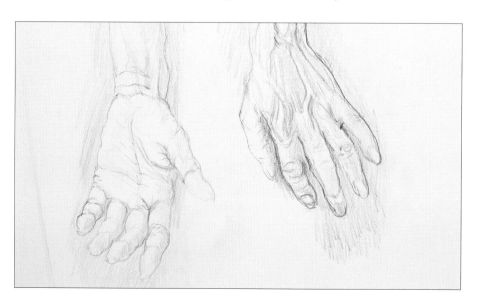

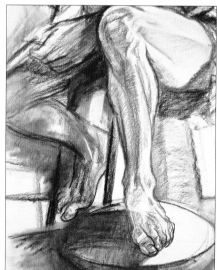

The palm and back of the hand ▲

The bony knuckles, tendons and veins are much in evidence on the back of the hand. Look at how they catch the light, as this will help you to convey their form and structure. Drawing the fleshy palm of the hand is a little more difficult, as there are fewer structures to guide you, but you will still see creases across the palm and around the knuckle joints that indicate the changing planes.

Creating light and shade ▲

In this charcoal sketch the highlights that convey the different planes of the feet and legs have been expertly created by wiping off charcoal with a kneaded eraser.

Colours and colour palettes

Although you may come across tubes of paint labelled 'flesh colour' in your art supplies store, in reality there is no such thing! Skin colour varies enormously from person to person and, of course, nobody's skin is a uniform colour all over. Take a look at your reflection in a mirror, or hold your hand up in front of you: you will soon see that, even on a relatively flat area, your skin colour actually contains many variations.

Things get even more complicated when we bring tone into the equation. Introducing tone is the main method artists use to make their subjects look solid and three-dimensional. A brightly lit area of skin will appear lighter in tone than one that is in shadow. In portraiture and figure painting, the transition from one plane to another – and hence from one tone to another – is often very subtle, and you need to be able to create a wide range of tones from every colour in your palette.

Mixing colours

Once you've selected your basic palette for a painting, it's a good idea to pre-mix a few tones, combining the same mixture of colours with different amounts of white (or water, in the case of watercolour) to achieve a light, mid and dark tone for each colour. You can then mix the subtle half tones around those main tones as required.

When mixing colours, use a large surface as a palette to prevent the colours from becoming muddied or jumbled. Try to begin and end with clearly defined tones and colours.

You can make any soft pastel lighter by adding white, but usually you will find such a huge range of ready-made colours in both soft pastels and coloured pencils that you do not necessarily need to darken or lighten them. However, it is worth experimenting to find out how different colours can mix optically on the paper.

Applying paint to the surface

However well you mix a colour on the palette, it will probably appear different when placed next to other colours on the support. If you are using a wet-into-wet technique (oils, acrylics, gouache and watercolour can all be used in this way), colours will mix into each other on the painting. You will need to be aware of this and work with a deft hand to prevent unwanted bleeds of colour.

If you are painting in layers and letting each colour dry, then the colour underneath will have an influence – a dark colour underneath will darken the top shade.

You can develop a painting in more opaque layers, putting thicker paint on thinner undercoats (the 'fat over lean' technique used in oil painting), then wiping off with a cloth or scraping through with a palette knife to create colour variations. Whatever technique you employ to apply paint, knowing how to use tonal values and warm and cool hues will help you control and evaluate the effects on the surface as they occur. The only way to know this is through practice.

Basic palette plus colour mixes for portrait opposite ▼
The basic palette shown below consists of the colours that the artist selected to make the portrait opposite. It is made up of just nine colours, which are shown down the left-hand side. Next to these colours you can see how each has been modified by combining it with one or more colours from the same basic palette. It's surprising how many different colours and tones you can create in this way.

Look at the painting and try to see where the different mixes occur. As you practise colour blending you will become adept at getting your tones right, even though at first it may seem a daunting element of portraiture. Just use scrap paper to experiment on before you colour your portrait.

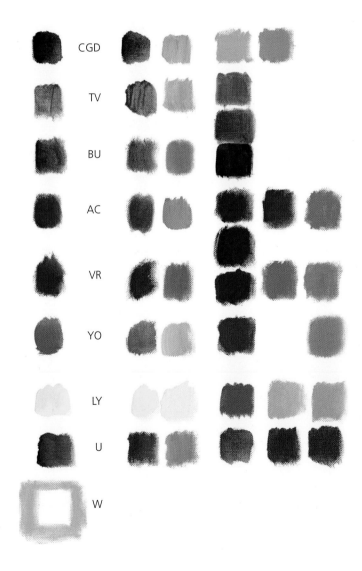

Key

CGD	Chrome green deep	YO	Yellow ochre
TV	Terre verte	LY	Lemon yellow
BU	Burnt umber	U	Ultramarine
AC	Alizarin crimson	W	Titanium white
VR	Venetian red		

Pale skin, painted in oils ▼

In this oil portrait of a woman with very pale skin, the artist toned the canvas with a warm earth mix of Venetian red and yellow ochre, so that he could allow the same mix to show through for the hair and parts of the skin (in the forehead, for example). White was used to lighten the skin tones and crimson to create the darks, with the addition of blues to make bluish and purplish (cool and warm) grey where appropriate. (Note how the interplay of warm and cool tones in the flesh helps to create a sense of modelling.) Terre verte was used as a dark mid tone in the shadow under the chin. White was used as a pigment to give the flesh body and to lighten and make cooler the colour of the flesh.

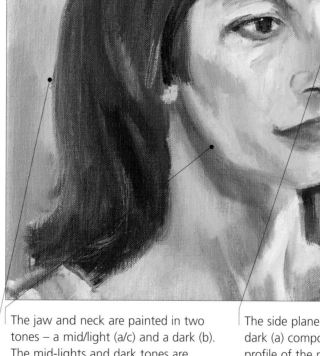

The forehead has three tones – light in the middle (a warm hue – b), a mid-tone on the left (a warm hue – a) and a dark on the right in the shadow of the hair (c). In both the mid and dark tones, the coloured ground is visible through scumbled and wiped-off areas. The dark tone and colour of the hair in the shade (d) contrasts with a light ochre (e).

The background has a warm, dark grey (a) and a cooler, lighter colour (b), to contrast with the warm dark of the hair (c). The contrast helps focus the attention on the woman's face.

The jaw and neck are painted in two tones – a mid/light (a/c) and a dark (b). The mid-lights and dark tones are composed of green and brown/red contrasts to create a sense of volume.

The side plane of the nose is a warm dark (a) composed of two hues. The profile of the nose is a cool, bright light (b). The whiteness of the light suggests natural daylight.

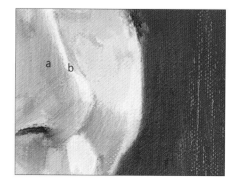

Assessing colours

When you're drawing or painting flesh, be it a portrait or a nude, you need to take into account two things: the actual colour of your model's skin and the effect of the light and surrounding colours on the model's skin. No two portrait situations are alike, so it's important that you make your observations with each model as carefully and as sympathetically as you can.

Beginners are often surprised to see how many colours artists discern (greens, blues, purples) in skin tones. It's impossible to be dogmatic about this, as it all depends on the particular lighting situation and the model, but often it's the interplay of warm and cool colours that makes a portrait really sparkle – so try using warm darks if you've got cool lights/mid tones – and vice versa.

Colour temperature

You also need to think about the relative warmth or coolness of colours. Colour temperature is important because of the way that warm colours appear to advance in a painting, while cool ones appear to recede. So in a portrait, areas that jut forwards, such as the nose, cheekbones and chin, have a contrast of warm and cool lights and mid tones. Highlights can be either warm or cool depending on the light source and the colour of the person's skin. You should have a warm and a cool version of each of the three primary colours – red, yellow and blue – in your palette, as this enables you to mix both warm and cool colours. Lemon yellow, for example, is cooler than cadmium yellow, while ultramarine blue is warmer than cerulean blue – so if you want to mix a cool green, mix it from a cool blue and yellow.

Basic palette plus colour mixes ▶
The palette for the opposite portrait is virtually identical to the one on page 56, with cadmium scarlet instead of the chrome green deep. Each colour has been modified by combining it with one or more colours from the same basic palette – but note how different some of the colours look on the coloured ground in the portrait.

Key

CS	Cadmium scarlet
TV	Terre verte
BU	Burnt umber
AC	Alizarin crimson
VR	Venetian red
YO	Yellow ochre
LY	Lemon yellow
U	Ultramarine
W	Titanium white

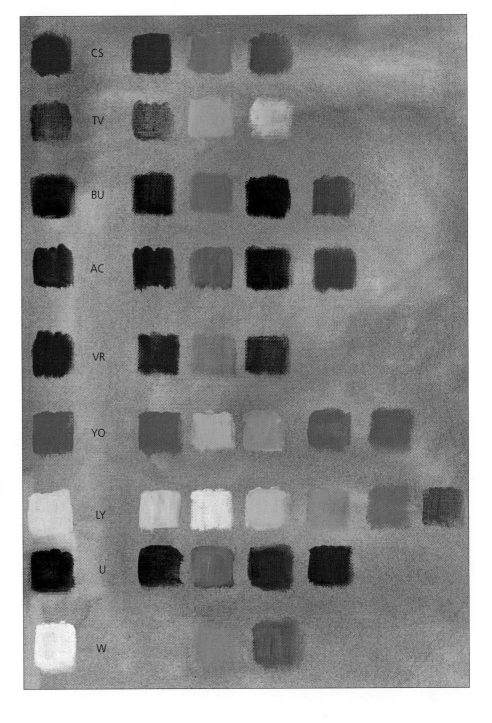

Dark skin, painted in oils ▼

This painting was also done on a toned ground; crimson was applied both thinly and thickly to create two different tones in the background. The thin ground colour on the right can also be seen as a mid tone in the face, giving the painting a liveliness that it might lack if the mid tones were painted in with more opaque colours. The basic skin tones are various mixtures of lots of yellow ochre, burnt umber and Venetian red with additions of white. The basic hair colour is a mixture of terre verte, ultramarine, burnt umber and crimson. Both warm and cool highlights can be seen, the warm highlight being a mixture of lemon yellow and white and the cool one a mixture of ultramarine with a hint of white.

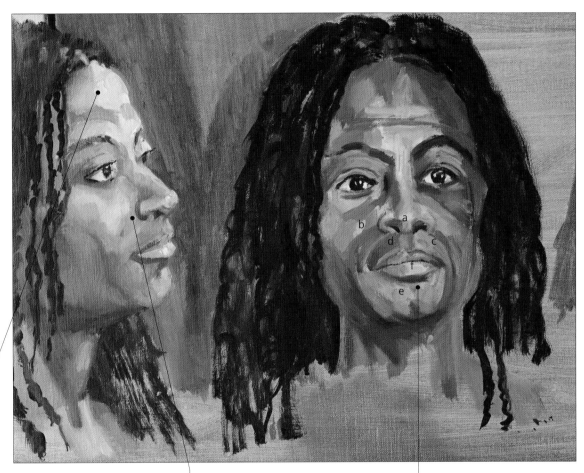

The forehead is in two planes – (a–b) and (c–d). (ab) has a range of cooler, light tones and (cd) a range of warmer mid and dark tones. The light tones are made from lemon yellow, white and a violet mixture. The warmer tones are a mixture of yellow ochre, alizarin crimson and burnt umber.

The end of the nose (a) has lights from pink, light blue, light green and lemon yellow and white. The objective was to have warm and cool lights next to each other. The cheek is a warm light (b) over a cooler green. A warm yellow ochre in the upper lip (c) overlaps the dark in the nostril.

Lemon yellow and white highlights (a) contrast with the mid tones at the end of the nose, which are composed of violet and Venetian red mixtures. The same highlight appears in the cheek (b), in contrast to a warm mid tone (yellow ochre) and a warm dark (Venetian red). Similar but slightly more subdued colours appear in the light side of the upper lip (c), with a warmer, darker Venetian red mixture on the opposite, darker side (d). Again, similar mixtures appear in the chin (e). The lips are a range of colours derived from alizarin crimson, with white and blue added to make light cooler violets mixed with ochre in the top lip. The bottom lip (f) is neat cadmium scarlet in the mid tone, with white for the lighter tone to show the fullness of the shape.

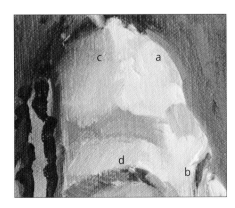

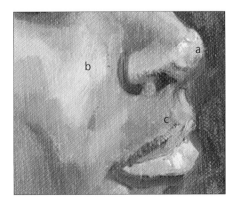

Composition

In its simplest terms, 'composition' is the way you arrange the different elements of your drawing or painting within the picture space. Before you can do that, however, you have to decide on the picture space itself – the size and proportions of your paper or canvas.

Many artists opt for a format in which the ratio of the short side of the canvas to the longer side is 1 : 1.6 – the so-called 'golden rectangle', which evolved as an artistic ideal during the Renaissance. The golden rectangle is a safe bet, as it works horizontally and vertically, so suits many different subjects, but it is by no means the only option. A lot depends on your subject matter and on the effect and mood you want to create. Look at other artists' work and, if you see an unusual format, think about why the artist might have chosen it. An artist might, for example, choose a long, thin panoramic format for a landscape painting to emphasize the breadth of the landscape, or a square format for a portrait in order to fill the canvas with a dramatic painting of just the sitter's head.

Arranging elements within the picture space

Over the centuries, artists have devised various ways of positioning the main pictorial elements on an invisible grid around specific positions within the picture space. One of the simplest is splitting the picture area into three, both horizontally and vertically, which gives a grid of nine sections with lines crossing at four points. The theory is that positioning major elements of the composition near these lines or their intersections ('on the third') will give a pleasing image.

It is also important to lead the viewer's eye towards the picture's main centre of interest. You can do this by introducing lines or curves, real or implied, into the composition. A road leading up to your main subject is an example of a real line; an implied line might be a composition in which the artist has arranged throws or cushions in a curving line that leads the viewer's eye through to the subject, a reclining figure on a sofa.

You can also imply geometric shapes within the composition to lead the viewer's eye around the picture. You might, for example, ask your sitter to hold a book in one hand. If you then take an imaginary line from this point to the crook of the model's other arm, and then up to the head, the three points joined together form a triangle: this leads the viewer's eye around the portrait, with the apex of the triangle – the sitter's head – being the focal and therefore the most important point.

Portraits and figure studies bring their own special compositional requirements. A central placing generally looks stiff and unnatural, as does a direct, face-on approach. Heads in portraits are usually placed off centre, with the sitter viewed from a three-quarter angle. More space is often left on the side towards which the sitter is looking. You also need to think about how much space to leave above the head. Too much and the head can appear pushed down; too little and it will seem cramped.

These are just a few of the compositional devices that have evolved over the years. The best way to learn about composition is to study other artists' work and try to work out how they have directed your eye towards the focal point of the image. You will gradually find that you can compose a picture instinctively – but if you're relatively new to painting, it really is worth taking the time to think about it, and even try sketching out different options, before you commit yourself and mark the canvas or paper.

Triangular composition ◄

In this family group by Ian Sidaway, the figures form a rough triangle that holds the group together visually and focuses attention firmly on them rather than on any background elements. There is also an inverted triangle below this, running across the painting between the heads of the two children and down to the dog. This helps to lead the viewer's eye around the painting. When you're arranging a group with some figures seated and some standing, make sure that there isn't too much of a disparity in height. Here the father is bending over slightly so that he's closer in height to the rest of the family; this also increases the sense of intimacy between him and the other family members.

Diagonal lines and props ▶

In the lovely *Interior with Jacqueline*, which is both a portrait and a visual essay on light, David Curtis has used the diagonal lines of the bureau to direct the viewer's eye to the subject and the work that she is concentrating upon. The gentle curve of the model's back echoes and balances the diagonal line of the bureau on the left and helps to draw the viewer's eye to the focal point of the image – the sitter's face and expression. Her right arm also provides a partial frame for her face, again helping to direct our eyes to the focal point.

When you intend to paint the whole figure rather than just a head and shoulders, you must consider what other elements to include and whether props will help to enhance your description of the sitter. If you paint the subject in their own home, you can show them in familiar surroundings and with personal possessions. Particular props are often used in portraiture to help describe the character and interests of the sitter. A writer or someone fond of reading might be shown with a selection of favourite books, or a musician with his or her instrument. Try to convey something of the atmosphere around your sitter.

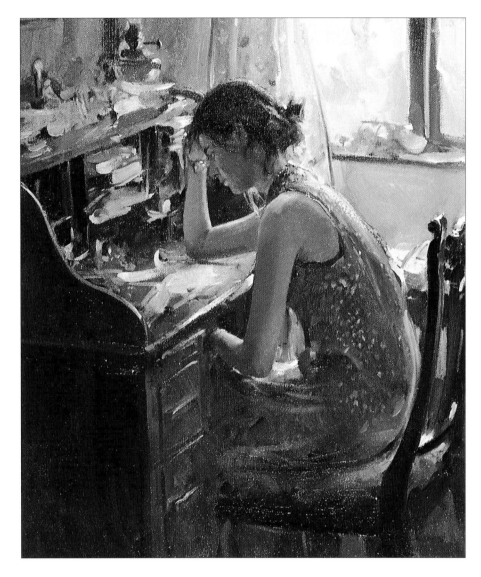

Sweeping curves ▶

In this portrait by Paul Bartlett, the viewer's eye is led around the picture in a circular fashion, starting from the focal point – the head, which is positioned roughly 'on the third' – down to the writing hand and back to the head again. The sweeping curves of the figure, chair and writing pad are balanced by the table and the dark upright of the lamp.

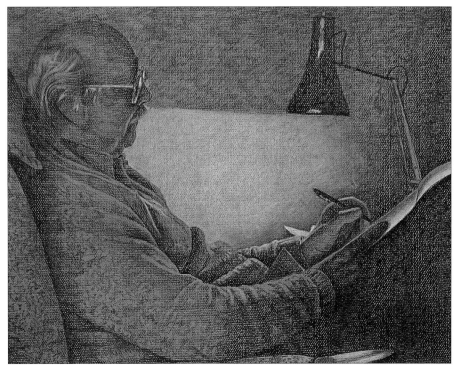

Light and shade

Light is a critical part of portraiture and figure painting: it is the contrast between light and shade, as the different planes of the head or body turn away from the light and into shadow, that enables artists to create a three-dimensional impression in their work. The four aspects of light that you need to consider are direction, quality (or intensity), colour and shadow.

Direction of light

First of all, think about where you are going to position your subject in relation to the light source. For beginners, the best direction is when the light is coming from just in front of and to one side of your subject – a set-up known as 'three-quarter lighting'. One side of your subject will be brightly lit, while the opposite side will be in shadow, making it much easier to distinguish the relative lights, darks and half tones. If the light is directly in front of your subject, it tends to 'flatten' the subject, making it harder to see the different planes and create that all-important sense of modelling. If the light is behind your subject it will create a 'halo' effect, again making it harder

to see the different planes. This is known as contre-jour lighting and is often used to good effect to create soft, romantic-looking images, so may be one of the many techniques you could work towards after you have become comfortable with working with three-quarter lighting.

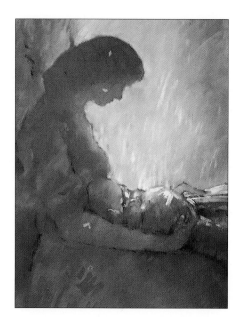

Backlighting ▶
This technique can create lovely effects, silhouetting the figure, softening the colours and reducing the tonal contrasts. In this charming portrait of a mother and child, Geoff Marsters has exploited this kind of lighting to create a gentle and meditative mood that is entirely in keeping with the subject.

Quality of light

Light, both natural and artificial, varies considerably in quality or intensity. On a cloudy day, natural light may be very soft and diffused, whereas on a sunny summer's day it may be very bright and contrasty. Artificial light, too, can be used to cast a strong beam on to one specific place (think of a theatre spotlight), or diffused and spread over a wider area by being shone through a translucent material such as paper or fabric.

The time of day has an effect, too. Early in the morning and late in the afternoon, when the sun is relatively low in the sky, the light is at an oblique angle, which throws things into relief and creates good modelling; at midday, on the other hand, the sun is almost directly overhead, which tends to make things look flatter.

Midday light ◀
In Ian Sidaway's delightful portrait of a little girl looking at her reflection in a pool, the midday light is harsh and intense, bleaching out much of the detail on the child's hair and skin. The short shadow and still, unrippled water add to the sense of a sultry, hot noon. The darkening tones of grey on the stone surround of the pool give the image a sense of depth, while the warmth of the skin tones in the upper half of the image is balanced in the lower half by the rich, orangey-red of the goldfish, which contrasts with the cool blue dress.

Colour of light

Different kinds of light have distinct colour casts. Late afternoon sunlight, for example, often has a rich, warm glow, while fluorescent light has a pink or yellow tinge. Needless to say, these colour casts affect the colour of the objects that the light is illuminating.

Most of the time colour casts do not matter too much, as our eyes automatically adjust. It can, however, become a problem if you begin a painting in natural light and then, as the day progresses, turn on the artificial room lights to complete your work. If you've been using, say, cadmium yellow for highlights, those same highlights may appear much cooler under electric light, causing you to switch to the more acidic-looking lemon yellow. When you view your work in daylight again, the discrepancies will immediately become apparent. So be aware that this is a potential problem and try to keep the same kind of lighting throughout, even though this may mean that you need several painting sessions to complete your work.

Shadows

In addition to helping you create a three-dimensional impression, shadows can form an integral part of a painting in their own right and add a sense of drama to your work. Think, for example, of horror films, in which the shadow of the monster looms large on a wall before we ever see it in the flesh.

At the other end of the spectrum, dappled light playing on a figure can create constantly fluctuating shadows that suggest a soft, romantic mood. Even something as simple as the glazing bars on a window can cast shadows inside a room, which you can exploit as a compositional device. So although they're insubstantial, shadows are an important way of adding interest to your drawings and paintings.

Remember, however, that natural light is constantly changing and so shadows can change position, or even fade away completely, during the course of a painting session. It's a good idea to block them in, however lightly, at the start – or at least take a few photos to use as reference.

Shadow play ▼
The strong shadows cast on the wall behind the model add drama to this deceptively simple-looking, almost monochromatic portrait by Ian Sidaway.

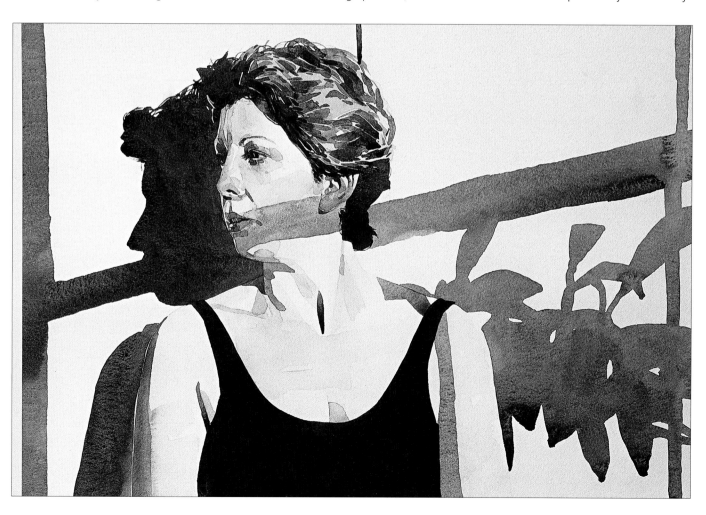

Character and mood

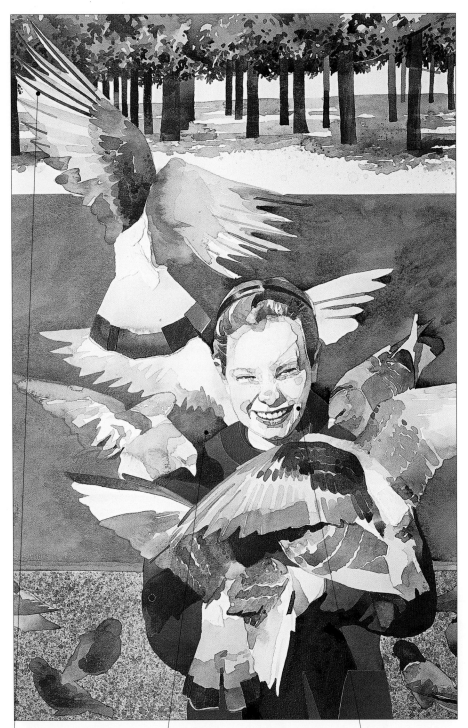

Placing the flapping bird's wings so close to the edge of the frame enhances the sense of movement.

The use of complementary colours – here, red and green – is a good way of imparting a sense of vibrant energy to a painting.

The expression is one of sheer delight.

Exuberance ◄

In this painting by Ian Sidaway, the youthful exuberance of this little girl is evident from both her expression and from the energetic portrayal of the birds' flapping wings as they flutter upwards. The complementary colours – the red of the girl's sweater against the vivid green of the grass – also give the painting a sense of life and energy.

Capturing your subject's character and mood in a portrait involves bringing together many of the topics explored in the previous pages of this section, and is one of the most difficult and most rewarding challenges in portraiture. Individual features vary considerably from one person to another and of course you have to use all your technical skill as an artist to capture a good likeness. But portraiture involves much more than this: a good portrait should also capture something of the sitter's mood and personality. This will give the portrait meaning – for example, you could be making a statement about a particular time of the sitter's life or capturing an achievement or element of their personality that you (or the person commissioning the portrait) particularly admire.

Facial expressions, gestures and stance all play an important part in revealing a person's mood and, like individual facial features, these are things that you can capture through keen observation. Spend as much time as possible talking to your sitter and getting to know their expressions before you mark your paper. Laughter, frowns, open-eyed amazement – the muscle movements required to form these expressions all affect the surface form of the face. If your model is smiling, for example, the cheek muscles will pull the mouth wide; they also push up the lower eyelids, narrowing and sometimes completely closing the eyes. In a frown, on the other hand, the brows are pulled down, covering the upper eyelids and allowing the lower lids to drop. Look, too, at the teeth: generally we see much more of the upper teeth than the lower in a

laughing expression or smile. In daily life we are very adept at detecting even slight muscular movements and reading the thoughts behind the resultant facial expressions. Combine these expressions with gestures – a shrug of the shoulders, upturned palms – and you can tell a lot about somebody's mood and temperament. Translating this into your artwork takes practice and patience but is one of the keys to successful portraiture.

Beyond this, you also need to make a series of aesthetic decisions. Some of these decisions are to do with composition – in other words, where you decide to place your subject in the picture space. In a conventional head-and-shoulders portrait, the figure is normally placed slightly off centre, with more space in front of them than behind; this creates a feeling of calm. If you feel a more confrontational mood is appropriate, however, you might choose a square format and a head-on view of the face, and place the head right in the centre of the picture space. Similarly, a profile view with the sitter's nose very close to the edge of the frame creates tension in the portrait.

You also need to think about what else to include in the portrait. Your choice of background will go some way to determining the mood of the portrait – so do you want a calm, pale background in a single colour or a lively, busy pattern? If you're painting a figure in a room setting, the items that you include can speak volumes about the sitter's interests and personality. Many great artists have taken this further, to include props or decor that are symbolic – think of the heraldic devices often present in portraits of aristocratic figures, for example. Every item included in the picture space is important in some way. While you may not be interested in symbolism, it is worth being selective about the props and background as they will affect the way your portrait is interpreted.

The way you light your subject affects the mood of the portrait. For a romantic portrait of a young girl, you might choose soft, diffused lighting or even position your sitter with window light

Sombre mood ▼

Portraiture involves more than simply achieving a likeness through correct observation of the shapes of noses, eyes and mouths. The best portraits give a feeling of atmosphere and express something of the sitter's character. In Karen Raney's *David* a sense of the sitter's melancholy and introspection is conveyed through the sombre colours of the clothing and background, and heavy, downward-sweeping brushmarks, as well as by the sitter's intense, yet inward-looking, gaze. The sitter seems to make direct eye contact with the observer, which is an important method by which a painting 'draws in' the viewer and encourages them to ask questions about the sitter's mood, the meaning of the painting, and about the feelings the artist wanted to evoke. Unlike the portrait on the opposite page, this painting evokes feelings of discomfort and curiosity.

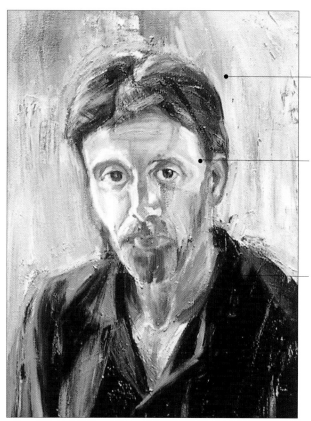

Long, downward-dragging brushstrokes and the cool, muted colour of the background enhance the sense of melancholy.

The subdued expression and the direct, almost challenging, gaze say much about the sitter's mood.

The dark, blue-grey clothing matches the sitter's sombre mood.

coming from directly behind her, so that the colours are muted and detail is subdued. Harsh, strongly directional light can accentuate details such as wrinkles and expression lines in the face, which can work for some dynamic, 'action' or character portraits but may be too unflattering or stark for other subjects.

Finally, there are decisions to be made about your colour palette and the way you apply the paint. You might think that you just paint the colours that you see, but colour can be critical in evoking a mood so choose the spectrum carefully. Bright, hot shades generally create a lively mood, whereas sombre, muted shades give the opposite effect. Pick up on the colours that your sitter is wearing and use them elsewhere in the painting to reflect their mood. Of course, you can change the colours of the clothing to suit the mood of your portrait, if you wish.

Your brush and pencil strokes, too, can affect the atmosphere of the drawing or painting. Lively, vigorous strokes and thick, impasto work can create a feeling of energy, while soft washes, in which the brushstrokes are not really visible, can evoke a mood of calm. Generally, getting to know your sitter's personality will help you to decide the colours, techniques and strokes that will suit your portrait best and create an appropriate mood.

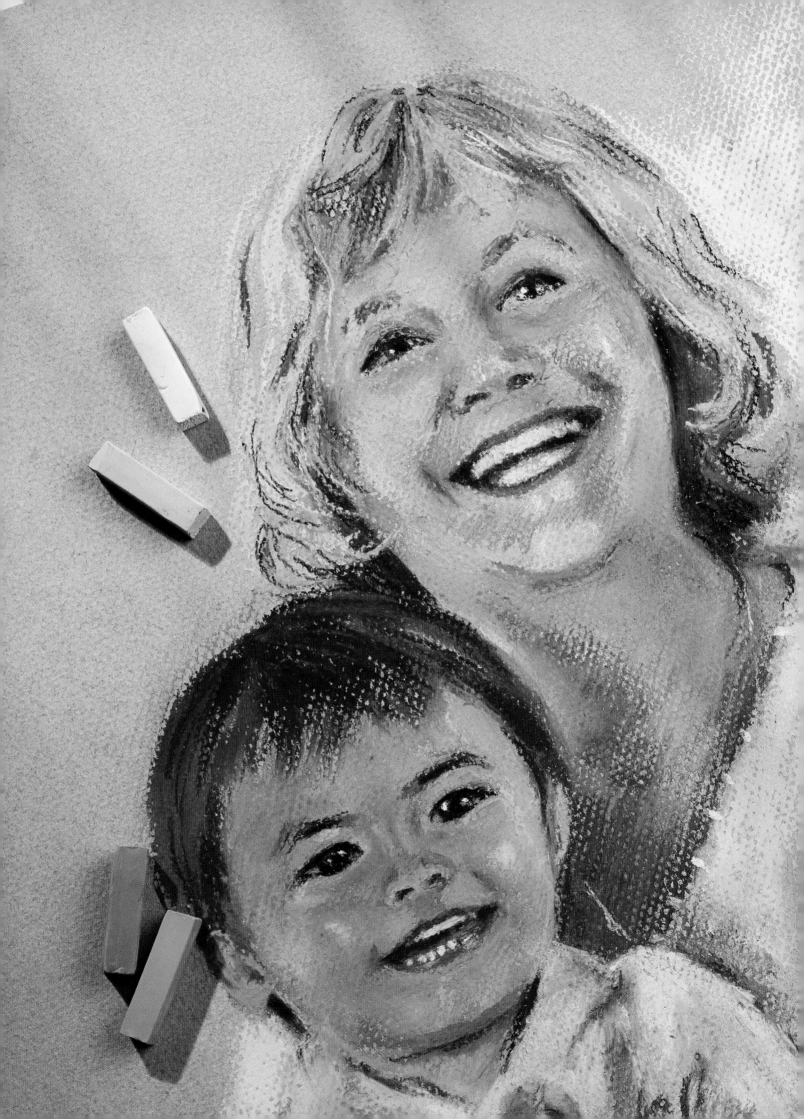

Projects

Portraiture is sometimes perceived as being one of the most difficult subjects for artists. The truth is that, provided you train yourself to look and measure carefully, it's no more difficult than anything else; it's all based on keen observation. This chapter begins with a gallery of portraits by professional artists. You can study these finished works to see how they've tackled a particular subject. Next follows a series of quick sketches, which are great exercises to get you familiar with using the different media. Try and set aside an amount of time each day or as often as you can to study the sketches in this section.

Finally, there are easy-to-follow and detailed step-by-step projects of people of all ages, from a young child to elderly subjects with a lifetime's experience. There are indoor and outdoor portraits, and there are smiling faces as well as more contemplative expressions. Each project lists the materials and equipment you will need so you can copy the project exactly if you wish, but it's even better to use them as a starting point for your own explorations.

Gallery

From self portraits and studies of individuals to groups of two or more people in more complicated settings, this section features portraits in varying styles and media. Study them carefully for ideas and approaches that you can apply in your own work – and don't be tempted to dismiss something simply because it doesn't suit your own personal taste. You can learn as much from things you dislike as from things you enjoy.

Painting in monochrome ▶
In this unusual oil painting, *Self Portrait at 32 Years*, Gerald Cains has ruled out colour altogether, while using highly expressive brushwork. The effect is extraordinarily powerful. It can be a useful discipline to work in monochrome, as it helps you to concentrate on composition and tonal balance without the distraction of colour.

Plain background ▼
Ian Sidaway's initial work on *Lydia and Alice* was made using wet-into-wet washes and the features were then sharpened using wet on dry. Gum arabic was used in many of the mixes. This has the effect not only of intensifying the colour but also of making the washes more transparent. Gum arabic also makes dry paint soluble if it is re-wet, so you can wash off dry paint and make any necessary corrections – a very useful facility when painting portraits. The background is deliberately omitted to focus attention on the sitters.

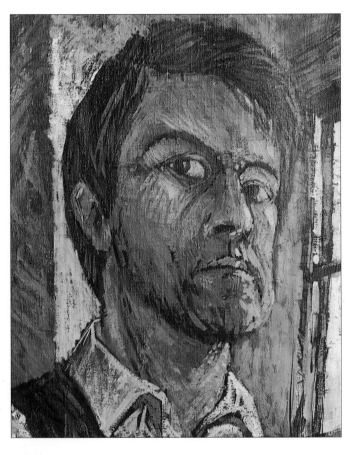

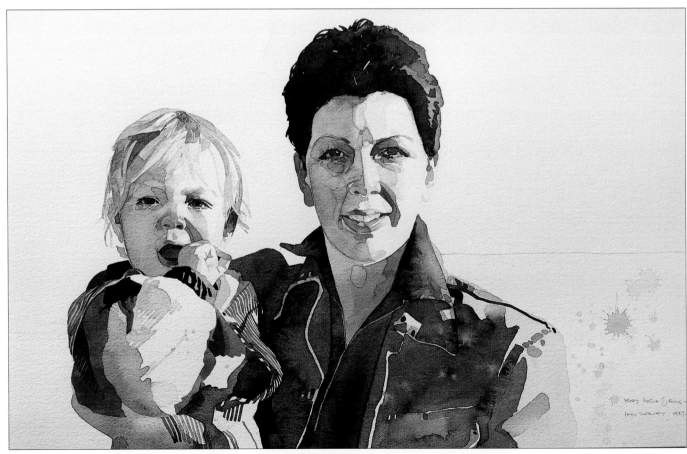

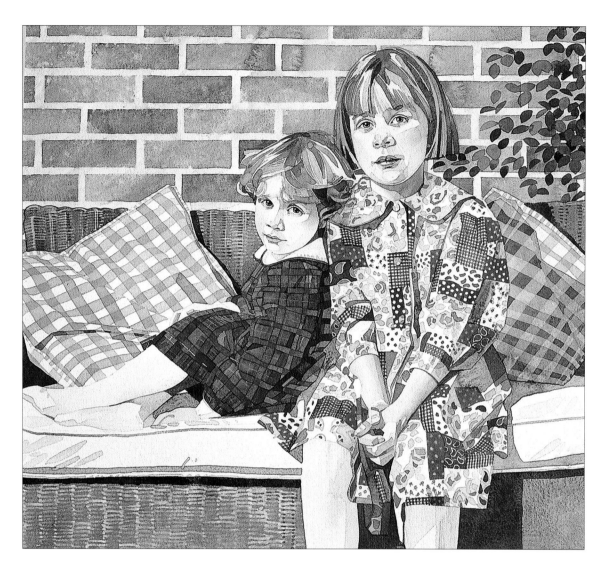

Limited palette ▲

Working over a careful pencil drawing using wet-on-dry washes in *Sisters*, Ian Sidaway achieved harmony by using a limited range of colours. Interestingly, the two girls were painted at different times. The poses were carefully chosen so that the figures could be combined on the support. If you are doing a portrait from a photograph, the background elements can be altered or added to as you work. Alternatively, if you are painting someone in their environment, work on the background and setting at the same time as the figure to avoid the portrait looking as if it has simply been pasted in.

Form through colour ▶

As a general rule, the colours in shadows are cooler – that is, bluer or greener – than those in the highlight areas, and Gerry Baptist has skilfully exploited this warm/cool contrast to give solidity to the head in his acrylic *Self Portrait*. Note, too, how the different planes within the head are painted using simple blocks of colour rather than subtle transitions from one tone to the next – an approach that requires bold, confident brushwork. Although all the colours are quite heightened, they are nevertheless based on the actual colours of flesh, and the picture is successful in its own terms.

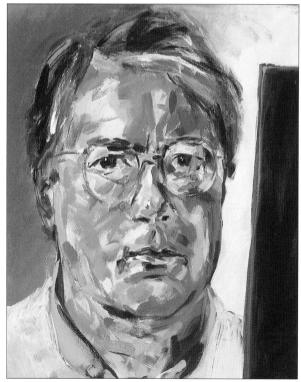

▶

Startling realism ▶

This self portrait by Paul Bartlett
demonstrates the versatility of the
pencil to perfection. Here the effect is
almost photographic in its minute
attention to detail and texture
and its subtle gradations of tone.

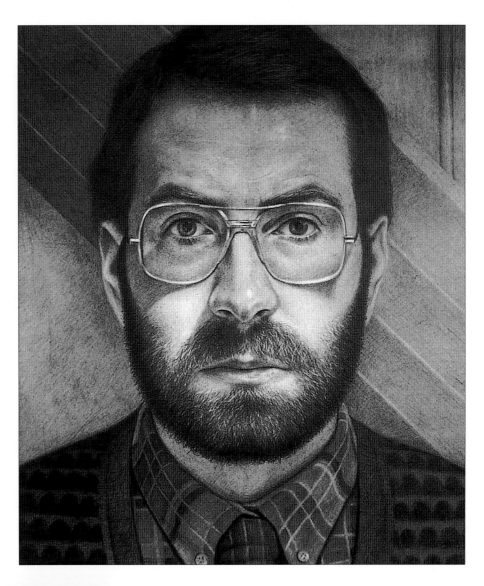

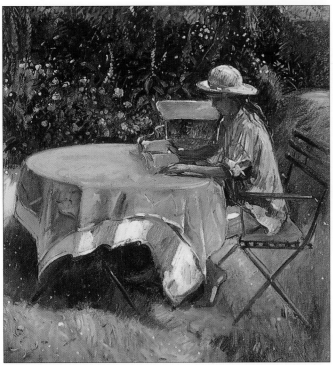

Outdoor setting ◀

Light is an important element in Timothy Easton's *The
Summer Read* and he has described the sitter more by
posture, clothing and general shape than by detailed
depiction of the features. With careful observation you will
find that it is perfectly possible to paint a recognizable
likeness without showing the face at all, just as you often
recognize a familar person from a distance by their posture.
The square format might seem a slightly unusual choice for a
portrait, but here the setting is as important as the sitter, who
occupies only a relatively small proportion of the picture
space. The table and chair virtually fill the entire width of
the picture space, with the flower border providing both
background colour and detail and a visual 'full stop'. The
viewer's eye is led around the image in a circular movement
from the sitter's head, around the table and back again.

Expressive use of watercolour ▶

At first sight, Ken Paine's expressive portrait *Amelia* might well be mistaken for an oil painting, but in fact it is watercolour with the addition of Chinese white. The artist made no initial pencil drawing, but started immediately with a brush and thin paint, gradually increasing the amount of white. The background is reduced to a minimum, very loosely painted, thus concentrating attention on the face.

Figure groups ▼

In landscape painting, a distant figure or group of figures is often introduced as a colour accent or an additional focus for the eye, but where figures form the whole subject, as in Sally Strand's charming *Crab Catch*, it is necessary to find ways of relating them to one another. Like many such compositions, this has an element of storytelling, with the boys sharing a common interest, but the artist has also used clever pictorial devices, notably the shapes and colours of the towel and bucket, to create a strong link between the two figures. The boys' absorbed expressions, and the fact that they are facing one another, also help to direct our attention to the centre of the scene – the contents of the bucket.

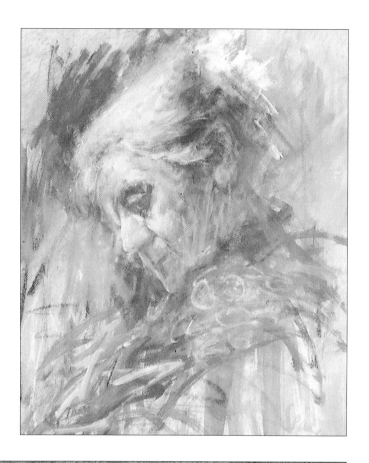

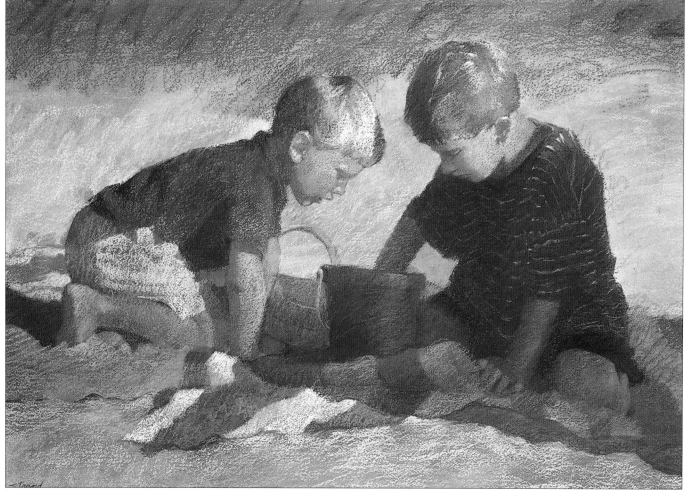

▶

Portrait of a group ▲

Figure groups are not the easiest of subjects to tackle in watercolour, as it is not possible to make extensive corrections, but Trevor Chamberlain's *Still-life Session at the Seed Warehouse* shows that in skilled hands there is nothing the medium cannot do. Each brushstroke has been placed with care and, although the artist has worked largely wet into wet, he has controlled the paint so that it has not spread randomly over the surface. The result it a fresh, lively painting with a wonderfully spontaneous feel. If you're attempting a subject like this, spend as much time as you can observing the scene before you commit brush to paper. Even though it may seem at first glance as though your subjects are continually moving, you'll find that when people are engrossed in an activity like this, they tend to revert to the same positions and postures; once you've recognized the essentials of each individual's 'pose', you'll find it much easier to set them down on paper.

Quick, expressive portrait in ink ▶

Pen and ink can achieve intricate and elaborate effects, but it is also a lovely medium for rapid line drawings. In this figure study *Girl in an Armchair*, Ted Gould has caught the essentials of the pose in a few pen strokes, sometimes superimposing lines where the first drawing was incorrect or where it needed clarifying.

Composing a figure study ▶

In a figure painting you must decide where to place the figure, whether or not to crop part of it, and whether you need to introduce other elements as a balance. Peter Clossick's *Helen Seated* gives the impression of spontaneity because it is so boldly and thickly painted, but it is carefully composed, with the diagonal thrust of the figure balanced by verticals and opposing diagonals in the background.

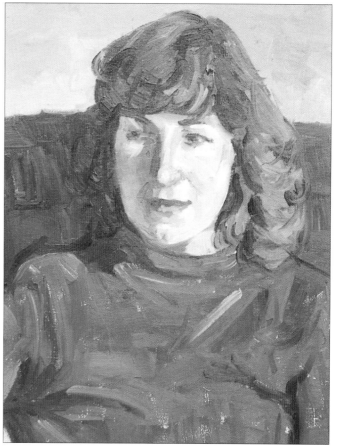

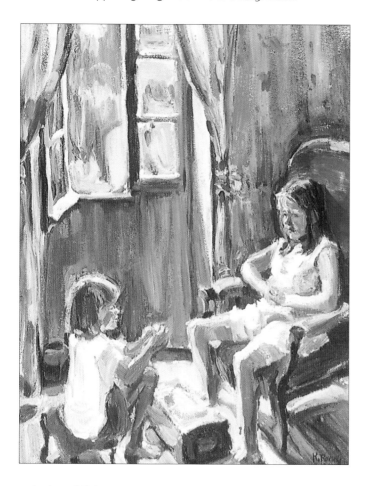

Painting children ▲

Painting an adult engaged in some typical pursuit can enhance your interpretation, but in the case of children it is a question of necessity; they seldom remain still for long, added to which they look stiff and self-conscious when artificially posed. In her delightful, light-suffused study of *Samantha and Alexis* (oil) Karen Raney has worked rapidly to capture a moment of communication between her two young subjects.

Form and brushwork ▶

As the human face and head are complex and difficult to paint, even before you have considered how to achieve a likeness of the sitter, there is a tendency to draw lines with a small brush. This is seldom satisfactory, however, as hard lines can destroy the form. In Ted Gould's *Sue* (oil), the features, although perfectly convincing, are described with the minimum of detail and no use of line, and the face, hair and clothing are built up with broad directional brushwork.

▶

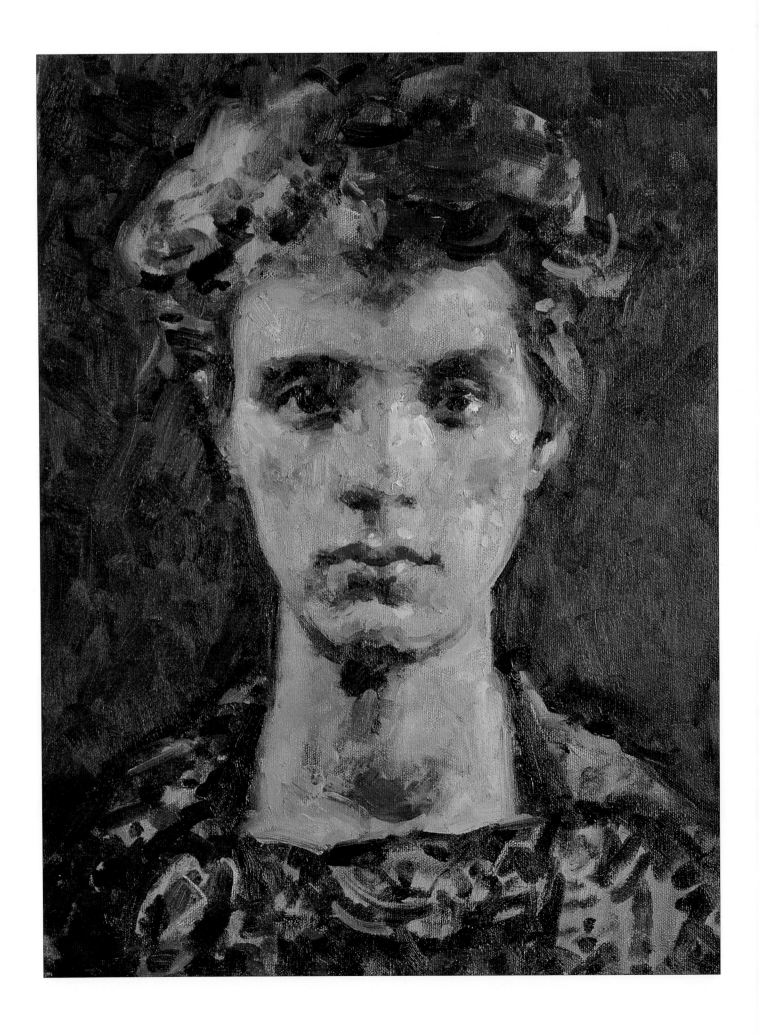

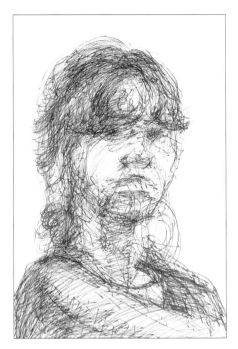

Using the paper colour ▶

In portraiture and figure work it is particularly important to choose the right colour of paper, especially if you intend to leave areas of it uncovered, as in Ken Paine's superb *Young Girl*. The painting is almost monochromatic, with the lights and darks built up from the mid-tone of the brown paper.

Freestyle in pen ▲

A fine fibre-tipped pen has been used for this self-portrait by Hazel Harrison, and the forms have been constructed in a spontaneous way, with the pen moving freely over the paper.

Symmetry ◀

One of the so-called 'rules' of composition is to avoid symmetry, but rules are made to be broken and Elizabeth Moore has deliberately flouted them in this unnamed portrait, to produce an oil painting that almost has the quality of an icon. The central placing of the head on the canvas and the outward gaze impart a sense of strength and dignity to the image.

Building tonal structure ▶

Ken Paine exploits the directness and expressive qualities of pastel in his *Head of a Young Woman*. He works with great rapidity, usually beginning by building up the tonal structure with a monochrome "underpainting" made with broad strokes of short lengths of pastel. Linear definition and bright colour accents are left until the final stages. The coloured paper is still visible in areas.

Quick sketches

The only way to get better at drawing and painting is to practise, so try to get into the habit of sketching every day. All you need is a small notebook and a pen or pencil. Carry them around with you wherever you go and do a bit of 'people watching' when you've got a few minutes to spare – on the train or bus to work, in a café during your lunch break, even when you're waiting to collect the kids from school.

Before you embark on really detailed portraits, start by practising getting the features in the right places. Draw heads from different angles so that you get used to how the relative positions of the features change when the head is tilted.

Sketch profiles as well as faces viewed from directly in front and look at where the nose breaks the line of the cheek and at how much of the eye on the far side of the face is visible. Look for different planes within the head and face. Ask friends or family members to pose for you so that you get used to drawing lots of different people. You'll be amazed at how quickly your powers of observation improve.

In the sketches shown on these two pages, the construction lines have been exaggerated so that they show up more clearly. In your own sketches, use very light lines and marks. You can cover or erase these as your artwork develops.

Soft pastel, 15 minutes ▷
The central axis of the face runs down through the nose, but because the sitter's head is turned slightly to one side, we can see more on one side of this line than on the other. The features are contained within an inverted triangle that runs from the outer corners of the eyes to the centre of the lips (the philtrum), while the centre of the eye is in line with the outer corner of the mouth.

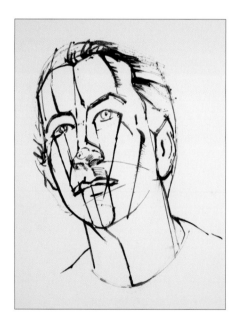

Dip pen and ink, 15 minutes ▲
As ink is indelible and virtually impossible to cover up if you make a mistake, the artist began by putting in tiny dots to mark the outer corners of the eyes and mouth and the nostrils. Note how large the area between the nose and chin appears in relation to the head as a whole when the head is tilted upwards like this.

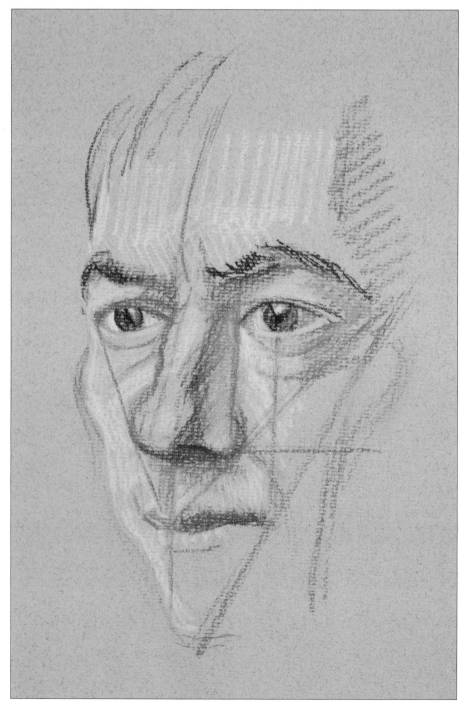

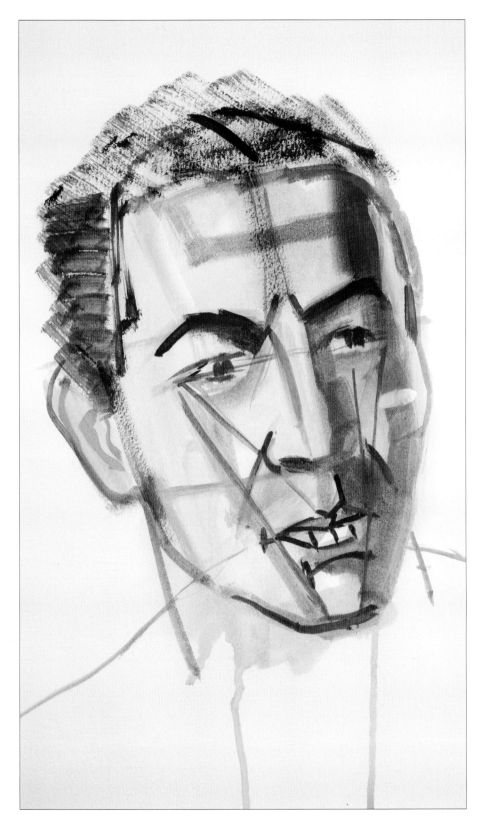

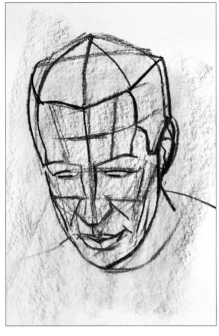

Charcoal, 10 minutes ▲

In this sketch the artist began by wiping the side of a stick of charcoal over the paper to create a broad area of tone, which he then softened by gently wiping with a paper tissue. On top of the basic 'egg' shape of the head, he has indicated the major planes of the face and cranium, as well as the hairline. Although this is intended as nothing more than an exercise in observation, making sketches like this is a good way of training yourself to look for the different planes of the head. Gradually, you'll find that you can use tone, rather than line, to express the transition from one plane to the next.

Acrylic, 15 minutes ▲

Here the artist roughly blocked in the shape of the face in yellow ochre paint to approximate to the skin tones, before adding the construction lines in a darker tone. Note how he established the underlying shape of the cranium before roughly scumbling on colour for the hair. He has also roughly marked in the major planes of the forehead and the side of the face, and applied a slightly darker tone to the shaded side of the sitter's face to create some sense of modelling.

▶

Make quick sketches – say 15 to 30 minutes – to train your eye to see subtle differences in tone in people's faces as the different planes turn towards or away from the light source. Look to see where the deepest shadows and the brightest highlights fall, and then try to assess the mid tones in between. Remember that there are many minor planes within the face and head, as well as major planes such as the sides of the nose. These minor planes – high or recessed cheekbones, furrows in the brow – are often what help you to capture the individuality of your sitter.

The way that you convey tone depends, of course, on the medium in which you're working. In pencil or pen and ink, you can use hatching or cross-hatching, making your hatching lines close together for dark tones and spacing them further apart for lighter tones. In charcoal and soft pastel you can create a broad area of tone by using the side of the stick, pressing hard for a very dark tone and applying less pressure for lighter areas – and of course in both these media you can wipe off pigment with a soft tissue or torchon to create lighter tones.

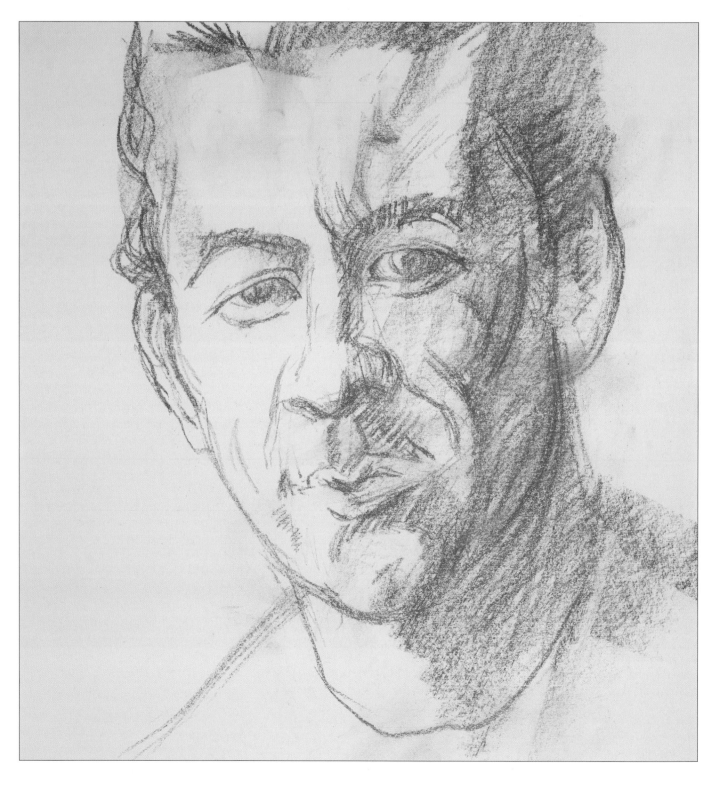

In watercolour, you can build up tones gradually, applying several layers of paint until you get the effect you want. In oils and acrylics, depending on the texture you want to create, you can either scumble the paint on quite roughly or apply it as a thin wash.

Remember that the colour of the support can play an important role, too. When working in soft pastels, artists often choose a coloured paper, while in oil and acrylic portraits it is accepted practice to tone the ground before you begin to paint. Select a colour that approximates to the mid tones in your subject, so that you can allow the colour of the ground to show through in the portrait. In watercolour sketches and drawings, you can allow the white of the paper to stand for the very brightest highlights. Letting the paper work for you in this way both speeds up the process and gives a feeling of spontaneity and light to your work.

Conté stick, 20 minutes ◄

Here, the sitter was lit very strongly from one side. On this side of the face, a few faint mid-tone lines convey the creases in the skin around the mouth and nose. On the shaded side of the face the artist created mid and dark tones in two ways: he hatched in small, precise areas such as the nose using the tip and the sharp edge of the square Conté stick and blocked in broad areas on the side of the face and neck with the side of the stick.

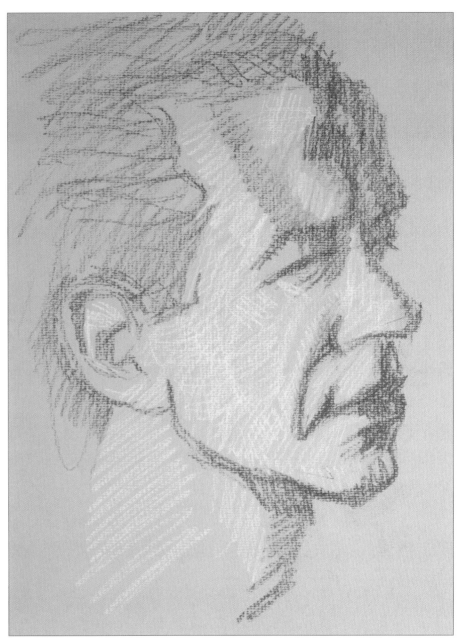

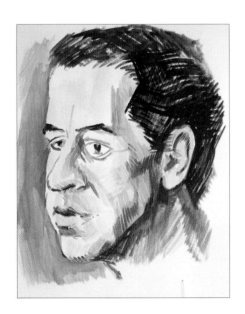

Acrylics, 15 minutes ◄

Using just two or three colours, the artist has created a wide range of tones. The white paper stands for the brightest highlights, while the lighter mid tones of the skin are a wash of yellow ochre. The mid and dark tones are varying dilutions of burnt umber, applied as a thin wash in some places and scumbled on more thickly and vigorously in the deep shadows on the side of the face and neck. Applying the paint with a flat brush has created a wide range of marks, from fine lines made by holding the brush almost vertically and using the tip, to broad areas of wash, as on the forehead.

Pastel pencil, 10–15 minutes ▲

In this sketch the buff-coloured pastel paper stands for the mid tones, with white pencil hatching being used for the highlights on the side of the face and neck and purple hatching for the shadows. Note how the density of the hatching varies depending on the depth of tone required, with lines drawn close together in the darkest areas (on the far side of the face and under the nose, for example) and spaced more widely in the hair.

The eyes, step by step

Before you embark on full-scale portraits, why not try making some small, quick sketches of individual features such as the eyes or mouth? Homing in on details like this is a great way of sharpening your powers of observation as it forces you to look really hard at shapes and tones. There are lots of undulations across the surface of the face that reveal the shape of the skull beneath and, whatever medium you work in, it's vital that you vary your flesh tones in order to convey these changes in surface form.

Structures such as the eyes and ears are particularly intricate and contain lots of tiny highlight and shadow areas that you need to render with great care. In addition to light and dark tones, remember to use both warm and cool mixes. Warm colours appear to advance, while cool ones recede – and you can exploit this fact to make prominent features such as the nose come forward in the painting.

This demonstration was made in watercolour, which, because of its natural translucency, is a lovely medium for painting the reflective, liquid surface of the eye. Take care not to lose the white of the paper, as this is the lightest tone. The painting took about 45 minutes to complete.

Materials
- *Rough watercolour paper*
- *Watercolour paints: yellow ochre, alizarin crimson, ultramarine blue, burnt umber, cadmium red, cerulean blue*
- *Brushes: Fine round, large flat*
- *Kitchen paper*

The pose
A three-quarter profile was chosen for this sketch, as both eyes are visible and it gives you the chance to explore the way the eyes relate to the nose. Note how, from this angle, the bridge of the nose partially obscures the far eye.

1 Lightly brush the area of paper that you are going to use with clean water so that you can work wet into wet, without creating any hard-edged marks in the early stages. Establish the axis of the eyes and, using a fine brush, dot in the outer corners of the eyes to mark their position. Using a pale mix of yellow ochre and alizarin crimson, outline the almond shape of the eyes, the eyebrows and the line of the nose.

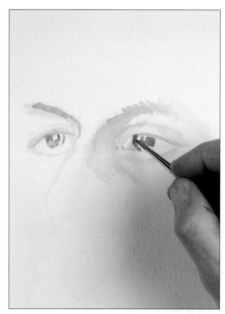

2 Using a grey mix of yellow ochre and ultramarine and short, spiky brush marks, paint in the eyebrows. Using a stronger version of the yellow ochre and alizarin mix, strengthen the line of the upper lids. Add a little ultramarine to the mix and, working wet into wet, put in the deep, recessed shadow around the inner corner of the near eye. Paint the irises using both burnt umber and ultramarine blue as appropriate, remembering to leave the white of the paper for the highlights.

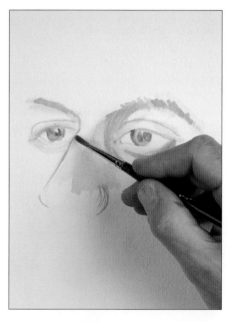

3 Using a very dilute mix of cadmium red, paint the lower lids, leaving the edges white where they catch the light. Paint the dark shadows under and around the inner edge of the near eye in the yellow ochre and alizarin crimson mix. Mix a warm orangey red from yellow ochre and cadmium red and apply it over the upper edge of the upper lids. Use the same colour for the line of the nose.

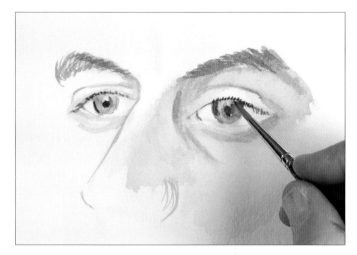

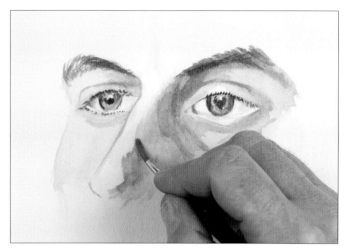

4 Brush the pale cadmium red and yellow ochre mix over the rounded socket of the near eye. Brush clean water over the cheek under the near eye, then drop the pale cadmium red and yellow ochre mix into it, wet into wet. Darken the yellow ochre and alizarin mix by adding ultramarine blue, then paint the line of the eyelashes, using short, spiky brush marks and dots. Use the same colour in the eyebrows.

5 For the shadow in the white of the eye, use a very pale cerulean blue. Dab it off almost immediately with kitchen paper so that there's only a tiny hint of colour. Apply a warm mix of yellow ochre and a little cadmium red to the far cheek, using a slightly darker version of the mix just under the eye. Using the yellow ochre, alizarin crimson and ultramarine mix from Step 2, model the shaded side of the nose, leaving the bridge of the nose (which is in the light) untouched.

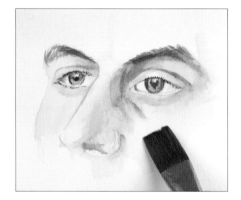

6 Put in the nostrils with a deep cadmium red. Using a large flat brush, wash the yellow ochre and cadmium red mix over the near cheek and the warm areas on the side of the nose, modulating the blue mix applied in Step 5 and remembering to leave the highlights white.

The finished sketch
This sketch clearly shows the eyeballs as spherical forms in deep, recessed sockets. Note how much larger the sitter's left eye is than his right; although we tend to assume that both eyes are the same size and shape, they are often asymmetrical. Allowing the white of the paper to stand for the brightest highlights gives this little study real life and sparkle.

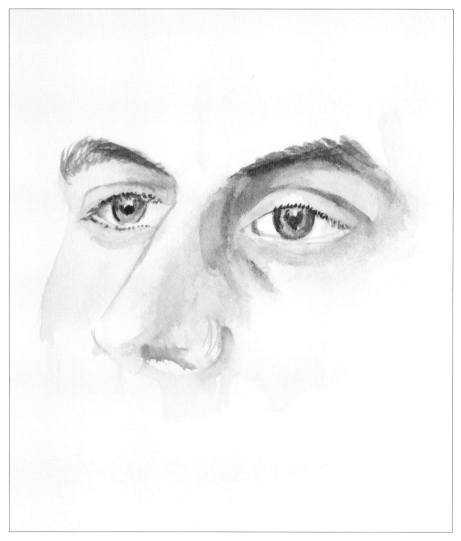

The ear, step by step

Just like any other human feature, ears can vary considerably from one person to another. Some people have long earlobes, while others have short ones. Some people have ears that stick out while others have ears that lie flat, close to the skull. The basic structure is the same in everyone, however – an outer and an inner fold, known respectively as the helix and antihelix, which lead around in a curve to the central cavity, or concha. Once you're aware of this structure, you're aware of what to look for. As always, it's the contrast between light and dark tones, and warm and cool colours, that gives a sense of form to drawings and paintings of the ear. Look to see where light catches the bony cartilage of the helix and antihelix and at where darker tones indicate the recessed concha, or central cavity.

This demonstration was done in acrylic paint, which looks slightly darker when it is dry than when it is wet – so always wait until the paint is dry before

deciding if you need to adjust the tones. Because acrylic paint is opaque, you can put down dark tones first and then paint highlights on top if you wish, in the same way that you can apply oil

paints or oil pastels. If you were to attempt the same sketch in watercolour, you would have to work from light to dark instead. This sketch took about 45 minutes to complete.

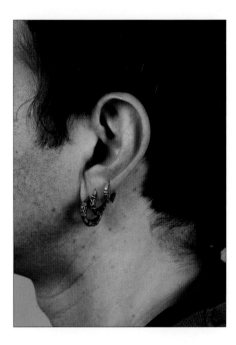

Materials
- *Paper*
- *Acrylic paints: yellow ochre, white, brown oxide, alizarin crimson, cadmium red, vermilion, lemon yellow*
- *Brushes: medium filbert, fine filbert*
- *Stay-wet acrylic palette*

The pose
In this profile view you can clearly see the structure of the ear – the outer fold, or helix, which runs around the outer edge and into the central cavity known as the concha, the antihelix (the inner fold) and the fossa (the 'ditch' or groove between the helix and antihelix).

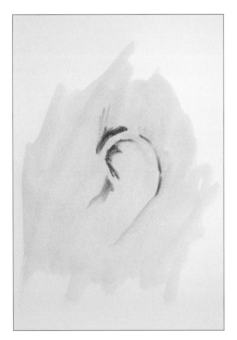

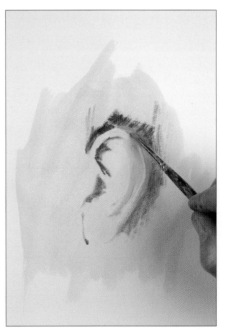

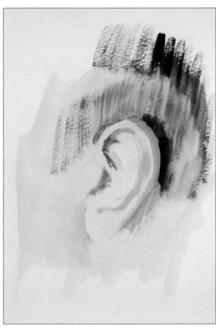

1 Mix yellow ochre and white to form a basic flesh tone and, using a medium filbert brush, scumble it on to the support. Using a fine filbert brush and brown oxide acrylic paint, map in the dark tones on the inside of the ear, looking at the shapes of the shadows in the recesses of the ear.

2 Using a cool purple mix of white, brown oxide and alizarin crimson, put in the curves of the helix and antihelix. Use brown oxide to establish the curve of the outer ear.

3 Add a little ultramarine to the brown oxide and, using vigorous vertical brushstrokes, begin putting in the hair around the ear. Using the same mix, fill in the cool shadows inside the ear; already you are beginning to develop a good sense of the three-dimensional structure.

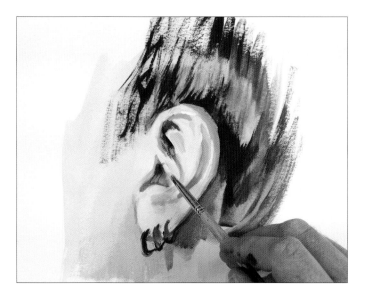

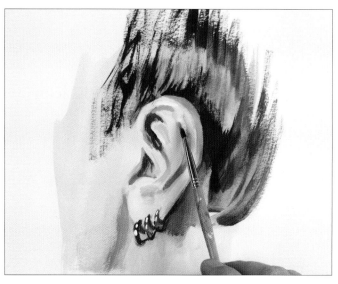

4 Build up texture in the hair, using brown oxide for the darkest parts and the ultramarine and brown oxide mix for the cooler shadows. 'Draw' the earrings in ultramarine blue. Using varying mixes of brown oxide, alizarin crimson and yellow ochre, put in the flesh tones and adjust the tones inside the ear, adding more alizarin for the area under the ear.

5 Using the same cool purple mix that you used inside the ear, put in the shadow around the jawline. Use pure white to paint the tiny highlights on the earrings and on the inside of the ear.

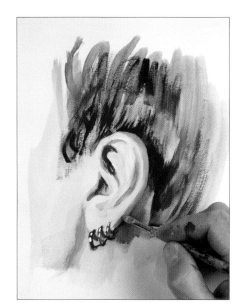

6 Soften any shadow areas that are too deep, and scumble more colour into the hair, making sure that your brushstrokes follow the direction of the hair growth.

The finished sketch
The contrast between light and dark tones and warm and cool colours has created a strong, three-dimensional sketch. Note, too, how the ear casts shadows on the hair and the nape of the neck, indicating that it does not lie flat against the skull.

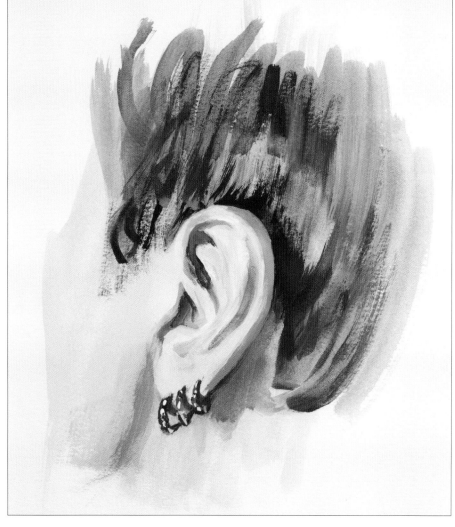

The hands, step by step

Hands can be such an expressive part of a portrait that it is well worth devoting lots of time to practising drawing them. The sketch on these two pages took just under an hour to complete and the artist spent as much time measuring and checking as he did drawing.

Hands are quite complicated forms and beginners are often very nervous of even attempting them, but the trick is to start by searching out the overall shape instead of laboriously drawing each finger in turn. When two hands are linked together, as in this sketch, it is often better to think of them as a single form rather than two separate shapes.

When you start putting in details such as creases and wrinkles in the skin, decide which ones are most important structurally and aim for a general impression rather than slavishly copying every single line. If you put in too much of this superficial detail, it can easily

detract from the overall shape and structure and dominate the sketch, thus destroying the three-dimensional illusion that you've built up.

Finally – although it sounds obvious – make sure you put in the right number of fingers and that each finger has the correct number of joints!

Materials
- *Good-quality drawing paper*
- *Red Conté stick*

The pose
Here we see each hand from a different angle. The sitter's left hand is angled away from us and is therefore slightly foreshortened: the back of this hand looks a lot shorter than the fingers. Note how the shapes of the fingernails appear to change depending on whether they are angled towards or away from our view.

1 Using a red Conté stick, put in faint guidelines to establish the outer limits of the composition. Try to think of the hands as a single unit and start by establishing where the different planes lie. Carefully measure the individual fingers and look at where each one sits in relation to its neighbour.

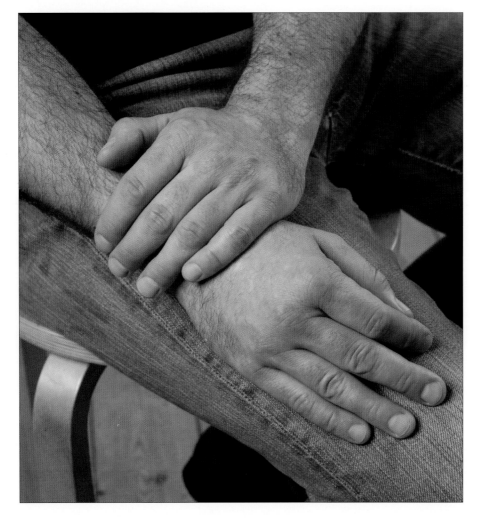

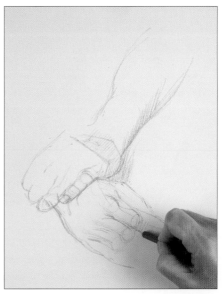

2 Using light hatching, put in some of the shadow on the underside of the sitter's left arm and wrist. (At this stage, the shading is intended mainly to indicate the planes of the arms, so don't do too much detail.) Begin to delineate the individual fingers, using a light, circular motion around the joints to imply their rounded form.

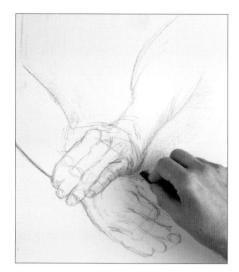

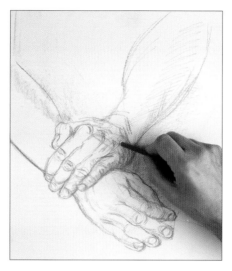

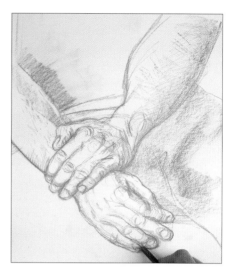

3 Continue delineating the fingers, observing carefully the shapes of the individual fingernails and where the joints occur. You can also begin putting in some of the more important creases and wrinkles in the fingers. Then put in the shadows on the little finger of the left hand. Using the side of the Conté stick, lightly block in the background.

4 Continue working on the linear detail and the shading on the back of the hand and fingers, using the tip of the Conté stick. (Note how much difference in tone there is.) Try to keep the whole drawing moving along at the same pace, rather than concentrating on one area at the expense of the rest.

5 Adjust the tones as necessary over the drawing as a whole, using the side of the stick to block in large, dark areas such as the jeans and the tip for crisp, sharp detailing.

 Tip: Use the negative shape of the background – in this case, the sitter's denim jeans – to help establish the shape of the arms and hands. You may well find it easier to put in the negative shape of the background first than to outline the positive shape itself – particularly in very small areas, such as the gaps between the fingers.

The finished sketch

In this sketch the artist has used a combination of sharp, linear detailing (in the fingers and hatched shadows) and broad, sweeping areas of mid and dark tone, allowing the white of the paper to stand for the brightest highlights. He has included just enough of the background to provide a context for the sketch and make it clear that the sitter's hands are resting, with relaxed muscles, on a solid surface.

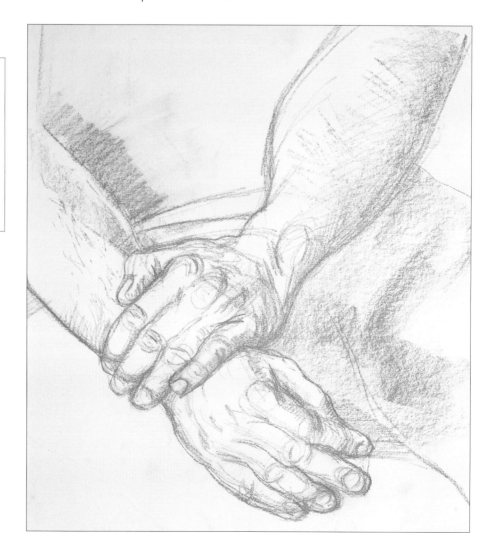

Head-and-shoulders portrait in watercolour

Painting a portrait from life for the first time can be a daunting prospect. Not only do you have the technical aspects to deal with, but you are working with a live model, who will almost certainly fidget and demand to see what you are doing. Before you embark on your first portrait session, practise drawing and painting from photographs to build up your skills and confidence.

This project is done in watercolour, which is the medium of choice for a great number of leisure painters. It is a wonderful medium for painting skin tones, as you can gradually build up layers of soft washes, allowing the paint to merge wet into wet to create soft-edged transitions from one tone to another. Put a lot of care into your underdrawing. If you can get the facial features in the right place and know where the main areas of light and shade are going to be, then you are well on the way to success.

Finally, don't try to do too much. Details like clothing are relatively unimportant in a head-and-shoulders portrait. Instead, try to capture your subject's mood and personality by concentrating on the eyes and expression.

The pose

If you are new to portraiture or to painting with a model rather than from a photograph, a simple pose, with the model looking directly at you, is probably the best way to begin. The eyes are the key to a good portrait, and this pose shows a strong, direct gaze that attracts the attention.

Place a strong light to one side of the model, as it will cast an obvious shadow on the back wall and make it easier for you to assess areas of light and shade on the face, which will assist you with your modelling work. Most importantly, make sure your model is seated comfortably, with good support for her back and arms, as she will have to hold the same pose for some time. You may find it helpful to take photographs for reference so that you can work from these once the model has left.

Select a plain background that does not draw attention away from your subject. You can rig up plain drapes behind the model to achieve this, and choose colours that suit the mood of the portrait or complement the model's skin or hair colour.

Materials

- HB pencil
- 300gsm (140lb) HP watercolour paper, pre-stretched
- Watercolour paints: light red, yellow ochre, alizarin crimson, sap green, sepia tone, neutral tint, ultramarine blue, ultramarine violet, cobalt blue, burnt umber, cadmium orange, cadmium red
- Brushes: large round, medium round, fine round

Tips:
- From time to time, look at your drawing in a mirror. This often makes it easier to assess if you have got the proportions and position of the features right. Also hold your drawing board at arm's length, with the drawing vertical, to check the perspective. When you work with the drawing board flat, the perspective sometimes becomes distorted.
- Over the course of a portrait session, you will probably find that your model will drift off into a daydream, and the eyelids and facial muscles droop, creating a bored, sullen-looking expression. If this happens, ask your sitter to redirect his or her gaze towards you (ideally without moving the head!); this immediately resolves the problem.

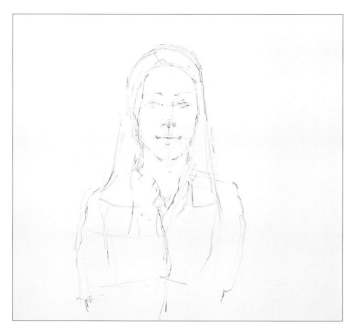

1 Using an HB pencil, lightly sketch your subject, putting in faint construction lines as a guide to help you check that the features are accurately positioned.

Resist the temptation to start the face by drawing an outline. If you do this, the chances are that you will find you haven't allowed yourself enough space for the features. Start by working out the relative sizes and positions of the features and then worry about the outline overall.

It is always a good idea to put in faint pencil guidelines – a line down through the central axis of the face and lines across to mark the positions of the eyes, nose and mouth. As a general rule, the eyes are level with the ear tips and approximately halfway down the face. The nose is roughly halfway between the eyes and the base of the chin. The mouth is usually less than halfway between the nose and chin. The sitter in this portrait appears at first glance to have a very symmetrical face, but be aware that most faces are not exactly symmetrical and look carefully at the differences between the left and right side.

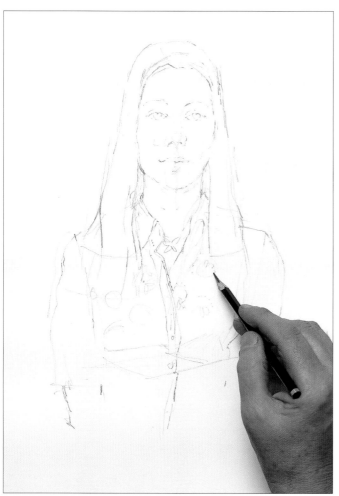

2 Begin to put in some indication of the pattern in the model's blouse. You do not need to make it detailed.

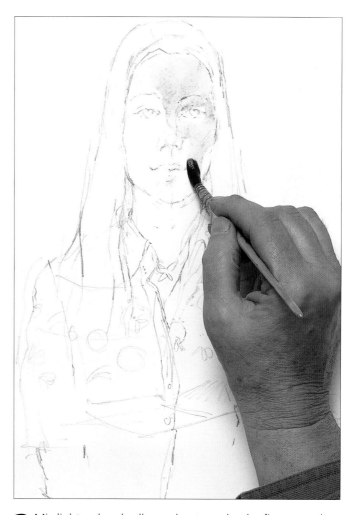

3 Mix light red and yellow ochre to make the first warm but pale flesh tone. Using a medium round brush, wash this mixture over the face, neck and forearms, avoiding the eyes and leaving a few gaps for highlights. This is just the base colour for the flesh. It will look a little strange at this stage, but you will add more tones and colours later on.

▶

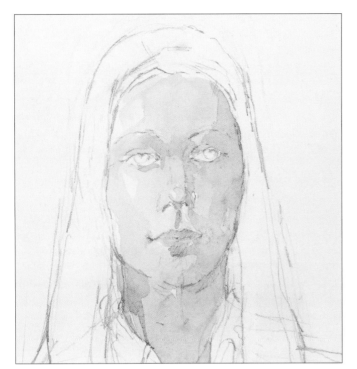

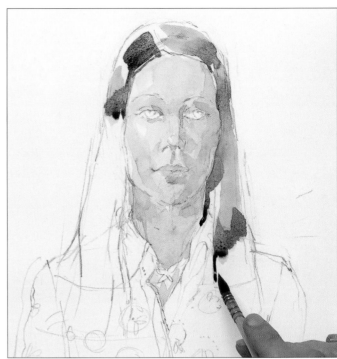

4 You have to work quickly at this stage to avoid the wash drying and forming hard edges. While the first wash is still damp, add more pigment and a little alizarin crimson to the first skin tone and paint the shadowed side of the face to give some modelling. Add more alizarin crimson to the mixture and paint the lips. Leave to dry.

5 Touch a little very dilute alizarin crimson on to the cheeks and some very pale sap green into the dark, shaded side of the face. Mix a warm, rich brown from sepia tone and neutral tint and start to paint the hair, leaving some highlight areas and the parting line on the top of the head completely free of paint.

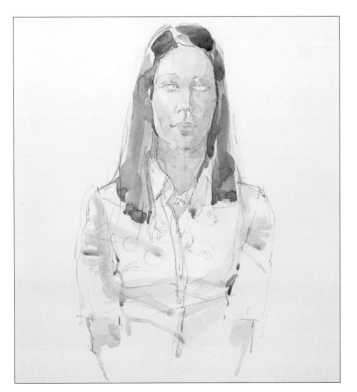

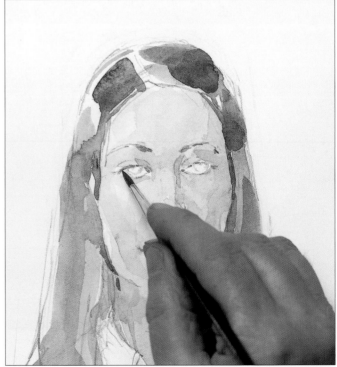

6 Mix a very pale blue from ultramarine blue and a hint of ultramarine violet. See where the fabric in the blouse creases, causing shadows. Using a fine round brush, paint these creases in the pale blue mixture.

7 Go back to the hair colour mixture used in Step 5 and put a second layer of colour on the darker areas of hair. Paint the eyebrows and carefully outline the eyes in the same dark brown mixture.

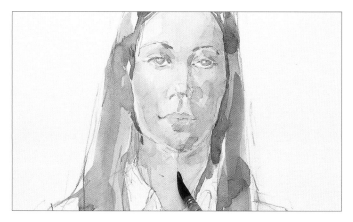

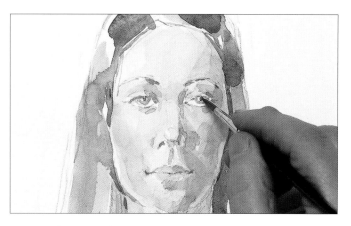

8 Mix a very light green from yellow ochre with a little sap green and, using a fine round brush, paint in the irises, leaving a white space for the highlight where light is reflected in the eye. Strengthen the shadows on the side of the face and neck with a pale mixture of light red and a little sap green.

9 Use the same shadow colour to paint along the edge of the nose. This helps to separate the nose from the cheeks and make it look three-dimensional. Mix ultramarine violet with sepia tone and paint the pupils of the eyes, taking care not to go over on to the whites.

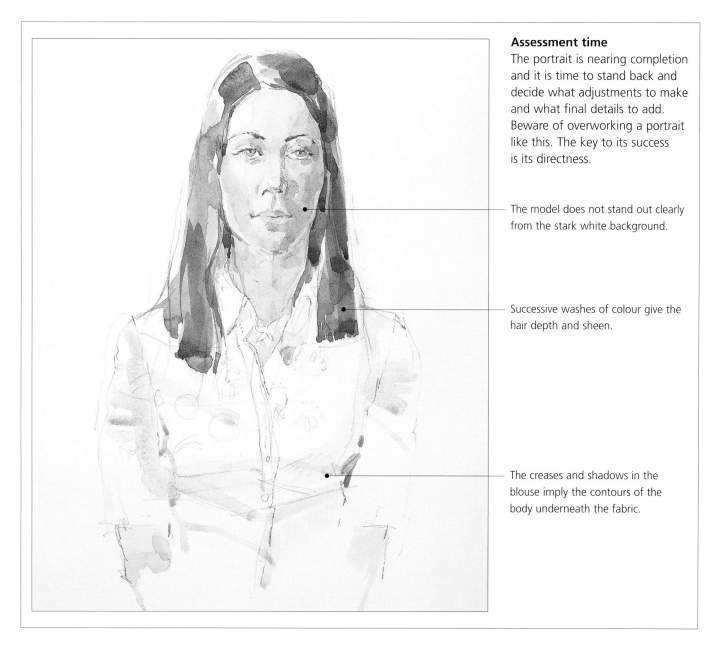

Assessment time
The portrait is nearing completion and it is time to stand back and decide what adjustments to make and what final details to add. Beware of overworking a portrait like this. The key to its success is its directness.

The model does not stand out clearly from the stark white background.

Successive washes of colour give the hair depth and sheen.

The creases and shadows in the blouse imply the contours of the body underneath the fabric.

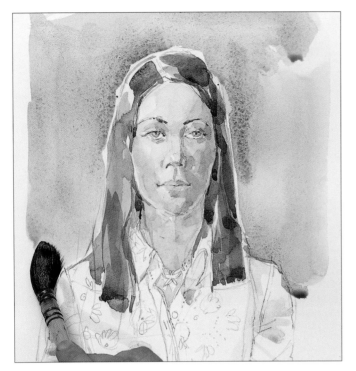

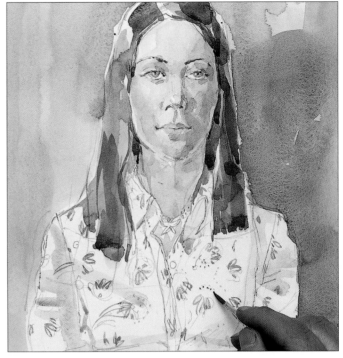

10 Mix a dark green from sap green, cobalt blue and burnt umber. Using a large round brush, carefully wash this mixture over the background, taking care not to allow any of the paint to spill over on to the figure. (You may find it easier to switch to a smaller brush to cut in around the figure.)

11 While the background wash is still damp, add a little more pigment to the green mixture and brush in the shadow of the girl's head. Mix an orangey-red from cadmium orange and cadmium red and, using a fine round brush, start putting in some of the detail on the girl's blouse.

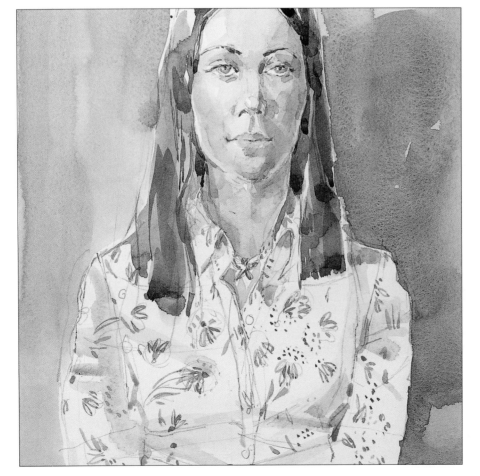

12 Continue building up some indication of the pattern on the girl's blouse, using the orangey-red mixture from Step 11, along with ultramarine blue and sap green.

Tip: Don't try to replicate the pattern exactly: it will take far too long and will change the emphasis of the painting from the girl's face to her clothing. A general indication of the pattern and colours is sufficient. The face should always be the most noticeable part of any portrait.

The finished painting

This is a sensitive, yet loosely painted portrait that captures the model's features and mood perfectly. It succeeds largely because its main focus, and the most detailed brushwork, is on the girl's eyes and pensive expression. Careful attention to the shadow areas has helped to give shape to the face and separate the model from the plain-coloured background.

Although the hair is loosely painted, the tonal variations within it create a sense of volume.

The detailed painting of the eyes and mouth helps to reveal the model's mood and character.

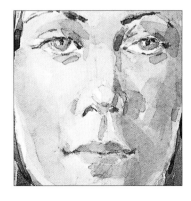

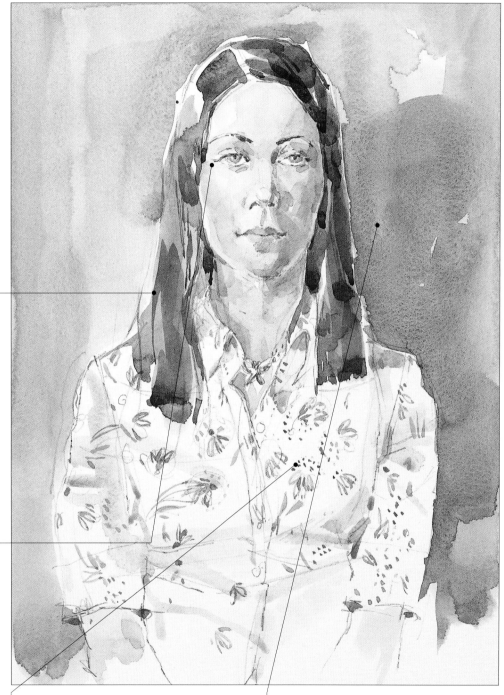

In reality, the pattern on the blouse is much more detailed than this, but a more accurate rendition would have drawn attention away from the girl's face.

The shadow on the wall helps to separate the model from the background and gives the image more depth.

Head-and-shoulders portrait in acrylics

The surroundings and the clothing in this head-and-shoulders portrait have been kept deliberately simple in order to give you an opportunity to practise painting skin tones.

You might think it would make life very simple for artists if there was a ready-mixed skin colour that could be used in all circumstances. However, although you may come across a so-called 'flesh tone' in some paint manufacturers' catalogues, it cannot cope with the sheer variety of skin tones that you are actually likely to encounter.

Even in models with the most flawless of complexions, the skin will not be a uniform colour in all areas. The actual colour (particularly in fair-skinned individuals) can vary dramatically from one part of the subject to another: the cheeks, for example, often look redder than the forehead or chin simply because the blood vessels are closer to the surface. And, just as with any other subject, you need to use different tones to make your subject look three-dimensional. To understand this, look at black-and-white magazine photographs of models

with good bone structure: note how the cheekbones cast a shadow on the lower face. Even though (thanks to make-up) the skin colour may be virtually the same all over the face, in strong light there may be differences in tone.

You also need to think about colour temperature: using cool colours for the shadows and warmer ones for the lit areas is a good way of showing how the light falls on your model. Although cool blues and purples might seem strange colours to use for painting skin, it is surprising how using them with warmer colours can bring a portrait to life.

The same principles of colour temperature also apply to the light that illuminates your subject. Although we are generally unaware of the differences, the colour of sunlight is not as warm as, say, artificial tungsten lighting. It's hard to be precise about the colours you should use for painting skin tones, as the permutations are almost infinite, so the best advice is simply to paint what you can actually observe rather than what you think is the right colour.

Materials
- *Board primed with acrylic gesso*
- *B pencil*
- *Acrylic paints: Turner's yellow, cadmium red, titanium white, burnt umber, cadmium yellow, lamp black, phthalocyanine blue, alizarin crimson, yellow ochre*
- *Brushes: large flat, medium flat, small flat*

The pose
A three-quarters pose with the light coming from one side, as here, is generally more interesting to paint than a head-on pose, as it allows you to have one side of the face in shadow, thus creating modelling on the facial features. It also means that the sitter can look directly at you, which generally makes for a more dramatic portrait. The lighting also creates highlights in the model's dark eyes, which always helps to bring a portrait to life. Although this model was sitting in front of a very busy background, the artist chose to simplify it to a uniform background colour in the finished portrait to avoid drawing attention away from the face. He also placed more space on the side of the picture space towards which the model is facing: it is generally accepted that this balance of composition creates a more comfortable, and less confrontational, portrait.

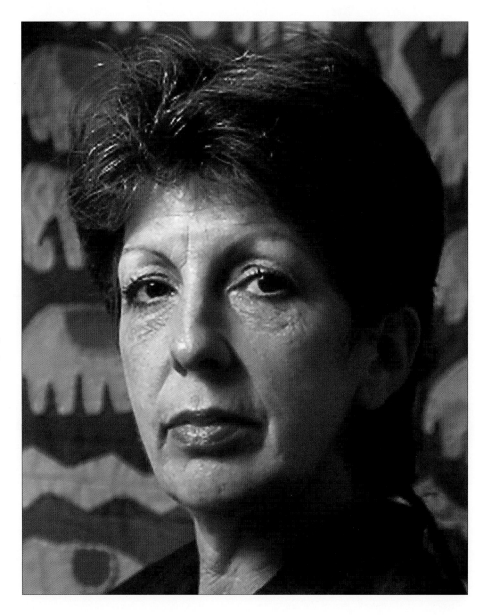

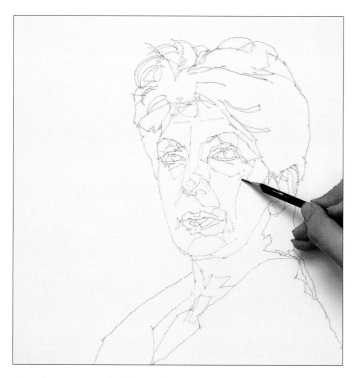

1 Using a B pencil, lightly sketch your subject, indicating the fall of the hair, the facial features and the areas of shadow. Put in as much detail as you wish; it is particularly important to get the size and position of the facial features right.

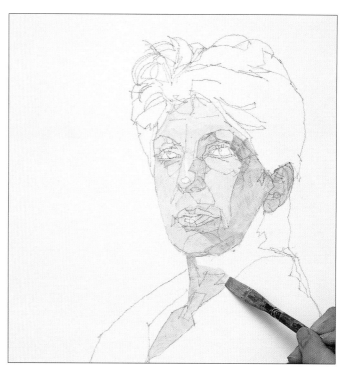

2 Mix a light flesh tone from Turner's yellow, cadmium red and titanium white. Using a medium flat brush, block in the face and neck, adding a little burnt umber for the shadowed side of the face.

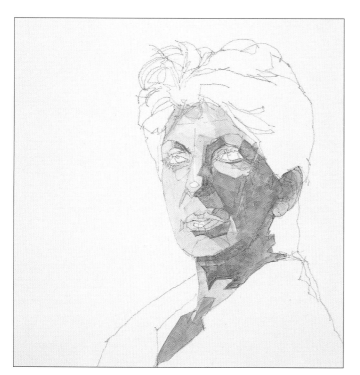

3 Add a little more cadmium red to the flesh-tone mixture and use it to darken the tones on the shadowed side of the face, under the chin and on the neck. Mix a red-biased orangey mix from cadmium red and cadmium yellow and paint the cheek and the shadowed side of the neck as well as the shaded area that lies immediately under the mouth. Immediately the portrait is taking on a feeling of light and shade.

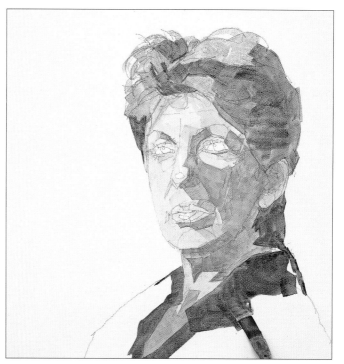

4 Mix a pale bluish black from lamp black and phthalocyanine blue and begin putting in the lightest tones of the hair, making sure your brushstrokes follow the direction in which the hair grows. When the first tone is dry, add burnt umber to the mixture and paint the darker areas within the hair mass to give the hair volume. Add more phthalocyanine blue to the mixture and paint the model's shirt.

▶

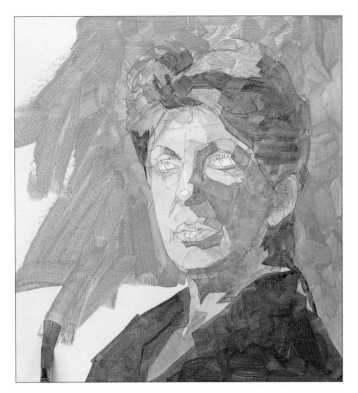

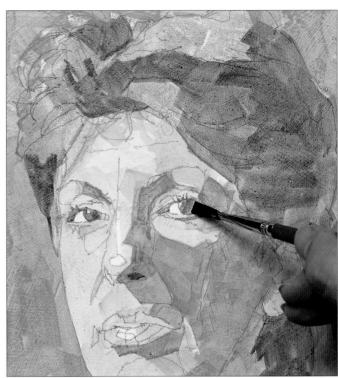

5 Mix a pale brown from cadmium red, burnt umber, Turner's yellow and titanium white and loosely block in the background, painting carefully around the face. You may find it easier to switch to a larger brush for this stage, as it will allow you to cover a wide area more quickly.

6 Mix a rich, dark brown from lamp black, burnt umber, cadmium red and a little of the blue shirt mixture from Step 4. Using a small flat brush, paint the dark of the eyes and the lashes, taking care to get the shape of the white of the eye right. Use the same colour for the nostril.

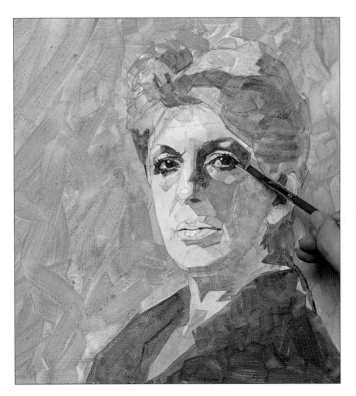

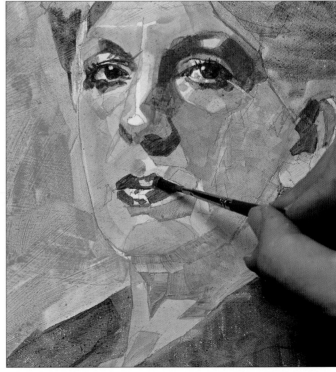

7 Use the same colour to define the line between the upper and lower lips. Mix a reddish brown from burnt umber and phthalocyanine blue and paint the shadows under the eyes and inside the eye sockets.

8 Paint the mouth in varying mixes of alizarin crimson, cadmium red and yellow ochre, leaving the highlights untouched. The highlights will be worked in later, using lighter colours.

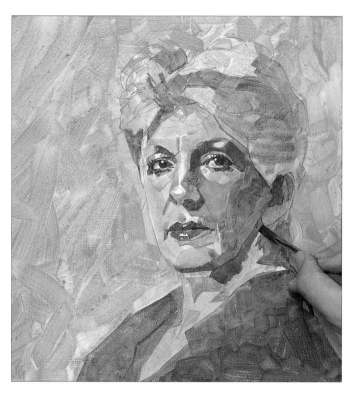

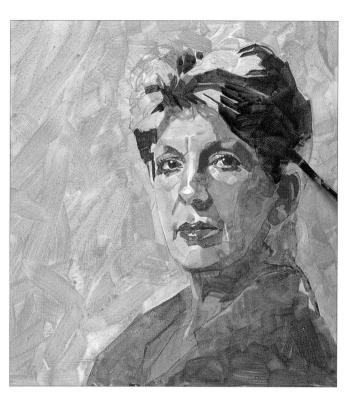

9 Darken the flesh tones on the shaded side of the face where necessary, using a mixture of alizarin crimson, phthalocyanine blue and a little titanium white, adding more blue to the mixture for the shadow under the chin, which is cooler in tone.

10 Mix a dark but warm black from burnt umber and lamp black and paint the darkest sections of the hair, leaving the lightest colour (applied in Step 4) showing through in places. This gives tonal variety and shows how the light falls on the hair.

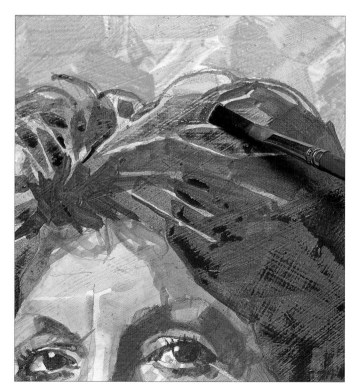

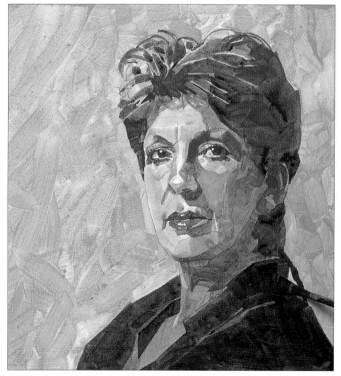

11 Add more water to the mixture to make it more dilute and go over the dark areas of the hair again, this time leaving only a few highlights showing through as relatively fine lines.

12 Mix a dark blue from phthalocyanine blue and lamp black and paint over the shirt again, leaving some of the lighter blue areas applied in Step 4 showing through. Your brushstrokes should follow the direction and fall of the fabric.

▶

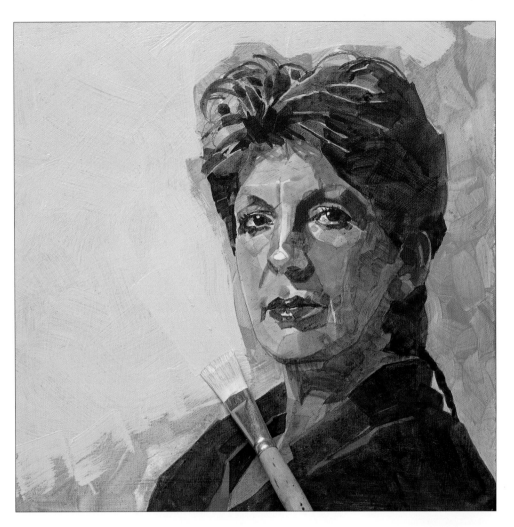

13 The beauty of acrylics is that you can paint a light colour over a dark one, without the first colour being visible. If you think the background is too dark and there is not sufficient differentiation between the model and the background, mix a warm off-white from titanium white, yellow ochre and burnt umber and, using a large flat brush, loosely paint the background again.

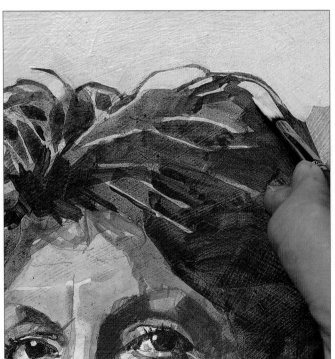

14 Using a small flat brush, cut around individual hairs with the background colour, carefully looking at the 'negative shapes'.

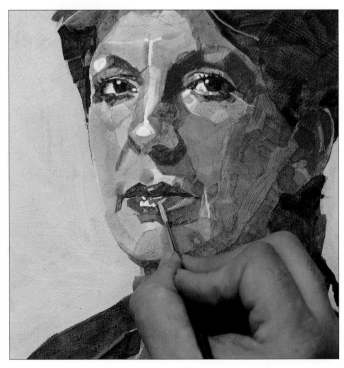

15 Using a fine round brush and titanium white straight from the tube, dot the highlights on to the eyes, nose and lower lip.

The finished painting

This is a relatively simple portrait, with nothing to distract from the sitter's direct gaze. Although the colour palette is limited, the artist has achieved an impressive and realistic range of skin and hair tones. Interest comes from the use of semi-transparent paint layers and allowing the directions of the brush marks to show through.

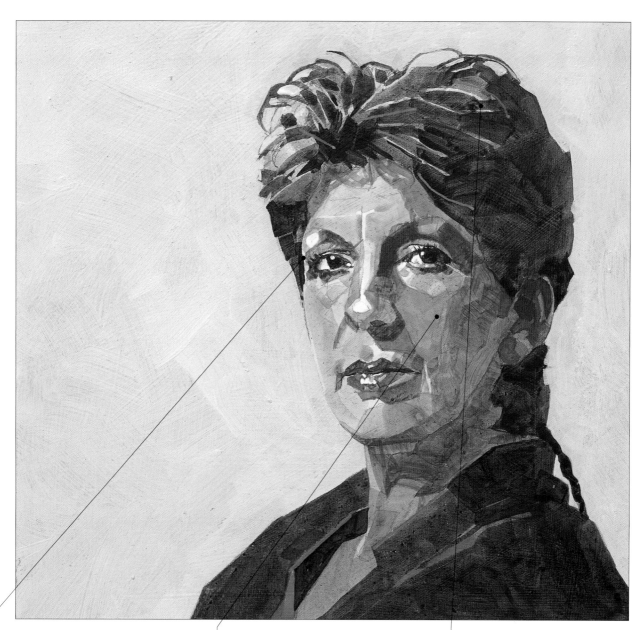

Carefully positioned highlights in the eyes make them sparkle and bring the portrait to life. The direct, critical gaze is an essential element of the portrait.

Variations in the skin tone, particularly on the shaded side of the face, help to reveal the shape of the face and its underlying bone structure.

The highlights in the hair are created by putting down the lightest tones first and then allowing them to show through subsequent applications of paint.

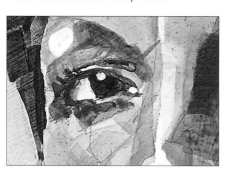

Portrait in oils on a toned ground

This portrait was painted from a photograph – you cannot expect a model to hold an expression as animated as this for any length of time.

Here, the artist opted for a head-and-shoulders portrait. Your most important decision when setting up a portrait is how much to include. If you leave out the shoulders, you will end up with what looks like a disembodied head; if you include much more of the torso than shown here, emphasis will be drawn away from the face and the balance of the portrait will be wrong.

In order to be able to start from a mid tone, the artist began by toning the canvas using a rich, warm mix of Venetian red and yellow ochre. Working on a white ground can be too strong a contrast. The artist was able to leave some of the ground showing through in the final painting for the brickwork and the mid tones of the model's skin.

The next stage was to make a thin underpainting in order to map out the basic pose. The advantage of using very thin paint for the underpainting is that if you make a mistake you can easily wipe it off with an old rag that has been dipped in turpentine.

In all portraits, it's important to continually refer back to your original points of reference – the width of the eyes, or the distance between the tip of the nose and the chin, for example – to check that your measurements and the proportions of the face are still correct. Be prepared to make adjustments as your work progresses.

Materials
- *Stretched oil-primed linen canvas*
- *Oil paints: Venetian red, yellow ochre, terre verte, burnt umber, titanium white, ultramarine blue, alizarin crimson, lemon yellow, lamp black, cadmium red*
- *Turpentine*
- *Old rag*
- *Brushes: selection of filberts in various sizes*

The pose
The model was posed in front of a brick wall, which provides texture and interest without detracting from her expression and features. The photograph was taken in late afternoon, so the sunlight that streams in from the left is both warm in colour and low in the sky, providing good modelling on the face.

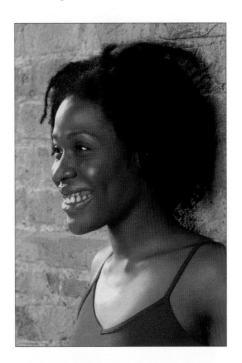

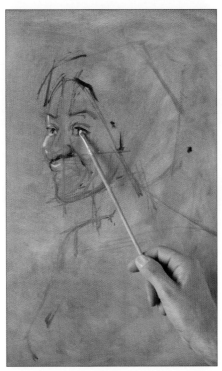

1 Tone the canvas with a dilute mix of Venetian red and yellow ochre and leave to dry. Dilute terre verte oil paint with turpentine to create a thin mix. Using a fine filbert brush, map out the overall structure of the portrait. Start by putting in the shoulder line (which in this case forms a strong diagonal through the composition), neck, facial area and the approximate area occupied by the hair. Then put in the facial features in burnt umber.

2 Put in more lines that you can use as a point of reference, such as the central line through the head. Begin putting in some of the mid tones, such as the bridge of the nose, with a yellowy mix of yellow ochre and terre verte. Mix titanium white with a little yellow ochre and put in 'markers' that you can refer back to later in the painting for the highlights – on the edge of the right cheekbone and top lip, for example. Carefully touch in the whites of the eyes.

Tip: The exact colour of your reference marks is not critical – but varying the colours a little makes it easier for you to differentiate these new marks from the previous ones and keep track of where you are in the portrait.

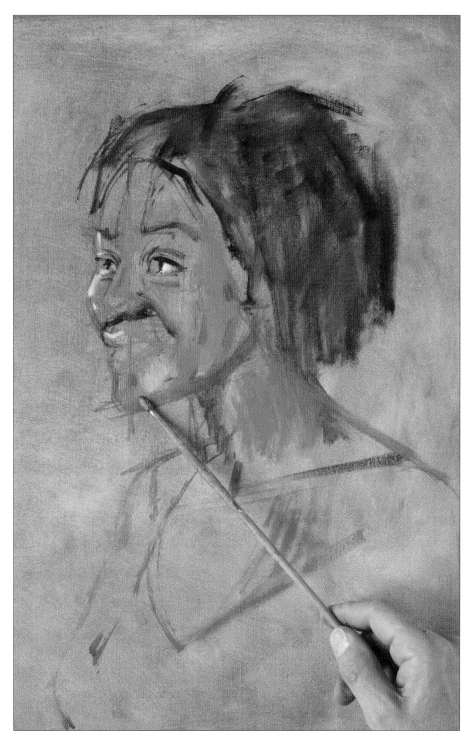

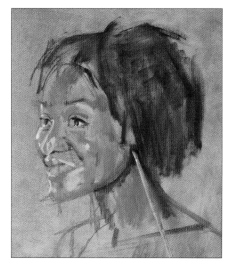

4 For the mid- to dark tones on the face – for example, down the centre of the brow and the bridge of the nose – use a mix of Venetian red, yellow ochre and burnt umber. Add white to this and put in some of the light highlights – on the left cheek and around the mouth, for example. Add ultramarine blue to the original mix for the shadow under the chin, and scumble a little of the same blue mix into the hair to create tonal variation.

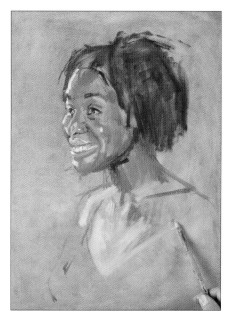

3 Scumble burnt umber over the hair, allowing some of the toned ground to show through in places. Roughly scumble the yellowy green mix used in Step 2 on to mid-toned shadow areas such as the neck and the side of the face. Mix a reddish brown from Venetian red, yellow ochre and a little titanium white and apply this on top of the earlier mix, allowing the colours to mix optically on the surface of the canvas. This generally creates a much more lively mix than physically mixing the same colours in the palette.

 Tip: Look for changes in tone across the face and neck that express the muscles underneath the surface of the skin.

5 Paint the dark tones on the chin with a mix of Venetian red and yellow ochre. Using the brush tip, put in some light marks for the teeth and paint the gums in alizarin crimson. On the model's right shoulder and chest, scumble on a light mix of white and yellow ochre for the highlight areas.

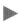

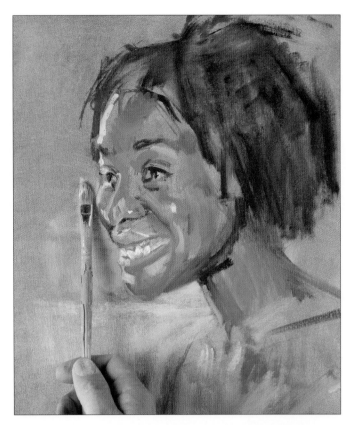

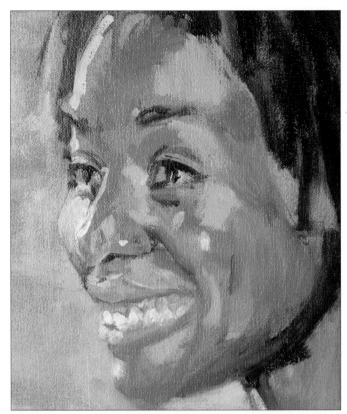

6 Refine the shape and position of the teeth. Mix a yellowy green from lemon yellow, a little terre verte and white and scumble it on to the background, leaving spaces for the mortar lines of the bricks. Looking at the negative spaces around your subject makes it easier to see the positive shapes.

7 Continue to build up the modelling on the face, alternating between warm and cool mixes and light and dark tones. Remember that warm colours tend to advance, while pale ones recede – so if you want an area such as a cheekbone to come forward, use a warm tone.

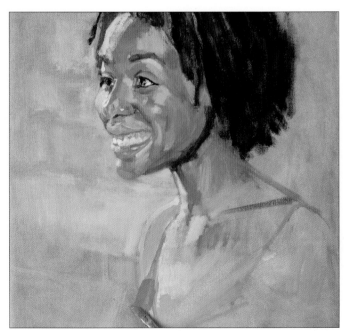

8 Put in the darkest tones in the hair, using a relatively thin mix of lamp black and ultramarine blue. Allow some of the canvas texture to show through.

9 Put in the white of the left eye with a mix of white with a hint of lemon yellow, and the white of the right eye with a cooler mix of white and ultramarine, so that it appears to recede slightly. Reassess the facial highlights and adjust if necessary. Begin blocking in the camisole in cadmium red.

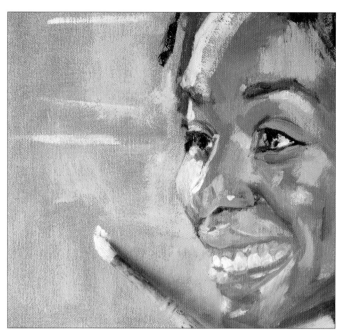

10 Now look at the highlights on the chest and shoulder. The collar bones are very prominent and catch the light, so use a warm mix of white and lemon yellow.

11 Scumble a mix of lemon yellow and white over the brick background, toning it down with a little terre verte in places and leaving the yellowy-green mix from Step 6 showing through for the mortar between the bricks.

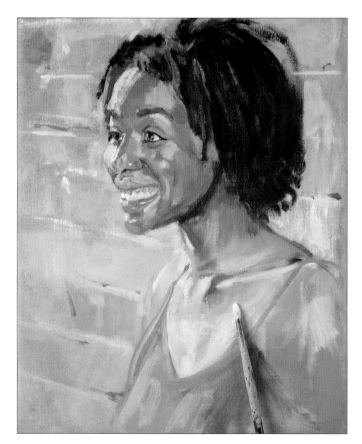

12 Add more terre verte to the mix and scumble it over the bricks on the right-hand side. Block in the shape of the model's red top more precisely with cadmium red, adding white to the mix in parts so that the colour is not flat. As you improve the modelling on the chest, look for the highlights.

13 Build up the modelling on the arm, using the same mixes as before. Put in the dark crease under the arm in a mix of burnt umber and terre verte.

▶

Assessment time

When you feel you're getting near the end of any painting, it's important to take time to look critically at what you've done and see what changes, if any, are required. Here, although the modelling on the face is virtually complete, there are a few gaps remaining – particularly around the hair line – where the toned ground shows through. The arms and shoulders almost merge into the background and need to be brought forward. Some of the skin tones are a little too dark in places and need to be toned down; the shadow under the chin and around the jawline, in particular, is both too dark and too heavy, but this is easy to rectify. In oils, you can apply a lighter colour on top of a dark one. You can even wipe off colour using a rag dipped in turpentine if necessary.

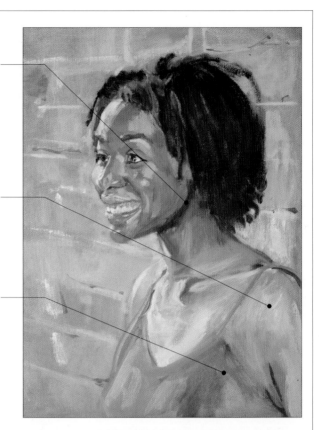

This shadow is too dark and heavy.

The arm is too pink and requires more modelling.

The model's top is too light and patchy in colour.

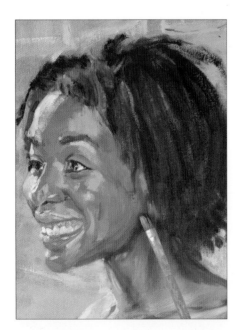

14 There are places on the head that have received no paint, allowing the toned ground to show. Block these in using the same skin tones as before. Strengthen the shadow on the back of the neck; because of the way the light falls, this area is quite dark. Lighten the shadow under the chin using a mix of Venetian red, yellow ochre and terre verte, and soften the edges.

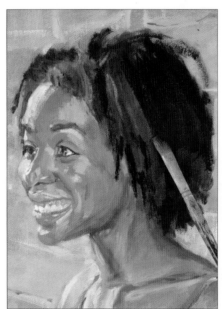

15 Cover any gaps and build up more texture in the hair with a deep blue-black mix of burnt umber and ultramarine blue.

Tip: Don't try to put in every strand of hair, but make sure your strokes follow the direction of growth.

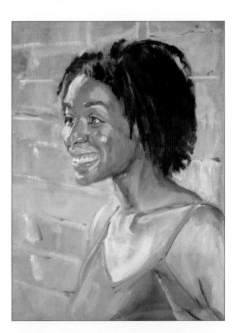

16 Using cadmium red paint, darken the red top. Note, however, that the colour is not totally uniform: creases and folds in the fabric create slight shadows that reveal the form beneath.

The finished painting

This is a lively portrait that perfectly captures the model's expression and personality. The artist began by toning the canvas with a mix of Venetian red and yellow ochre, which was similar in colour to both the mid-tones of the model's skin and the brick wall in the background. This enabled him to allow some of the ground to show through in his finished painting, unifying the surface. Although the colour palette is relatively restricted, the bright highlights and the white of the eyes and teeth really sing out and help to bring the portrait to life. Note, too, the effectiveness of the contrasts in texture – the smoothness of the skin, achieved by blending the paint wet into wet, versus the roughly scumbled paint on the background and the short, spiky brushstrokes used for the hair.

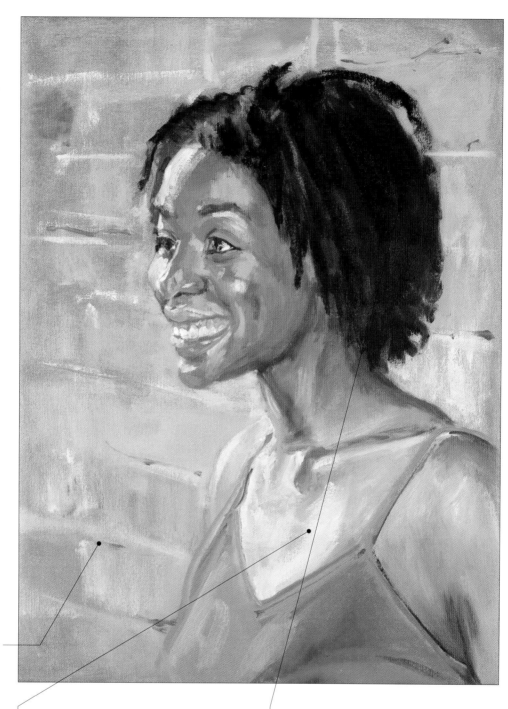

Paint has been lightly scumbled on to the brick wall, exploiting the texture of the canvas.

Because the light is so bright, the highlighted skin areas are paler than you might expect.

Energetic, spiky brushstrokes capture the texture of the hair.

Young child in acrylics

There are several things to remember when drawing or painting a child. The first is that children are very active and have a short attention span: you cannot expect them to sit still for hours while you work on your portrait, and for this reason you will probably find it easiest to work from a photograph.

Second, in children the head is much larger in relation to the overall body size than it is in adults. Although the human race is infinitely varied, as a general guideline the head is about one-seventh of the total height of the body in adults – but in babies it may occupy almost as much as one-third of the total. The little girl in this portrait is about two years old: her head represents approximately one-quarter of her total height.

This project starts with toning the support – a classic technique that was much used by some of the great portraitists such as Peter Paul Rubens (1577–1640). This provides the advantage of starting to paint from a mid-tone background, rather than a stark white ground, which makes it easier to judge the subtle flesh tones and the effects of light and shade cast by the sun. It also establishes the overall colour temperature of the portrait from the outset. In this instance, burnt sienna gives the portrait a lovely warm glow, which is appropriate to the dappled sunlight that illuminates the scene.

Materials
- *Board primed with acrylic gesso*
- *Acrylic paints: burnt sienna, ultramarine blue, titanium white, cadmium red, lemon yellow, alizarin crimson, phthalocyanine green*
- *Brushes: small round, medium flat, small flat*
- *Rag*
- *Matt acrylic medium*

The pose
Relaxed and informal, this child's attention is occupied by something that we cannot see. Note that she is positioned slightly off centre. If a figure in a portrait is looking off to one side, it is generally better to have more space on that side, as this creates a calmer, more restful mood. Placing a figure close to the edge of the frame creates a feeling of tension.

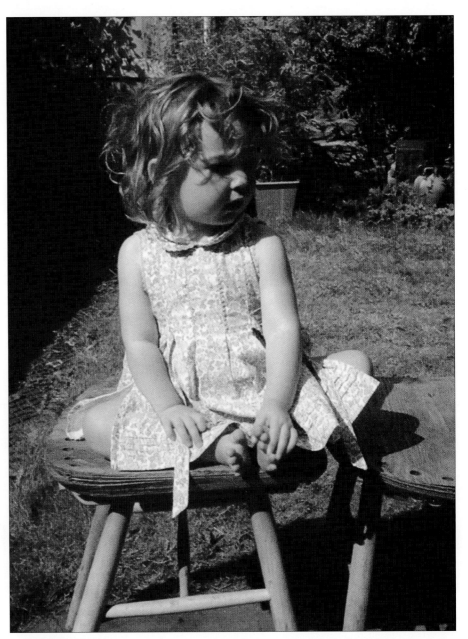

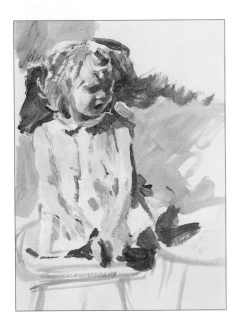

Preliminary sketch
Flesh tones can be tricky, and you may find it useful to make a quick colour sketch experimenting with different mixes, such as the one shown on the left, before you start painting.

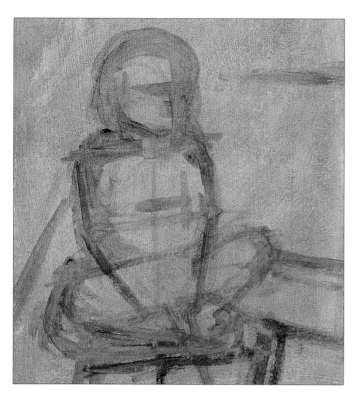

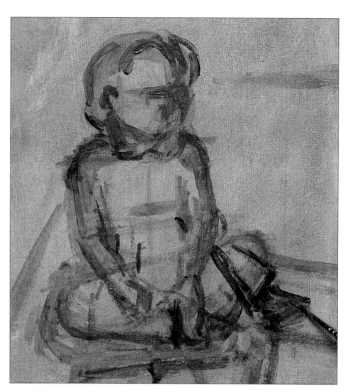

1 Tone the primed board with burnt sienna acrylic paint and leave to dry. Mix a dilute, warm brown from burnt sienna and a little ultramarine blue. Using a small round brush, make a loose underdrawing, concentrating on getting the overall proportions and the angles of the head and limbs correct.

2 Mix a darker, less dilute brown, this time using more ultramarine blue. Using the small round brush, put in the darkest tones of the hair, the shadows on the face and under the collar of the girl's dress, and the main creases in the fabric of the dress. These creases help to convey form.

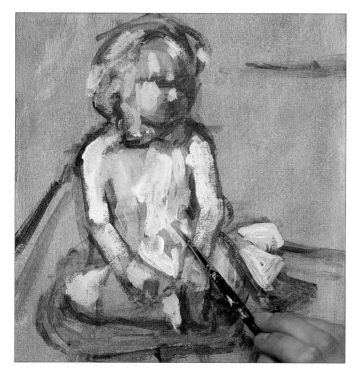

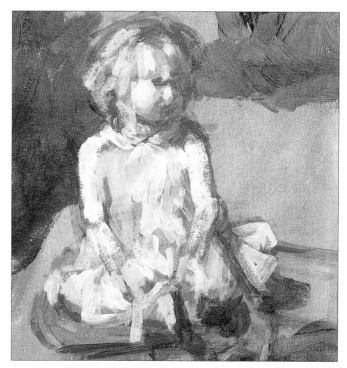

3 Mix a very pale pink from titanium white, cadmium red and a little lemon yellow and paint the palest flesh tones on the face, arms and legs, as well as some highlights in the hair. Add more water and put in the lightest tones of the girl's dress. Note how the colour of the support shows through.

4 Mix a warm purple from ultramarine blue and alizarin crimson. Using a medium flat brush, block in the dark foliage area to the left of the girl. Add more water and ultramarine blue to the mixture and paint the darkest foliage areas to the right of the girl and the shadows under the stool.

▶

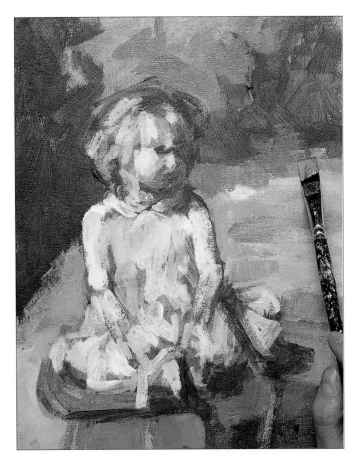

5 Mix a bright green from phthalocyanine green, lemon yellow, titanium white and a little cadmium red. Block in the lawn and background foliage. Use less lemon yellow for the shaded grass and more white for the brightest parts.

6 Mix a very pale green from titanium white and phthalocyanine green and brush it loosely over the child's sun-bleached cotton dress.

7 Mix a dark brown from burnt sienna and ultramarine blue and start to put some detailing in the hair and on the shadowed side of the face. Mix a warm shadow tone from alizarin crimson and burnt sienna and build up the shadow tones on the left-hand (sunlit) side of the face, alternating between this mixture and the pale pink used in Step 3.

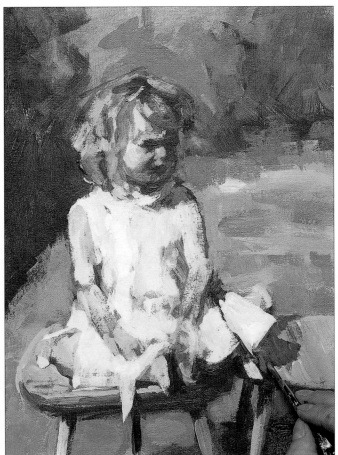

8 Add titanium white to the purple mixture from Step 4 and paint the stool to the right of the child. Paint the stool on which she is sitting in a mixture of brown and titanium white, with brushstrokes that follow the wood grain. Mix a rich brown from burnt sienna and alizarin crimson and, using a small round brush, paint the shadows at the bottom of her dress.

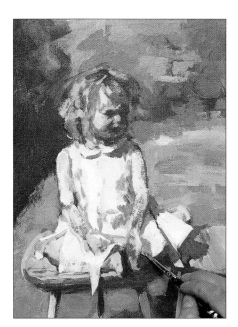

9 Dab some of the purple mixture (the stool colour) over the foliage in the background. Using the same colour in this area establishes a visual link between foreground and background; the light colour also creates the impression of dappled light in the foliage. Mix a dark, bluish green from ultramarine blue and phthalocyanine green and paint the shadow under the dress collar and any deep creases and shadows in the fabric of the dress.

10 Using the pale pink mixture from Step 3 and a round brush, go over the arms and legs again, carefully blending the tones wet into wet on the support in order to convey the roundness of the flesh.

Assessment time
The blocks of colour are now taking on some meaning and form: for the rest of the painting, concentrate on building up the form and detailing.

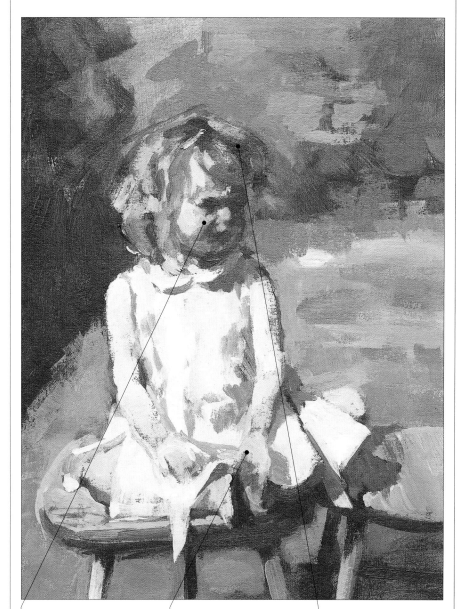

The tonal contrasts on the face are too extreme and need to be blended to make the skin look more life-like.

The hands and feet, in particular, need to be given more definition.

The child is not sufficiently well separated from the background.

Tip: To make flesh look soft and rounded, you need to blend the tones on the support so that they merge almost imperceptibly; it is rare to see a sharp transition from one colour to another. Working wet into wet is the best way to achieve this, gradually darkening the tone as the limb turns away from the light. With acrylic paints, you may find that adding a few drops of flow improver helps matters: flow improver increases the flow of the paint and its absorption into the support surface.

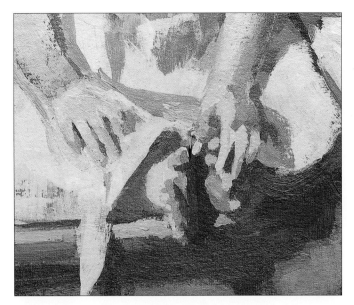

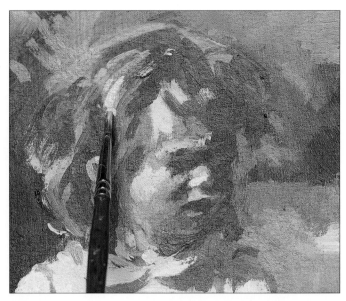

11 Mix burnt sienna with a tiny amount of titanium white. Using a small round brush, paint the dark spaces between the fingers and the shadows between the feet and on the toes. Try to see complicated areas such as these as abstract shapes and blocks of colour: if you start thinking of them as individual toes, the chances are that you will make them bigger than they should be.

12 Refine the facial details, using the same mixes as before. Put in the curve of the ear, which is just visible through the hair, using the pale pink skin tone. Mix a reddish brown from alizarin crimson, ultramarine blue and burnt sienna. Build up the volume of the hair, looking at the general direction of the hair growth and painting clumps rather than individual hairs.

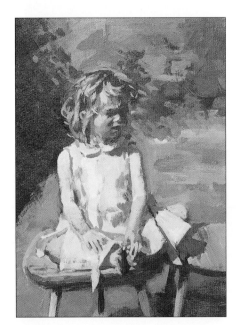

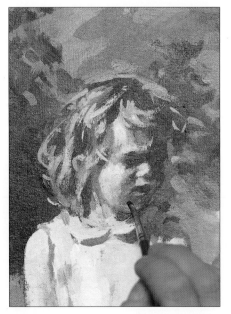

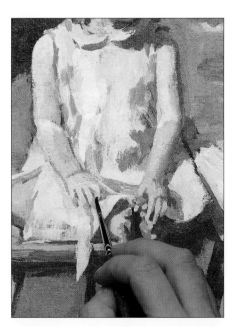

13 Using the purple shadow mixture from Step 4 and a small flat brush, cut in around the head to define the edge and provide better separation between the girl and the background. Mix a dark green from phthalocyanine green and ultramarine blue and loosely dab it over the dark foliage area to provide more texture. Using cool colours here makes this area recede, focusing attention on the little girl.

14 Add a little matt acrylic medium to the pale pink flesh tone and go over the light areas of the face, working the paint in with the brush to ensure that it blends well and covers any areas too dark in tone. The matt medium makes the paint more translucent, so that it is more like a glaze. Do the same thing on the arms, adding a little burnt sienna for any areas that are slightly warmer in tone.

15 Make any final adjustments that you deem necessary. Here, the artist felt that the girl's hands were too small, making her look slightly doll-like; using the pale flesh colour from previous steps, she carefully painted over them to make them a little broader and bring them up to the right scale.

The finished painting
This is a charming portrait of a toddler with her slightly chubby face and arms, rounded mouth, big eyes and unselfconscious pose. There is just enough detail in the background to establish the outdoor setting, but by paying very careful attention to the tones of the highlights and shadows, the artist has captured the dappled sunlight that pervades the scene.

Although no detail is visible in the eyes, we are nonetheless invited to follow the child's gaze.

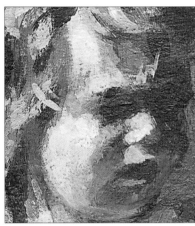

The subtle blending of colour on the child's arms and face makes the flesh look soft and rounded.

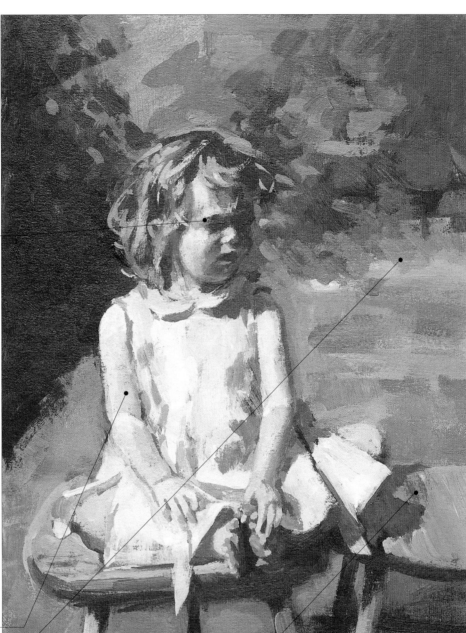

There is just enough background to give the scene a context without distracting from the portrait.

Brushstrokes on the stool follow the direction of the woodgrain – an effective way of conveying both pattern and texture.

Grandmother and child in soft pastels

Family portraits, particularly of very young children, are always popular – and a project like this would make a wonderful present for a grandparent. Soft pastels capture the skin tones beautifully, and you can smooth out the marks with your fingers or a torchon to create almost imperceptible transitions from one tone to another. Build up the layers gradually. You can spray with fixative in the later stages to avoid smudging the colours, but be aware that this could dull or darken the colours that you've already put down. Soft pastel is also a lovely medium for drawing hair, as you can put down many different colours within the hair mass to create depth and an attractive sheen. When drawing hair, look at the overall direction of the hair growth.

Young children have very short attention spans and they certainly can't hold the same pose for the time it takes to draw a detailed portrait. You'll be lucky if they sit still for long enough for you to do anything more than a very quick sketch – so working from a photograph is probably your best option. Even then, it's very hard to get a young child to do exactly as you want if you tell them what to do. Often you either get a shot with the child staring grumpily at the camera, or he or she will wriggle, making a good shot impossible.

One simple solution is to make the photo session into a game by pulling faces, clapping your hands, holding up a favourite toy and generally interacting with the child so that he or she forgets all about the camera. Above all, take lots of shots so you have plenty of reference material to choose from. Then you can combine material from several shots – invaluable if you can't get a shot in which both sitters are smiling at the same time.

Materials
- *Pale grey pastel paper*
- *Soft pastels: pinkish beige, white, dark brown, mid-brown, orangey beige, pale yellow, pinkish brown, reddish brown, dark blue, red, pale blue, grey, pale pink, black*

The pose
This is a happy pose, with both child and grandmother smiling broadly. To help them relax for the shot, the photographer got them to make a little game out of clapping their hands which, in addition to helping them forget that they're having their photo taken, imparts a sense of movement to the pose.

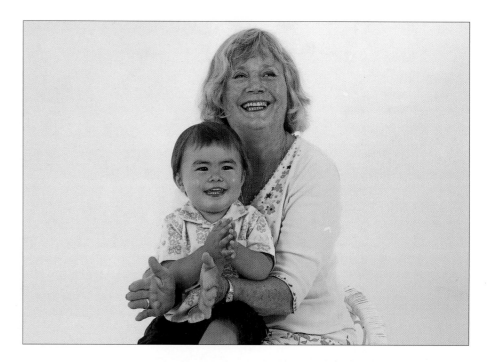

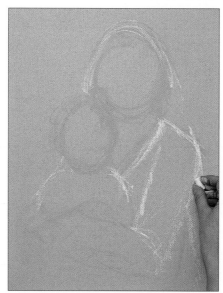

1 Using a pinkish beige soft pastel map out the basic shapes – the heads of the two sitters and the position of the arms. Draw the sleeves and neckline of the grandmother's sweater in white pastel, putting in the most obvious creases in the fabric, and put in the slant of the little boy's shoulders in white, too.

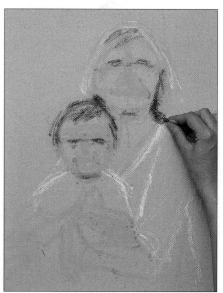

2 Using the pinkish beige pastel again, indicate the position of the facial features by marking a central guideline with the eyes approximately halfway down. The grandmother's head is tilted back, so her eyes are a little above the halfway point. Roughly block in the child's hair and the shadows in the woman's hair in dark brown.

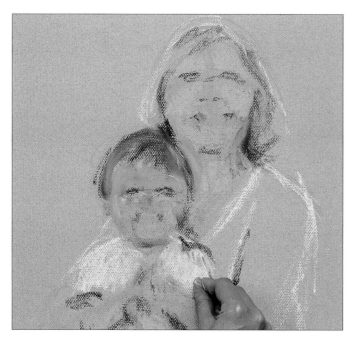

3 Still using the dark brown pastel, put in more of the hair, smudging the pastel marks with your fingers. Indicate the darkest parts of the facial features – the recesses of the eye sockets and nostrils. Apply some flesh tone to the child's face, using mid-brown for the darker parts and a more orange version of the beige used in Step 1 for the lighter parts. Using the side of a pale yellow pastel, roughly block in the base colour of the little boy's shirt.

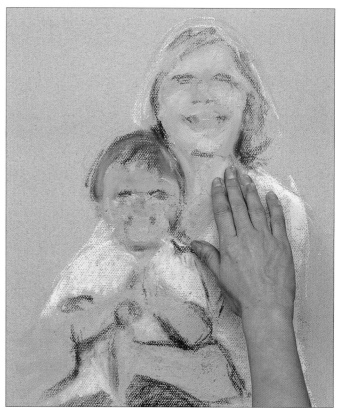

4 Using the side of a white pastel, block in the grandmother's sweater. Apply a pinkish beige to her face and neck, blending the marks with your fingers.

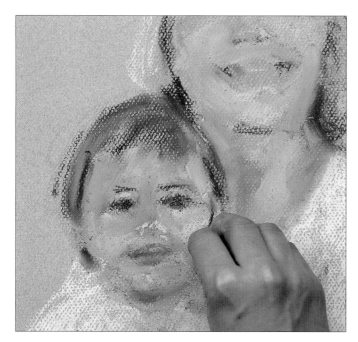

5 The grandmother's neck is slightly warmer in tone than her face. Use a reddish brown for the slightly darker tones in this area, again blending the marks with your fingers. Use the same colour for the child's lips. Using your fingertips, smooth out the mid-brown on the child's face, leaving the orangey beige for the lighter parts. Use a very dark brown for the child's eyebrows and eyes.

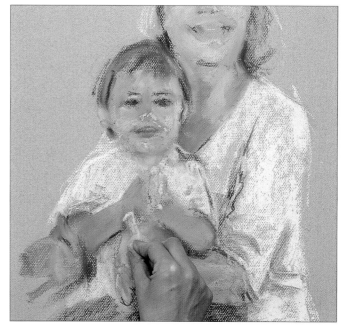

6 Using a dark blue pastel, put in the creases in the fabric of the grandmother's sweater. Block in the arms, using a pinkish brown for the grandmother and a reddish brown for the little boy. Overlay various flesh tones – pinkish beige, orangey beige, red – as appropriate, blending the marks with your fingers. Flesh is not a uniform colour; look closely and you will see warm and cool tones within it.

▶

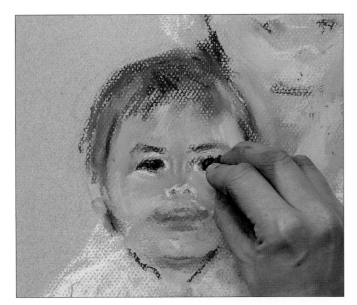

7 With a dark brown pastel, put in the shadow under the child's chin and around the collar of his shirt. Put in some jagged strokes on the hair so that you begin to develop something of the spiky texture. Darken the child's eyes.

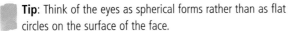

Tip: Think of the eyes as spherical forms rather than as flat circles on the surface of the face.

8 Using the same flesh colours as before, continue building up the modelling on the little boy's face. Add some red to the cheeks, blending the marks with your fingers. Like most toddlers, he has a fairly chubby face, so there are no deep recesses under the cheekbones, but with the mix of light and darker-coloured tones the flesh is starting to look more natural. Using the tip of a white pastel and dabbing on small marks, lightly draw his teeth and apply some tiny, glossy highlights to the lips.

9 Repeat the process of building up modelling on the grandmother's face. Apply pale yellow to her hair.

10 Continue working on the hair, putting in browns and greys to get some tonal variation within the hair. Note, too, how the hair casts a slight shadow on her face. Use a brown pastel to draw in the creases in the little boy's shirt. Draw in the crease lines around the grandmother's nose and mouth with a reddish brown pastel.

Assessment time

The expressions and pose have been nicely captured, but in places the skin tones appear as blocks of colour and need to be smoothed out more. A little more modelling is also needed on the faces and hands. The eyes need to sparkle in order for the portrait to come alive.

The pupils and irises have been carefully observed, but there is no catchlight to bring the eyes to life.

The child's hands, in particular, appear somewhat formless.

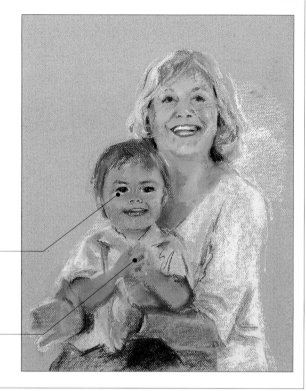

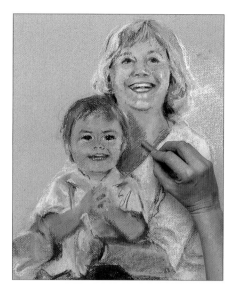

11 Continue the modelling on the grandmother's face and neck, gradually building up the layers and fleshing out the cheeks. Use the same colours and blending techniques as before. The adjustments are relatively minor at this stage.

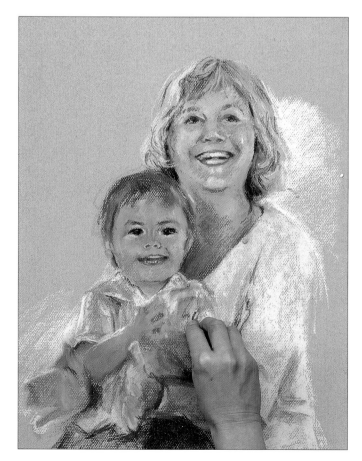

12 Apply more yellow to the boy's shirt, scribbling it in around the dark crease marks. Smudge more brown over the yellow for the stripes in the fabric. A hint of the pattern is sufficient; too much detail would detract from the face.

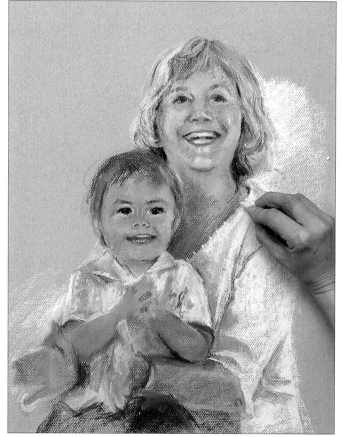

13 Using the side of the pastel, block in the grandmother's sweater with a very pale blue. Reinforce the dark blue applied in Step 6 to define the folds in the fabric. Apply tiny pale-blue dots around the neckline of the sweater.

▶

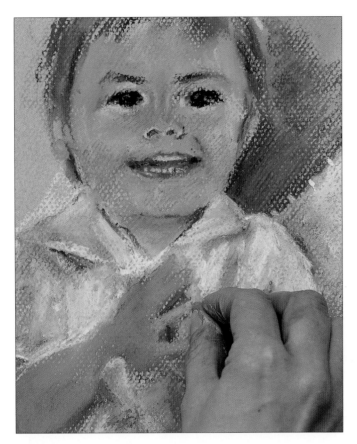

14 Draw the little boy's fingernails with a pale pink pastel and apply light strokes of reddish brown between the fingers to separate them. Like his face, the fingers are fairly chubby so you don't need to put too much detail on them. Blend the marks with your fingertips if necessary to create soft transitions in the flesh tones.

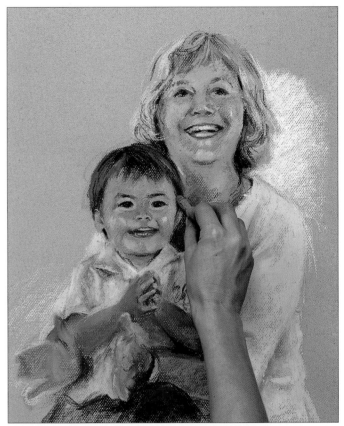

15 If necessary, adjust the flesh tones on the boy's arms and fingers. Here, the artist judged that the face was too dark, so she applied some lighter flesh tones – a very pale orangey beige – to the highlights to redress the balance. Apply a range of browns to his hair to build up the texture and depth of colour.

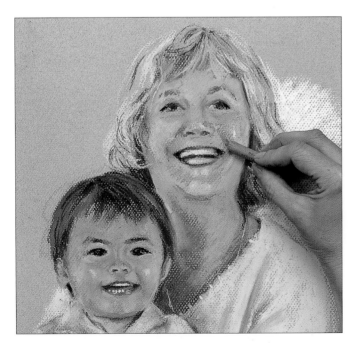

16 Add a thin white line for the grandmother's necklace. Darken her lips and inner mouth; adjust the flesh tones. Redefine the creases around the nose and mouth, if necessary.

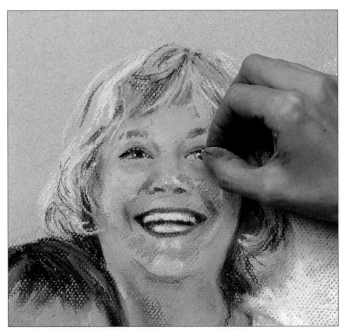

17 The final stage is to put in some detail in the eyes – the black pupils and some tiny dots of white for the catchlights.

The finished drawing

This is a relaxed and informal portrait that captures the sitters' moods and personalities. Using soft pastel has allowed the artist to build up the flesh tones gradually, achieving a convincingly life-like effect. Leaving the grandmother's hands slightly unfinished helps to create a sense of movement as she claps her hands together – in much the same way as a blurred photograph tells us that a subject is moving.

In wide smiles, the lips are stretched taut across the arc of the teeth. We see more of the upper teeth than the lower teeth; sometimes only the tops of the lower teeth are visible and almost never the gums.

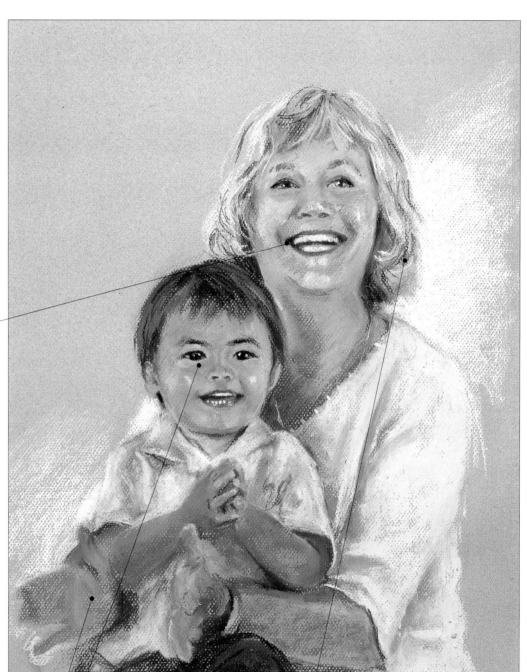

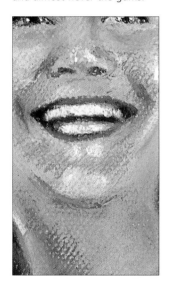

Leaving the hands unfinished creates a sense of movement.

The eyes sparkle: a tiny dot of white is sufficient to bring them alive.

Note how many different tones there are within the hair.

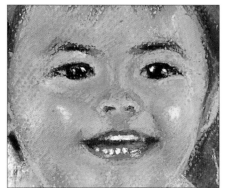

Character portrait in charcoal

Markets are a great place to do quick sketches or take snapshots of people going about their daily business, which you can then work up into more detailed portraits at a later date. People are so engrossed in what they're doing that they're unlikely to take much notice of you – so your photos and sketches may be much more natural.

Here, the artist decided to omit both the background and the woman on the left and to concentrate on making a character portrait of the man – but you could, of course, include the setting, too, provided you kept the main emphasis of the drawing on his face.

This particular portrait gains much of its strength from the fact that there is direct eye contact between the subject and the artist, which immediately brings the portrait to life and makes the viewer feel involved in the scene. His gaze is quizzical, perhaps even slightly challenging, and even without the inclusion of the market setting, his slightly hunched pose and wrinkled face indicate that he leads a hard life.

Charcoal is a lovely medium for character portraits and, like black-and-white reportage or documentary-style photographs, a monochrome drawing has a strength and immediacy that works particularly well with this kind of subject. The same drawing in colour would have a very different feel – and probably far less impact. Why not try the same project in coloured pencil, too, to see the difference?

Materials
- *Fine pastel paper*
- *Thin charcoal stick*
- *Compressed charcoal stick*
- *Kneaded eraser*

The pose
In this scene two market traders in Turkey were spotted by chance rather than asked to pose formally. So these are character portraits. The artist concentrated on the man on the right, as the three-quarters pose, with direct eye contact, is more interesting than the head-on view of the lady. He has a strong profile, while the woman's face is more rounded and her features less clearly defined. The plastic sheeting could be confusing so it was omitted.

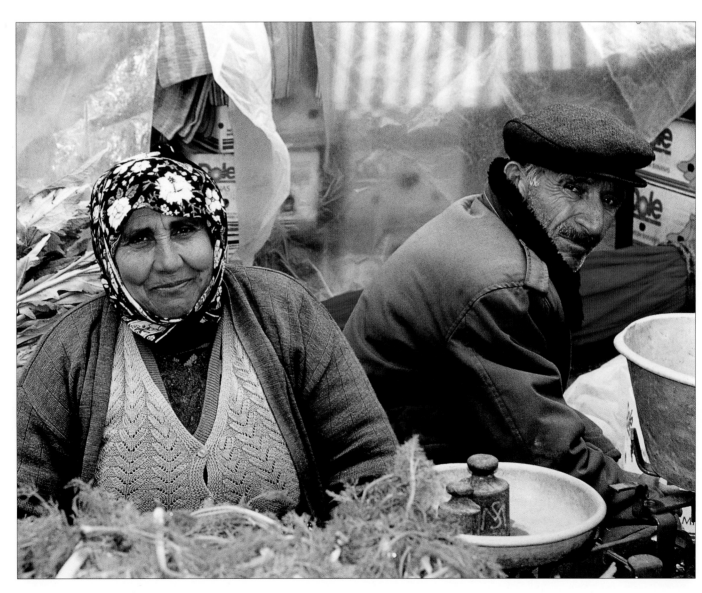

1 Using a thin stick of charcoal, map out the lines of the pose. Look at the angle of the shoulders and back and at where imaginary vertical lines intersect, so that you can place elements correctly in relation to one another. Here, for example, the peak of the man's cap is almost directly in line with his wrist.

2 Still using the thin charcoal stick, lightly put in guidelines to help you place the facial features. Draw a line through the forehead and down to the bottom of the chin, lines across the face to mark the level of the eyes, the base of the nose and the mouth, and an inverted triangle from the eyes down to the nose.

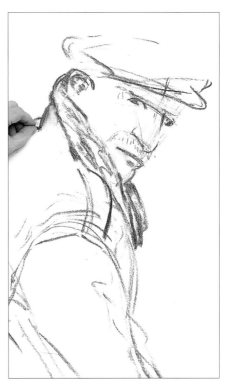

3 Refine the facial features and roughly block in the fur collar on the man's jacket. (It provides a dark frame for the face.)

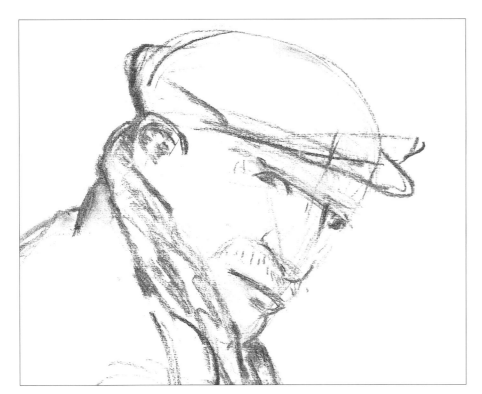

4 Lightly draw the curve of the top of the skull. Although you can't actually see the skull beneath the cap, you can use the tilt of the head and the features you've already put in to work out where it should be. Remember that the base of the eye socket is generally about halfway down the face, so the top of the skull is likely to be higher than you might think.

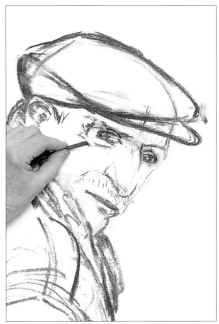

5 Now you can draw the cap. Without the faint guideline of the skull that you drew in the previous step, you'd probably make the cap too flat and place it too low on the head. Draw the eyes and eyebrows and the sockets of the eyes. Already you can see how the form is beginning to develop.

▶

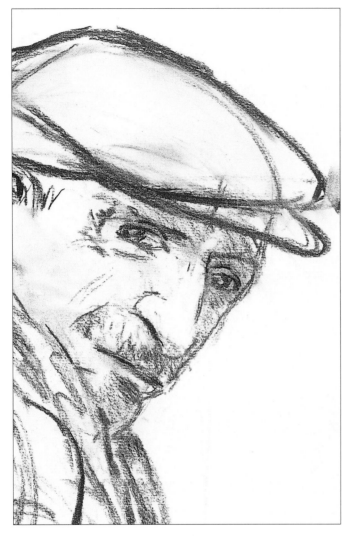

6 Sharpen the line of the far cheek and apply loose hatching on the far side of the face (which is in shadow) and on the forehead, where the cap casts a shadow.

Assessment time
The facial features are in place and most of the linear work has been completed, although the details need to be refined and the eyes darkened. Now you can begin to introduce some shading, which will make the figure look three-dimensional and bring the portrait to life.

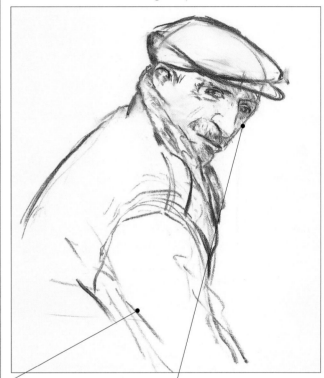

The jacket looks flat. There is nothing to tell us how heavy it is or what kind of fabric it is made from.

Shading has introduced some modelling on the far side of the face, but more is needed.

7 Using a compressed charcoal stick, which is very dense and black, put in the line of the mouth.

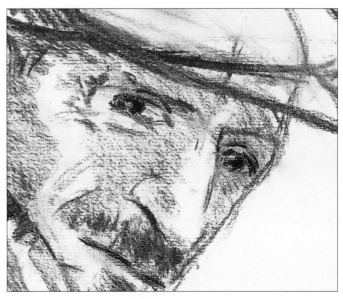

8 Again, using the compressed charcoal stick, put in the pupils of the eyes, remembering to leave tiny catchlights.

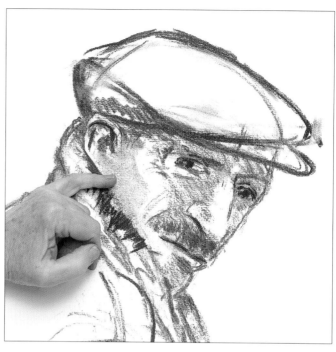

9 Using the side of a thin stick of charcoal, very lightly shade the right-hand side of the man's face. The shadow is not as deep here as on the far side of the face, but this slightly darker tone serves two purposes as it helps to show how tanned and weatherbeaten his face is and also creates some modelling on the cheeks.

10 Using the tip of your little finger, which is the driest part of your hand, carefully blend the charcoal on the right cheek to a smooth, mid-toned grey.

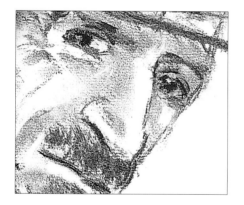

11 Using a kneaded eraser, pick out the highlighted wrinkles on the face, and the whites of the eyes. Each time you use it, wipe the eraser on scrap paper to clean off the charcoal and so prevent smudges.

 Tip: To get a fine point on the eraser for intricate areas, mould the eraser with your fingers.

12 Block in the dark, shaded side of the cap, using the side of the charcoal stick. Note that the cap is not a uniform shade of black all over: leave areas on the top untouched to show where the highlights fall.

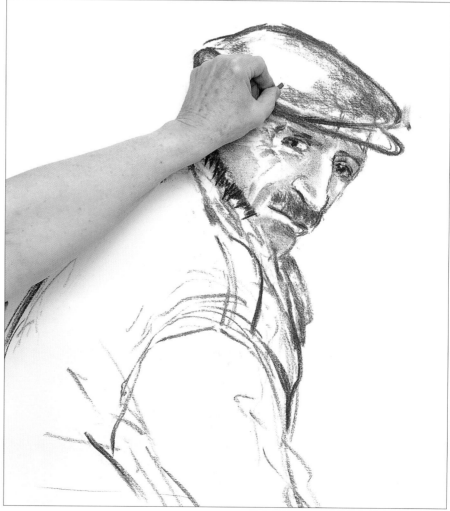

▶

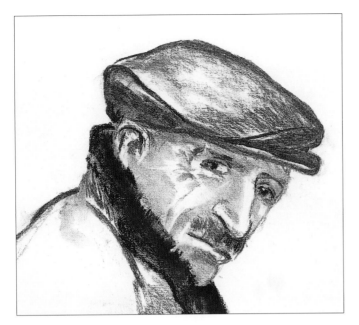

13 Using compressed charcoal, block in the fur collar on the jacket and smooth out the marks with your fingers. By making slightly jagged marks, you can suggest the texture of the fur. Note how the face immediately stands out more strongly when framed by the dark fur.

14 Put in the dark crease lines of the folds in the jacket. The deep creases help to show the weight of the fabric.

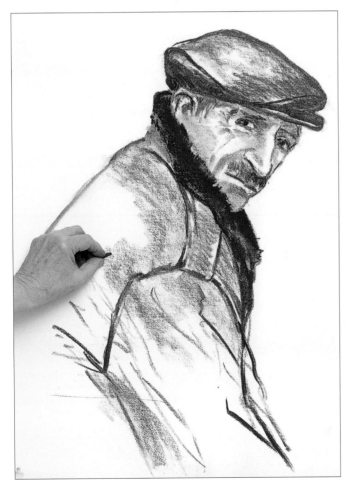

15 Using the side of the charcoal, apply tone over the jacket, leaving highlights on the sleeve untouched.

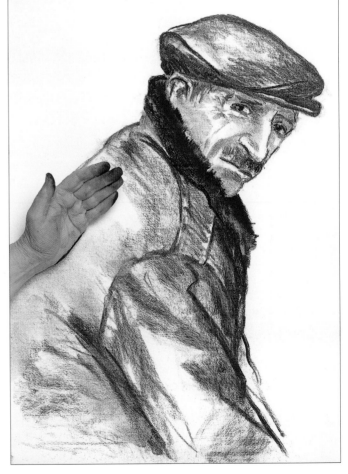

16 Using the side of your hand in a circular motion, blend the charcoal to a smooth, flat tone.

The finished drawing

This portrait is full of character. Note the classic composition, which draws our attention to the face – the overall shape of the portrait is triangular, with the strong line of the back leading up to the face and forming the first side of the triangle, and a straight line down from the peak of the cap to the arm forming the second side.

In addition, the face is positioned roughly 'on the third' – a strong placement for the most important element in the drawing. The three-quarter viewpoint with the sitter's face turned partway towards the viewer, means that there is direct eye contact, immediately involving the viewer in the painting. The sitter's strong profile is also evident from this viewpoint.

Wrinkles in the skin are picked out using the sharp edge of a kneaded eraser.

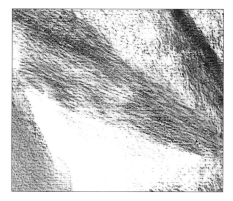

The crease lines and variations in tone show the weight and bulkiness of the fabric.

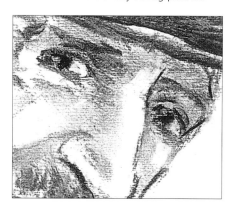

The direct eye contact between sitter and viewer makes this a very strong portrait.

Character study in watercolour

A good portrait is about more than capturing a good likeness of the sitter: it should also reveal something of their personality and interests. You can do this by including things that they would use in everyday life as props. You might, for example, ask a keen musician to sit at the piano. Alternatively, you could depict someone at his or her place of work. The sitter for this portrait loves literature and is an avid reader – hence the book that she is holding and the piles of books in the background. Take care, however, not to allow the background and props to dominate. Here the books are little more than simple, graphic shapes. If elements threaten to overpower, reduce their importance in the composition – or even omit them altogether.

As we grow older, we inevitably acquire a few wrinkles and 'laughter lines', all of which give a face character and expression. Here, the artist decided to make a pencil underdrawing and to allow many of the pencil marks to show through in the final watercolour painting. The result is a fresh, lively portrayal that combines the very best characteristics of two very different media – the linear quality of pencil and soft, wet-into-wet washes of watercolour paint in the skin tones. He primed his watercolour paper with an acrylic gesso, which renders any pencil marks softer and blacker than they would otherwise be and creates an interesting, slightly broken texture.

Don't worry about creating an exact likeness of your sitter in the early stages, or you may get caught up in the fine detail and lose sight of the overall composition and proportions. If you get the basics right, the rest will follow.

Materials
- *Heavy watercolour paper primed with acrylic gesso*
- *B pencil*
- *Watercolour paints: raw sienna, cadmium orange, indigo, ultramarine blue, raw umber, black, vermilion, cerulean blue*
- *Brushes: small and medium round*

The pose
This elderly lady's face is full of character and, by including the book that she is reading and the piles of books in the background, the artist has also managed to tell us a little about her interests. However, the television in the background adds nothing to the scene; in fact, it distracts attention from her face. For this reason, the artist decided to omit it.

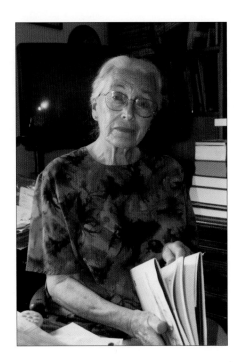

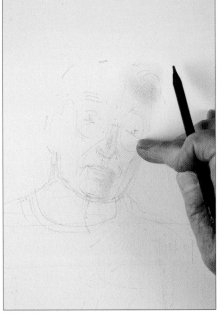

1 Using a B pencil, begin your underdrawing by putting in faint marks and dots for the relative positions of features such as the crown and chin and the outer and inner points of the eyes. Then work upwards from the chin, putting in the central line through the head, which tilts here at an angle of about 20°. Put in a little shading on the left side of the face and smudge it with your finger– simply to help define areas rather than to add tone.

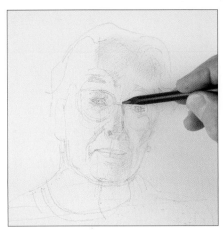

2 Once you've mapped out the position of the features, you can gradually put in more details, such as the spectacles. Loosely hatch shaded areas such as the left cheek; this is simply to delineate the extent of these areas rather than introduce modelling.

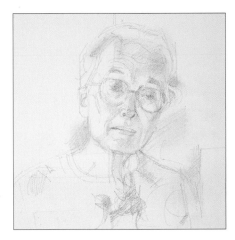

3 It's a good idea to lightly hatch or shade part of the area around your subject's head fairly early on in a portrait. Also put in any areas of shade that help you to keep track of where you are in the portrait – for example, in the hair and on the neck.

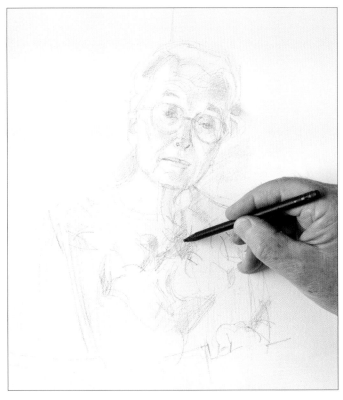

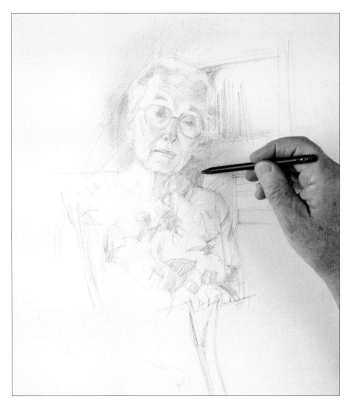

4 Although you only want to give an impression of the dress fabric, rather than slavishly copy every last detail, you can use elements of the pattern as a guide to the placement of other features. Here, for example, the top of the black pattern just below the neckline is roughly level with the top of the right sleeve. Look, also, for folds within the fabric that cast slight shadows, which suggest the body beneath.

5 Once you've mapped out the figure, decide how much of the surroundings to include and what to change or omit. Although the artist here chose to leave out the television set, he put in a dark background which frames the face and allows the white of the hair to stand out. He also lightly sketched the piles of books, as the sitter's interest in literature is an element of her character he wanted to convey.

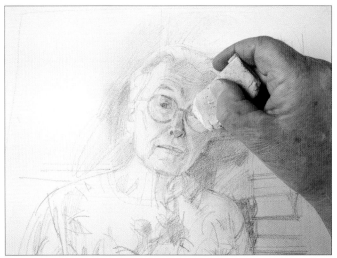

6 Begin to define the different planes of the fingers. (Note that the thumb on the right hand is foreshortened: we're looking at the underside of the thumb, with the nail on the very edge.) Put in some shading on the sitter's right arm. There is a strong area of shadow in the underside of the forearm, which clearly shows the muscles of the lower arm. Although you're only establishing the basic lights and darks at this stage, this is the beginning of creating some modelling.

7 To make them stand out more, put in some stronger tones in the facial features – the nostrils, the pupils of the eyes, and the deep creases around the mouth – as well as in the metal rims of the spectacles. Use a kneaded eraser to retrieve any highlights that have been accidentally covered over – for example, on the tip of the nose and within the spectacles. For very fine details, use the sharp edge of the eraser, or mould it to a fine point with your fingertips.

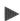

Assessment time

Once you've mapped in the position of the books to the left of the sitter, the pencil underdrawing is virtually complete; now you are ready to begin applying the colour. The underdrawing is relatively detailed and the time and attention you've taken to produce it will pay dividends later, when you come to apply the colour. Although there is not much modelling, you have established the main areas of lights and dark, which you can use as a guide when applying the different tones in watercolour. Most importantly, there is plenty of linear detail in the face, which you will be able to retain in the finished painting.

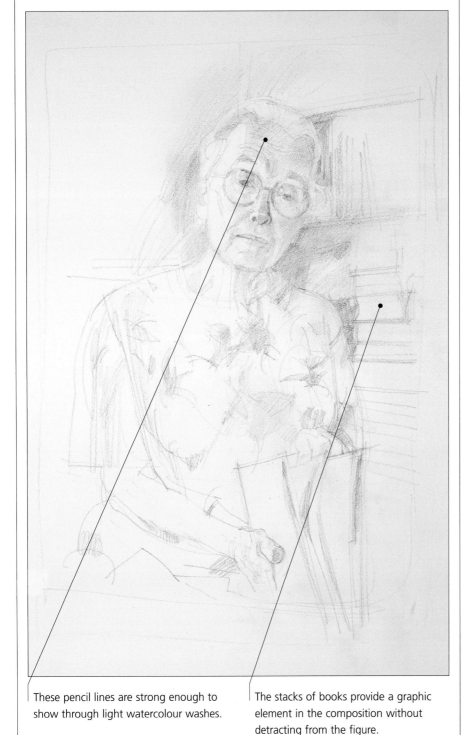

These pencil lines are strong enough to show through light watercolour washes.

The stacks of books provide a graphic element in the composition without detracting from the figure.

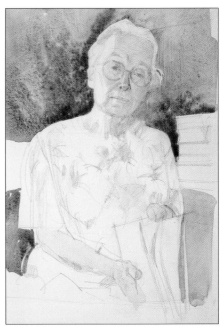

8 Mix a very dilute wash of raw sienna and cadmium orange and, using a small round brush, wash it over the arms and face, omitting only the very bright highlights on the face. Leave to dry. Then mix a blackish blue from indigo and ultramarine blue. Using a medium round brush, wash it over the darkest areas of the background and leave to dry. Note how the brushstrokes of the primer are visible in places, adding texture to the washes.

9 Using a medium round brush, apply a fairly strong wash of cadmium orange over the sitter's dress, leaving a few small areas untouched for the very lightest colours. Leave to dry.

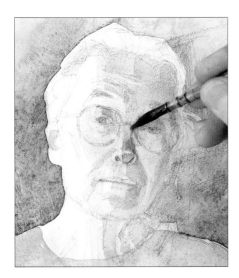

10 Use the oranges from the previous two steps, for the dark and mid tones on the face and neck. The colours are modified a little by the pencil lines that are already there.

11 Mix a warm brown from raw sienna and a little raw umber and put in the pattern of the dress, leaving the underlying cadmium orange showing through where necessary. Leave to dry. Then, using a mix of black and ultramarine blue, put in the darkest tones of the books in the background and the lines of the books behind the sitter's left shoulder, as well as the shadow between the book she is holding and its cover. Allow to dry.

> **Tips**:
> • Assess the relative sizes of the various books carefully.
> • Leave some of the blue-black mix from Step 8 showing through for pages of the books in the background.

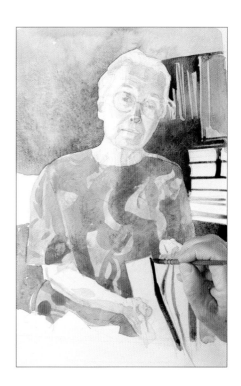

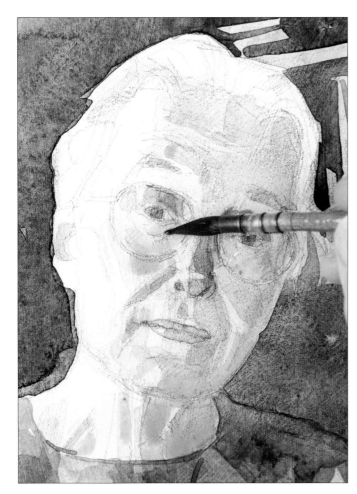

12 Darken the warm brown used for the dress in Step 11 and put in a little more of the mid-to-dark patterning. Continue with the skin tones, using the various tones of the orange and reddish mixes used before and paying attention to the lights and darks. Apply a touch of vermilion to the lips.

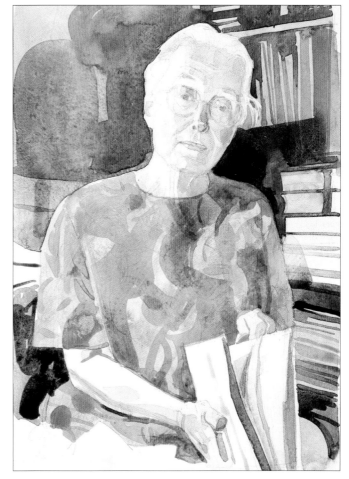

13 On the arm and hands, apply dilute washes of vermilion and cadmium orange, singly and together, wet into wet. Using very dilute cerulean blue, 'draw' faint marks on the open book to indicate print and pictures. Wash the same dilute mix over the books to her left.

▶

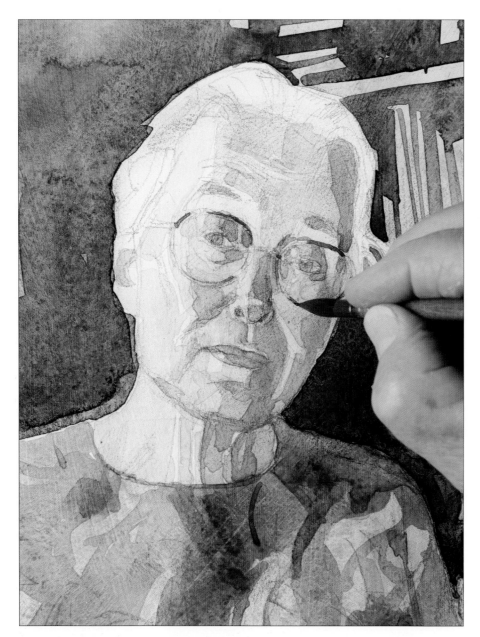

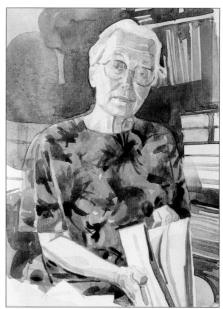

15 Use the same blue-black mix for the very darkest patterning on the dress. Don't try to put in every detail, or the pattern will overpower the painting. A general impression is sufficient. At this point you may find that you need to deepen the very pale orange applied in Step 9; if you do, ensure that all other colours on the dress are completely dry or they will blend wet into wet and ruin the effect.

14 Continue building up the layers on the skin tone, using slightly darker versions of the previous mixes. Brighten the red of the lips with a touch of vermilion. Using the blue-black mix from Step 11 and a small round brush that comes to a fine tip, paint in the metal rim of the spectacles. Darken the pupils of the eyes with the same blue-black mix and wash a very dilute grey into the shaded parts of the hair to create some texture and tonal variation. Be careful not to colour the hair grey, however – your grey shading should, on the contrary, make the white of the hair more striking.

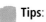 **Tips**:
• The spectacle rims catch a lot of reflected light, so the outer edge virtually disappears in places. Observe this carefully and leave gaps where necessary.
• If the hair is to read as white in the finished painting, all of the face – except for the very brightest highlights – must have some tone, however dilute.
• Before you make any last-minute adjustments, make sure that your palette and water jars are clean so that you do not risk muddying your colours in the final stages.

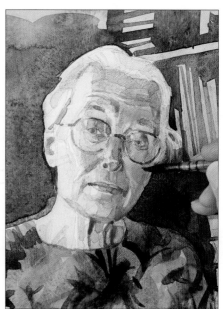

16 You may find that the very dark tones of the dress now dominate and that you need to adjust the skin tones accordingly. Use the same mixes as before, taking care not to lose sight of the overall tonality of the painting.

The finished painting

This is a sensitive portrait that captures the sitter's expression and personality beautifully. Carefully controlled wet-into-wet washes have been used to build up the skin tones and create subtle modelling on the face and neck; the white of the paper has also been exploited to good effect in the highlight areas. The wrinkles and creases in the face, drawn in during the initial pencil underdrawing, add character and expression and show through the later watercolour washes without dominating them. The distracting elements in the background have been reduced to graphic shapes and monochromatic areas of mid and dark tone, against which the figure stands out clearly. The composition and use of light and shade help to convey the lively personality of the sitter.

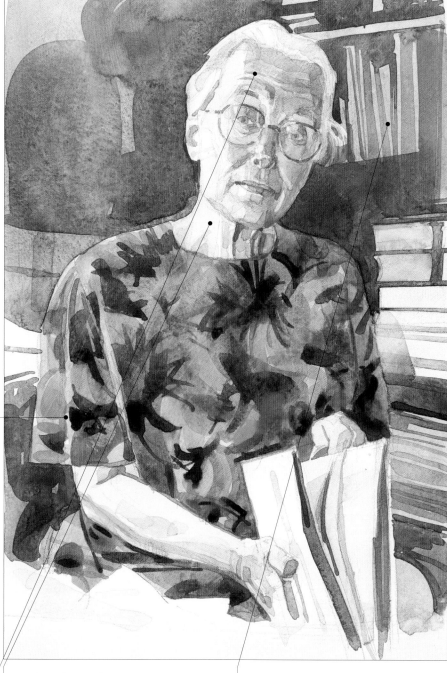

The patterning of the dress has been subtly painted so that it does not overpower or dominate the portrait.

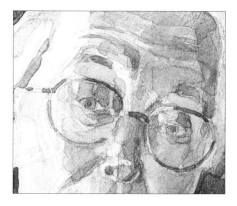

The wrinkles are conveyed through linear pencil marks.

Note how the very brightest highlights are left untouched by paint.

The background has been reduced to a series of graphic, monochromatic elements.

Seated figure in watercolour

As you have discovered, painting someone in a setting allows you to say much more about them than you can in a straightforward head-and-shoulders portrait. You might include things that reveal something about your subject's interests – a musician with a guitar, perhaps, or an antiques collector surrounded by some of his or her possessions – or their work. In a domestic setting, the décor of the room itself is very often a reflection of your subject's tastes and personality.

The most important thing is not to allow the surroundings to dominate. The focus of the painting must remain on the person. This usually means that you have to deliberately subdue some of the detail around your subject, either by using muted or cool colours for the surroundings, so that your subject becomes more prominent, or, if the setting is very cluttered, by leaving some things out of your painting altogether.

Materials
- *3B pencil*
- *Rough watercolour board*
- *Watercolour paints: raw umber, alizarin crimson, cobalt blue, lemon yellow, phthalocyanine blue*
- *Brushes: medium flat, Chinese, fine round, old brush for masking*
- *Masking fluid*
- *Craft (utility) knife or scalpel*
- *Sponge*

Reference photographs
Here the artist used two photographs as reference – one for the seated, semi-silhouetted figure and one for the shaft of light that falls on the table top. Both photographs are dark and it is difficult to see much detail, but they show enough to set the general scene and give you scope to use your imagination. Instead of slavishly copying every last detail, you are free to invent certain aspects of the scene, or to embellish existing ones.

The highlight on the figure's hair is very atmospheric.

The shaft of bright sunlight illuminates part of the table top while almost everything else is in deep shade.

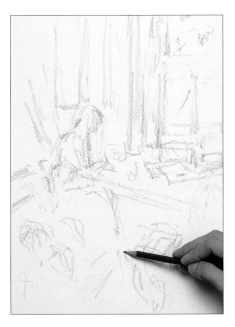

1 Using a 3B pencil, lightly sketch your subject, making sure you get the tilt of her head and the angles of the table, papers and books right.

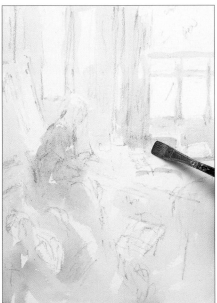

2 Mix a warm, pinky orange from raw umber and alizarin crimson. Using a medium flat brush, wash it over the background, avoiding the highlight areas on the window. Add more alizarin crimson to the mixture for the warmest areas, such as the girl's shirt and the left-hand side of the curtain, and more raw umber for the cooler areas, such as the wall behind the girl and the glazing bars on the window. Leave to dry.

3 Mix a very pale green from cobalt blue and lemon yellow and, using a Chinese brush, paint the lightest foliage shades outside the window, remembering to leave some white areas for the very bright sky beyond.

Tip: To enhance the impression of bright sunlight streaming through the window, take care not to paint foliage right up to the edge of the window frame. Instead, allow the white of the paper to stand for the very brightest patches of sky.

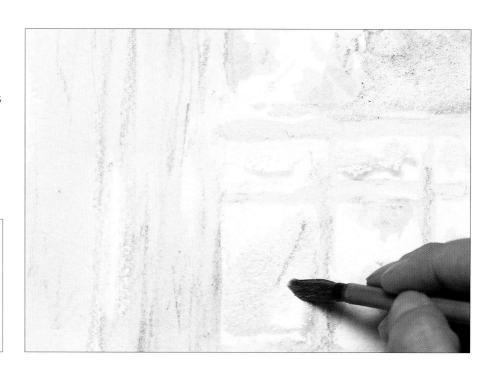

Assessment time

Mix a very pale blue from cobalt blue and a touch of raw umber and put in the cooler tones inside the room – the left-hand side, which the shaft of sunlight coming through the window doesn't reach, and the shadows under the table. Leave to dry.

You have now established the warm and cool areas of the painting, which you will build on in all the subsequent stages. Because of her position within the frame (roughly in the first third), the girl is the main focus of interest in the painting, even though she is largely in shadow. Keep this at the forefront of your mind as you begin to put in the detail and as you continually assess the compositional balance while painting.

This area is left unpainted, as it receives the most direct sunlight.

The warm colour of the girl's shirt helps to bring her forwards in the painting.

The shadow areas are the coolest in tone. They recede.

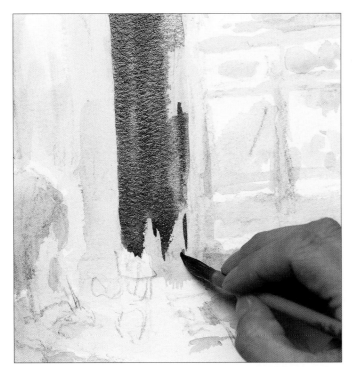

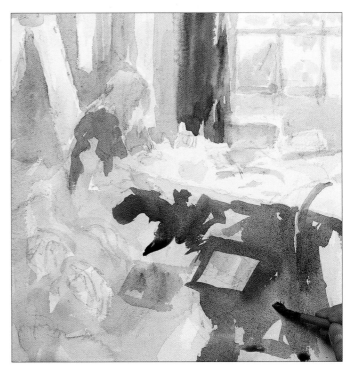

4 Mix a warm brown from alizarin crimson and raw umber and paint the girl's hair. Mix a rich red from alizarin crimson, cobalt blue and a little raw umber and, using a Chinese brush, paint the curtain. Apply several vertical brushstrokes to the curtain, wet into wet, to build up the tone and give the impression that it hangs in folds.

5 Using the same red mixture, paint the shoulders and back of the girl's shirt. Add more raw umber to the mixture and paint the shadow area between the wall and the mirror, immediately behind the girl. Mix a warm blue from phthalocyanine blue and a little alizarin crimson, and paint the dark area beneath the table using loose brushstrokes.

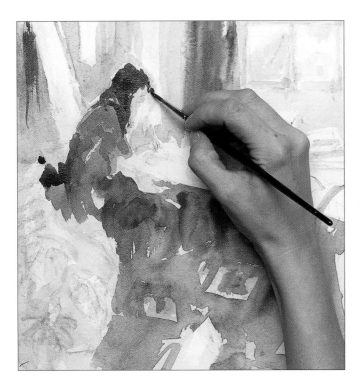

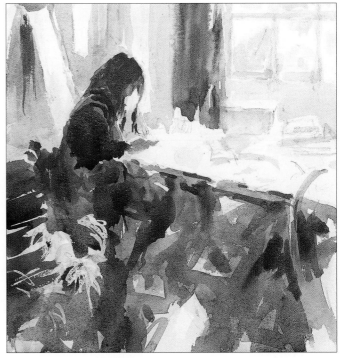

6 Using an old brush, 'draw' the shapes of leaves in the bottom left-hand corner in masking fluid. Leave to dry. Mix a rich, dark brown from raw umber and a little alizarin crimson and, using a fine round brush, paint the darkest areas of the girl's hair.

7 Add a little raw umber to the mixture for the lighter areas of hair around the face. Build up the shadow areas in the foreground of the scene, overlaying colours as before. Darken the girl's shirt in selected areas with the alizarin crimson, cobalt blue and raw umber mixture.

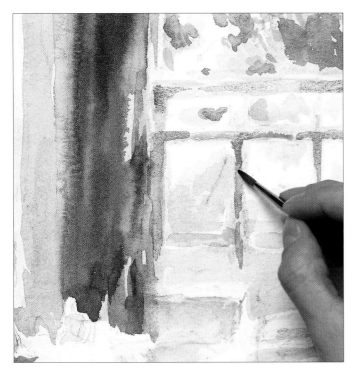

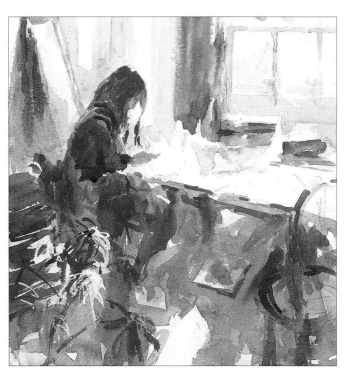

8 Mix a mid-toned green from phthalocyanine blue and lemon yellow and, using a fine round brush, dot this mixture into the foliage that can be seen through the right-hand side of the window. Mix a very pale purplish blue from pthalocyanine blue and a little alizarin crimson and darken the glazing bars of the window.

9 Paint the area under the window in a warm mixture of alizarin crimson and phthalocyanine blue. Mix a dark, olive green from raw umber and phthalocyanine blue and, making loose calligraphic strokes, paint the fronds of the foreground plant. Brush a very dilute version of the same mixture on to the lower part of the mirror. Build up the background tones.

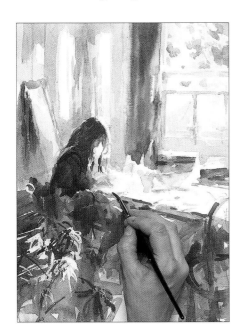

10 Mix a muted green from phthalocyanine blue and lemon yellow. Brush it over the background behind the girl. Because the green is relatively cool, it helps to separate the girl from the background. It also provides a visual link between this area and the foliage on the right.

11 Paint a few vertical strokes on the curtain in a dark mixture of alizarin crimson and phthalocyanine blue. This helps to make the highlight on top of the pile of books stand out more clearly. Mix a warm brown from raw umber and phthalocyanine blue and paint under the window.

12 Rub off the masking fluid from the bottom left-hand corner. Continue building up the tones overall, using the same paint mixtures as before and loose, random brushstrokes to maintain a feeling of spontaneity.

▶

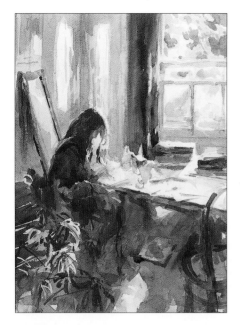

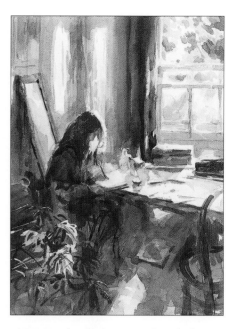

13 Mix a very pale wash of raw umber and lightly brush it on to some of the exposed areas in the bottom left-hand corner. Build up more dark tones in the foreground, using the same mixtures as before.

14 Using a craft (utility) knife or scalpel, carefully scratch off some of the highlights on the bottle on the table. Paint the wall behind the girl in a pale, olivey green mixture of raw umber and phthalocyanine blue.

15 Brush a little very pale cobalt blue into the sky area so that this area does not look too stark and draw attention away from the main subject.

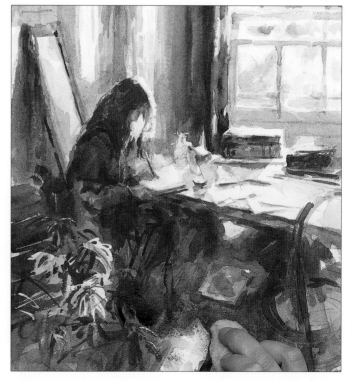

16 Continue building up tones by overlaying colours. Use very loose brushstrokes and change direction continually, as this helps to convey a feeling of the dappled light that comes through the window.

17 Using a 3B pencil, define the edges of the papers on the table. Mix a very pale wash of phthalocyanine blue and, using a fine round brush, carefully brush in shadows under the papers on the table to give them more definition. Dip a sponge in a blue-biased mixture of phthalocyanine blue and alizarin crimson and gently press it around the highlight area on the floor to suggest the texture of the carpet.

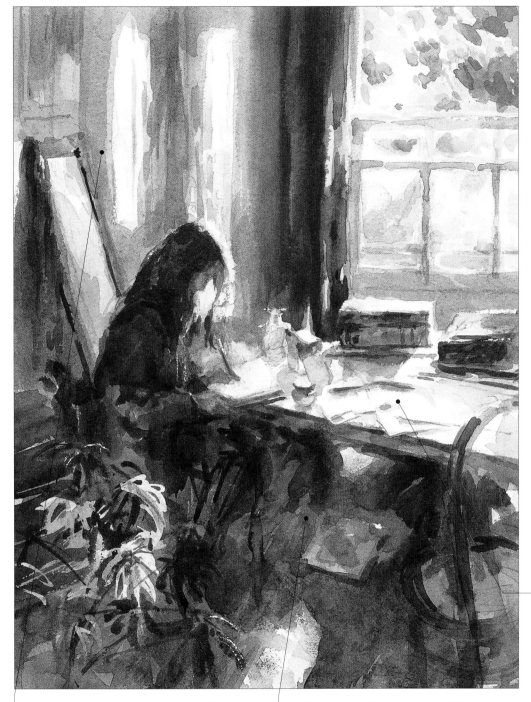

The finished painting
There is a wonderful sense of light and shade in this painting, and the loose brushstrokes give a feeling of great freshness and spontaneity. The scene is beautifully balanced, both in terms of its distribution of colours and in the way that dark and light areas are counterposed.

Sunlight pours through the window, illuminating the books and papers. Much of this area is left unpainted.

Pale, cool colours on the wall help to differentiate the girl from the background.

The foreground is loosely painted with overlayed colours, creating a feeling of spontaneity.

Girl playing on a beach in acrylics

When you include the setting in a painting as well as a person, you need to decide how much of the picture space to allocate to each. If you want to create a character portrait in which the person is the main focus of interest, then you need to make that person a large part of the picture as a whole; a mere hint of the surroundings may be sufficient. If, on the other hand, you want to set the figure in context so that the surroundings become an important part of the overall story, then the landscape or interior may well take up the majority of the picture space. Here, the artist decided to include the wider landscape as a way of bringing back memories of a happy family holiday.

In compositional terms, the position of the figure in a portrait such as this is just as important as the overall amount of space it occupies. Although the girl in this painting takes up only a small part of the scene, it is to her that our eyes are drawn. This is partly because the artist has changed the composition of her reference photo and positioned the child 'on the third' – a classic device for leading the viewer's eye to the main point of interest in a painting – and partly because the beach, sea and headland are painted in less detail.

In situ, you could never do more than make a few quick reference sketches of a scene such as this, as young children never stay still for long. This is where a digital camera can prove invaluable; you can fire off a whole series of shots in a matter of seconds and also play back the images immediately to check that you've got all the reference material you're likely to need before you leave the scene.

Materials
- *Watercolour board*
- *Acrylic paints: brilliant blue, yellow ochre, lemon yellow, brilliant yellow green, alizarin crimson, cadmium red, phthalocyanine blue, white*
- *Brushes: large round, medium round, fine round*
- *HB pencil*

The pose
This shot of a little girl playing on a beach is the kind of photo that every parent has in the family album. However, she is positioned so close to the edge of the frame that part of her shadow is cut off. The sea and headland take up so much of the photo that they dominate the composition.

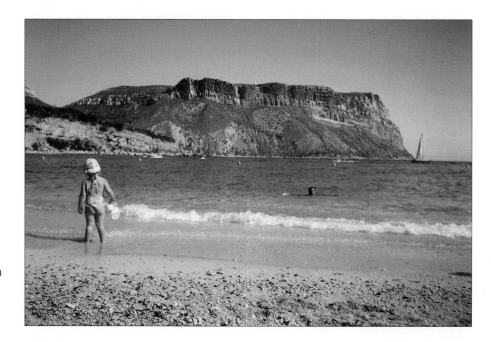

1 Using an HB pencil, lightly sketch the scene, putting in the lines of balance of the figure (the central spine and the tilt of the shoulders). Note how the artist has changed the composition by positioning the little girl 'on the third', including less of the headland and moving the boat to balance the composition and frame the figure.

2 Mix a thin wash of brilliant blue with a little phthalocyanine blue acrylic paint and, using a large brush, wash it over the sky and sea, making the mix a little darker for the sea. Mix a sand colour from yellow ochre and alizarin crimson and wash it over the beach, adding more yellow ochre for the foreground. Use a redder version of the sand mix for the girl's skin.

Tip: Make sure you leave some space above the little girl's head so that it stands out clearly against the blue of the sea. In the photograph her pale hat is too close to the line of the headland.

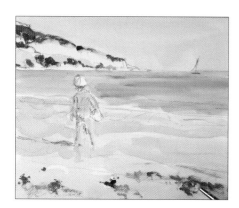

3 While the paper is still wet, brush a dilute purple (mixed from alizarin crimson and brilliant blue) over the wet sand, allowing the colour to spread wet into wet. Apply a pale wash of the sand colour over the headland. When dry, mix a dark green from phthalocyanine blue, lemon yellow and yellow ochre and dab in the vegetation. Add a little cadmium red and phthalocyanine blue to a thicker mix of yellow ochre and dot in sand and pebbles in the foreground.

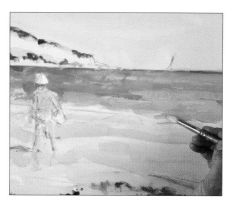

4 Mix brilliant yellow green and brilliant blue to give a vivid blue and brush this colour on to the sea along the horizon. Look for different tones of blue and green in the sea and brush them in, using various versions of the vivid blue mix and adding white to the mix in places. For the wet sand along the shoreline, mix a slightly thicker, pale blue violet from alizarin crimson, white and brilliant blue, and apply using a dry brush.

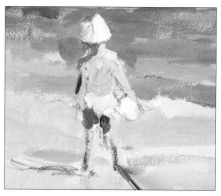

5 Using a fine round brush, put in the white of the little girl's sun hat, bucket and bathing costume. Mix a warm flesh colour from cadmium red, white and a tiny bit of yellow ochre and put in the shaded tones on the little girl's body – mostly on the left-hand side, but also on the inner edges of her right thigh and calf.

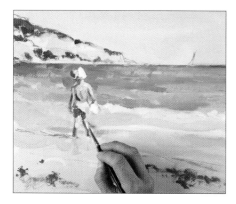

6 Use phthalocyanine blue for the bright blue of the little girl's bathing costume, and a pale purple mix for the shaded side of her sun hat. Continue working on the flesh tones, looking for the light and dark tones within the figure. Use variations of the mixes from the previous step for the darker tones and a mix of lemon yellow, white and cadmium red for the sunlit side of the figure, which is warm in tone.

Tip: You may find it easier to judge the shapes if you turn your painting upside down. This helps you to reproduce how things look, rather than following the way your mind says they should look.

Assessment time
The figure requires very little extra work other than adding the cast shadow on the sand. Although the combination of different colours in the sea works well, there is no real sense of the wavelets breaking on the shore.

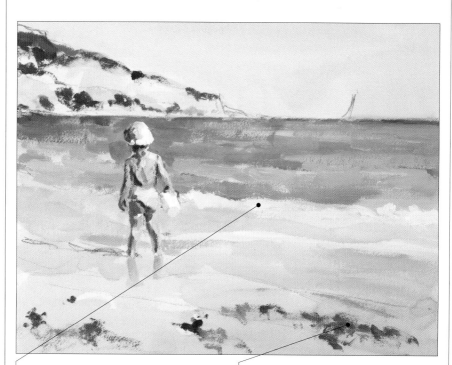

The boundary between sea and shore can be made clearer by making more of the breaking waves.

Adding a little more detail and texture to the foreground sand will help to bring it forwards in the picture.

▶

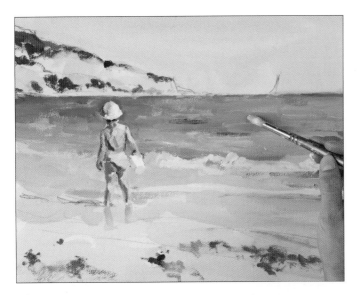

7 Brush more colour into the water, using the same green and violet mixes as before. Mix white and the pale blue-violet mix from Step 4 and, using both your fingers and a relatively dry brush and slightly thicker paint than before, dot in the breaking wavelets along the shoreline.

Tip: It's important not to spend too long on one area; instead, keep alternating between the main subject and the background, so that the whole painting moves along at the same pace and you can continually assess the tonal values.

8 Mix a violet shadow colour from the pale blue-violet mix and phthalocyanine blue and, using a fine round brush and fairly thin paint, brush in the shadow that the little girl's body casts on the sand.

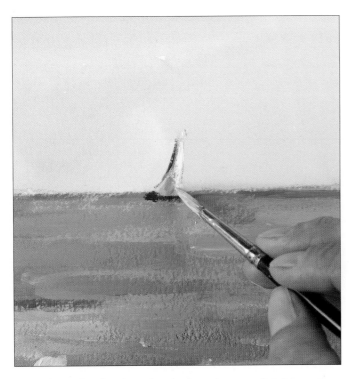

9 Using a fine brush, paint the boat in a purplish-blue mix of phthalocyanine blue and alizarin crimson and touch in the light edge of the sail in white.

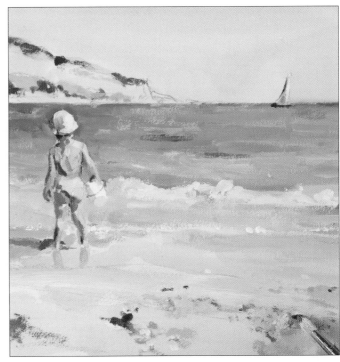

10 Scumble thicker mixes of yellow ochre and reddish browns into the foreground to create some texture in the sand and pebbles. Paint the sunlit sides of the pebbles in lighter grey-purple mixes.

The finished painting

Acrylic paints are a good choice for a subject such as this as they come in a huge range of colours and can be used very thinly, like watercolour, for delicate areas such as the wet sand, or thickly, like oils, for textural details in the foreground. This painting is full of light and sunshine, and the warm colours on the figure and foreground sand balance the cooler blues and greens of the landscape beautifully, while the composition leads the viewer's eye around the picture, from the figure of the little girl, up to the boat and then across to the headland and back to the girl again.

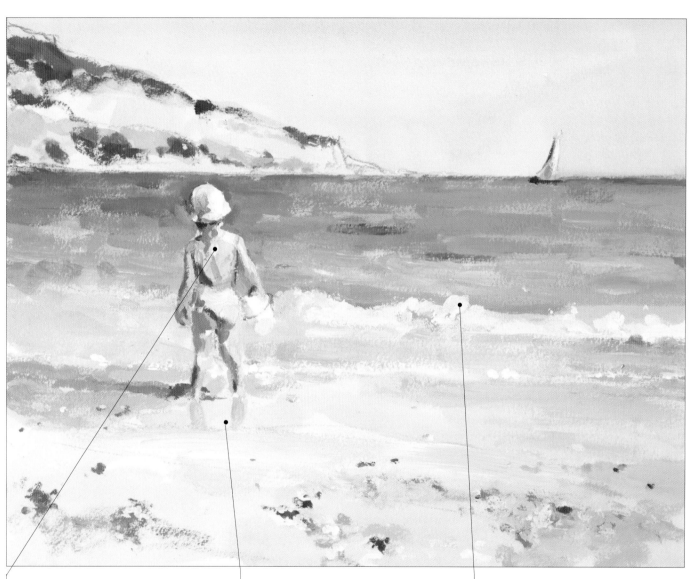

The modelling on the figure is subtle but effective and conveys the childish plumpness of the figure well.

Note how delicately the reflection in the wet sand has been painted.

Thicker paint, applied both with a brush and with the fingers, is used to give the breaking waves more solidity.

Informal portrait in watercolour

There's no rule that says a portrait has to be formal; a snapshot of a moment in time can be just as effective. Here, the artist took a series of photos of this young couple as they walked along, holding hands, on a sunny autumn afternoon and selected this shot as the one to work from because it was the only one that showed them looking directly at each other, oblivious to the camera. The fact that they are moving also gives the otherwise very static and calm scene more dynamism.

The other thing that makes the scene so appealing is the warm, dappled light. Because of its luminosity and translucency, watercolour is an obvious medium to choose to render the subtle effects of light and shade. Here, you can use wet-into-wet washes to build up the tones of the stonework and create the soft-edged shadows cast on the columns by the leaves. Combine this with wet-on-dry applications for the hard edges of the columns and areas that require more detailing, such as the figures and the foreground leaves. Remember, however, that you cannot apply a dark colour on top of a light one. You have to start with the lightest colour and work up to the darkest.

Materials
- *Heavy HP watercolour paper*
- *Watercolour paints: Prussian blue, raw umber, alizarin crimson, cadmium yellow, cadmium red, Venetian red, yellow ochre*
- *Gouache paint: white*
- *Brushes: large round, medium round, fine round*
- *HB pencil*

The pose
The couple are positioned one third of the way into the picture space – a classic compositional device, as the viewer's eye is immediately drawn to this area. The viewpoint has been chosen so that we are looking back along the row of columns; the line 'linking' the base of the columns seems to slope towards the vanishing point.

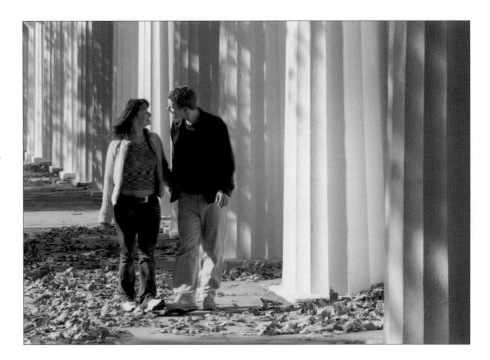

1 Using an HB pencil, lightly sketch the couple and their surroundings. Look for anything that you can use as a guide to where things are positioned. Look at the base of the row of columns in particular; as the columns recede into the distance, this line appears to slope upwards towards the vanishing point. Put in the vertical lines of the columns.

2 Continue with the underdrawing until you feel you have put down all the information you may need. The fluted facets of the columns and creases in the young couple's clothing are all things that you can make use of when it comes to doing the painting.

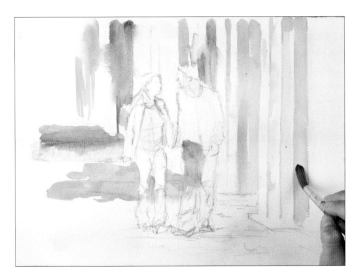

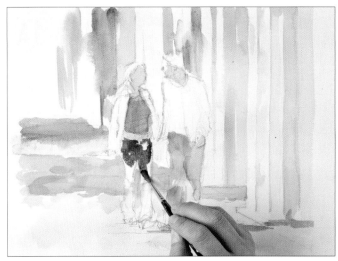

3 Mix a dark olivey green from Prussian blue and raw umber and, using a large round brush, put in the dark tones of the stonework and shadows. Then mix a very dilute reddish orange from alizarin crimson and cadmium yellow and wash it over the sunlit parts of the columns and ground. Use firm, straight strokes for the edges of the columns, otherwise you will get a wobbly effect.

4 Continue painting the columns, with variations on the previous mixes as appropriate. Using a medium round brush, loosely dab in the palest colour of fallen leaves using a dilute wash of cadmium yellow and cadmium red. Mix a flesh colour from Venetian red with a touch of yellow ochre and paint the exposed skin, leaving the highlights untouched. Begin painting their clothes, using Prussian blue with a hint of Venetian red for the jeans and Venetian red for the girl's top.

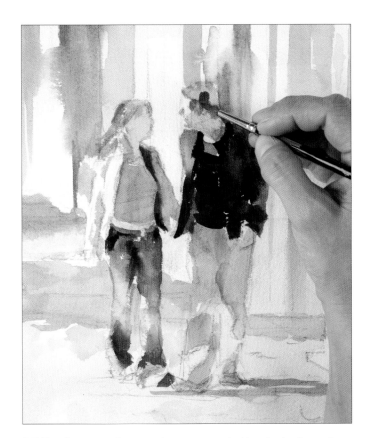

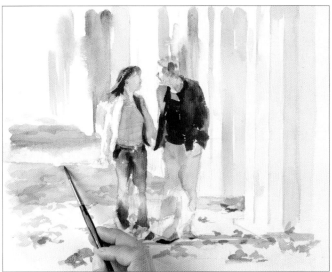

6 For the darker tones in the girl's hair, use a purplish black mix of Prussian blue and alizarin crimson. Use short, delicate brushstrokes and a fine round brush to build up some texture and detail. Put in the mid-toned leaves using a fine round brush and a reddish brown mix of cadmium yellow and alizarin crimson. Work wet into wet for the background leaves and wet on dry for those in the foreground.

5 Touch raw umber wet into wet on to the denim jeans to create tonal variation, leaving some areas very pale. For the boy's jacket, mix a dark, purplish black from Prussian blue, alizarin crimson and a little raw umber. Paint the girl's hair in an orangey red mix of raw umber and alizarin crimson, and the boy's hair in a mix of olive green and raw umber.

Tip: Having more texture and detail in the foreground than in the background is one way of creating an impression of distance. The viewer's eye assumes that any textured, detailed areas are closer.

▶

7 Apply more warm browns and pinks to the stonework, cutting in around the girl's head to help define her better. Using warmer, slightly darker versions of the previous mixes, begin to build up some modelling on the faces and hair. Darken the clothing, looking for the different tones and creases within the fabric that imply the movement of the limbs beneath.

Tips: Count the columns and their 'flutes' carefully to make sure you put in the right number. Aim for nothing more than a loose impression of the fallen leaves: if you try to put in every single one accurately, your painting will become very tight and laboured.

Assessment time
When you've put in all the basic elements of the composition and established the colours, look for areas that need to be strengthened. This looks a little flat in places, with insufficient contrast between the fore and background. The shadows, in particular, require work. Although the warm and cool colours give an impression of light and shade on the columns, the shadows of the leaves, which add real atmosphere, are missing.

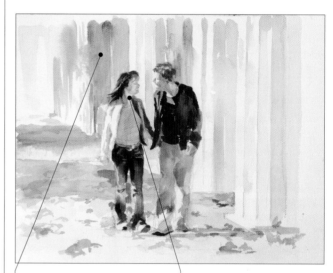

The cast shadows of the leaves, which add real atmosphere to the scene, need to be added.

This highlight area on the girl's neck is too bright.

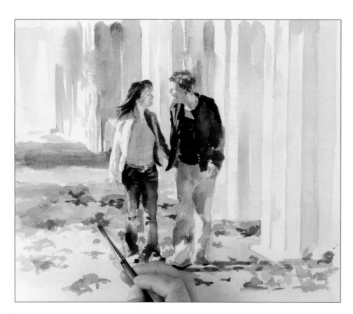

8 Deepen the shadows on the ground, using dark greys and browns. If you wish you can add a little white gouache to your mixes to create an opaque colour and brush in loose strokes to imply the dappled sunlight on the ground. Using a fine round brush and a range of reddish browns, put in the darkest colours of the fallen leaves.

9 Using short, broken brushstrokes and the same colours as before, build up the tone on the stonework columns. To create a sense of dappled light, add a little white gouache to your mixes for the most brightly lit areas and dab on small randomly-shaped marks for the cast shadows of the leaves.

The finished painting

This portrait exploits the characteristics of watercolour to the full, using wet-into-wet washes of translucent colour while still allowing the white of the paper to shine through. One of the keys to the success of a painting such as this is observing how the figures relate to one another: the time the artist spent on the underdrawing, establishing lines of balance such as the tilt of the shoulders and the angle of the hips, has paid dividends. Although loosely painted, the young couple's animated expressions are clear to see. The beautiful dappled lighting and soft colours give a warm glow to a portrait that is full of charm and life. The diagonal line of the stone columns is a strong compositional device that adds dynamism.

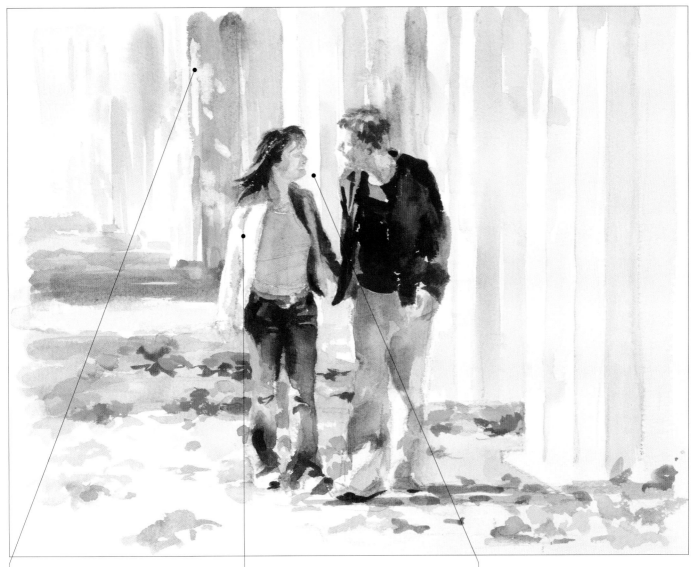

Dabs of opaque gouache, tinted with the appropriate colour, convey the cast shadows on the columns.

The way the light falls across the figures has been carefully observed and rendered, making the portrait atmospheric.

The animated expressions and body language bring the portrait to life, giving it movement and character.

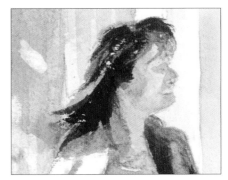

Index

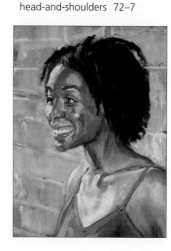